PET PHOTOGRAPHY

THE SECRETS TO CREATING AUTHENTIC PET PORTRAITS

NORAH LEVINE

rockynook

PET PHOTOGRAPHY:
THE SECRETS TO CREATING AUTHENTIC PET PORTRAITS

Norah Levine
norahlevinephotography.com

Project editor: Maggie Yates
Project manager: Lisa Brazieal
Marketing manager: Jessica Tiernan
Copyeditor: Valerie Witte
Front Cover: Jess Glebe Design
Cover Photography: Norah Levine
Interior Design: Jess Glebe Design
Interior layout and compositing: WolfsonDesign
Indexer: Maggie Yates

ISBN: 978-1-68198-097-3
1st Edition (1st printing, December 2016)
© 2017 Norah Levine
All images © Norah Levine unless otherwise noted

Rocky Nook Inc.
1010 B Street, Suite 350
San Rafael, CA 94901
USA

www.rockynook.com

Distributed in the U.S. by Ingram Publisher Services
Distributed in the UK and Europe by Publishers Group UK

Library of Congress Control Number: 2015956200

This book is printed on acid-free paper.
Printed in China

For Ruckus and Pepe for expanding my heart.

ACKNOWLEDGMENTS

My ability to write this book stems from much love and support. I would like to thank my husband, Adam, for his tremendous encouragement; my three loving parents; my sister, Jess, for her love and incredible talents; my teacher and friend Chelsea Beauchamp for too much to list; my dear friends in the animal community who work tirelessly for animals—you continue to inspire and teach me; to the many people and animals who trust me to honor them and their loved ones with my camera; to my animal family—those in my home and the ones forever living in my heart. You are my inspiration.

NORAH LEVINE

Norah Levine is cofounder of the philanthropic Lifelines Project (honoring the bond between the homeless and their pets), fine artist, and professional child and pet photographer based in Austin, Texas.

Leah Overstreet

Levine's work has been featured in a number of prestigious publications, including Austin Monthly and Professional Photographer magazine, highlighting her creative work with animals. As an instructor at the world renowned Santa Fe Photographic Workshops in New Mexico, Levine focuses her instruction on the intricacies, challenges and rewards of photographing pets. In 2010, Norah moved from Santa Fe, NM, to Austin with her husband and their five rescued pets.

Visit Norah's website or connect with her on social media:

norahlevinephotography.com
facebook.com/norah.levine.photography
twitter.com/NorahLevine
instagram.com/norahlevine

CONTENTS

INTRODUCTION

Pet photography is about more than cute photos. The experience of creating impactful pet imagery offers you the opportunity to combine your love of photography with animals; provide priceless images to the people who love their pets; collaborate with pet-related businesses; and support valuable animal welfare causes. There is so much opportunity available to you as a pet photographer, whether you are creating images for yourself, your friends and family, as a volunteer, or as a business owner.

It is important to note that this genre incorporates *every* element associated with portrait photography—with animals as the subjects. This book will support you in your journey toward better pet photography by giving you the confidence you need to take your next steps on this challenging, yet rewarding path.

As pet photographers, it is very important to develop the skills necessary to visually and emotionally connect with pets and their human companions—while also considering the integral elements of lighting, composition, and directing. This book will help you develop an understanding of animal behavior as well as logistical, technical, and creative tools that will allow you to communicate your vision via your images.

I hope my experiences will encourage you on your path to more rewarding pet photography. Since collaborating with animal welfare groups has been such a big part of my journey, I have dedicated an entire chapter to this subject matter with the hopes of inspiring you to get involved with your camera at similar types of organizations.

Pet photography has expanded my world and opened my heart. I have been invited into people's homes to photograph their relationships with their beloved pets, had the chance to collaborate with businesses and nonprofits, pursued personal projects, and helped guide others in their own journey. While there have been many challenges, pet photography has been incredibly rewarding.

Writing this book has put my career as a pet photographer into perspective. I can attest to the fact that my strongest images of pets were created with the knowledge gained from practicing and continued learning. I can't promise that reading this book will prevent you from taking any more bad photographs, but it can help you get to the next level with your pet photography, faster.

It is my sincere hope that after reading this book you feel inspired to take your next steps as a pet photographer. Enjoy the journey!

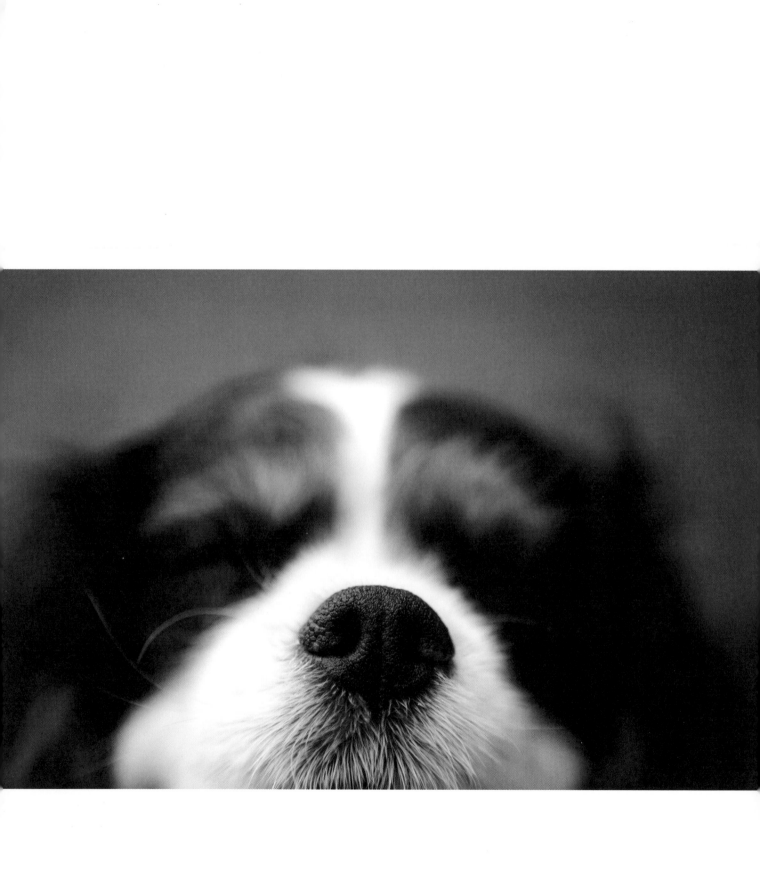

CHAPTER 1: DISCOVERING OPPORTUNITIES, CHALLENGES, AND REWARDS

We are starting this journey together by taking a close look at the many opportunities—both the challenging and the rewarding—that pet photography can offer. (Yes, there are challenges but the rewards are yummy!) Pet photography has many different facets, leaving lots of room for creative application. The ways we approach this type of photography can vary greatly based on our desires and goals. Rather than becoming overwhelmed by the options, we'll begin by asking some valuable questions, which will hopefully provide clarity. The goal of answering these questions is to determine what we want so that we can begin to develop an approach to the genre of pet photography that allows us to feel the most fulfilled.

The information in this chapter addresses anyone interested in pet photography—those of you who are just beginning to delve into this category and others who have already been exploring pet imagery but are looking for some inspiration or new direction. These ideas can also serve as a brainstorm for any photographer wishing to become aware of the many opportunities available in pet photography.

I applaud all of you for showing up to explore, and I'm committed to supporting you in your journey.

The Power of Asking Why

Consulting with ourselves about what is driving us to creating pet portraits can provide useful information about how to move forward creatively. The inquiry process can benefit those of you who are just starting out in pet photography, as well as people with a bit more pet photography experience. As I mentioned earlier in the chapter, I believe there is great value in the process of occasionally "checking in" about your priorities and motivation. The inquiry process has helped me tremendously over the years.

To determine what we need with regard to our photographic experience, begin by asking the question, "Why?" Through this process, we can start to figure out how we want to integrate our photography with the animal world and say *yes* to situations that support opportunities aligning with our values. Spending some time in inquiry can also help us gain insight on when to pass on opportunities that don't quite fit with our needs. Try not to get overwhelmed by having the "right" response to these questions (because there isn't one). Consider recognizing that all you can really do is make decisions based on what you know in your life right *now*. Keep in mind that your responses to the questions today may very well be different in a year or six months from now. That's totally perfect!

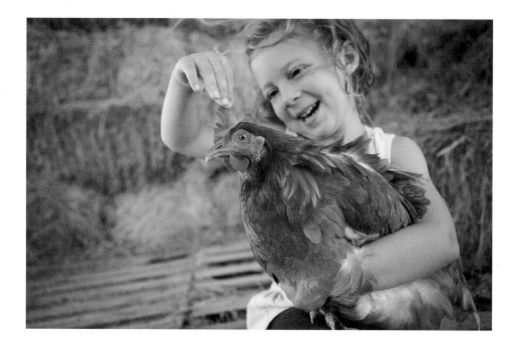

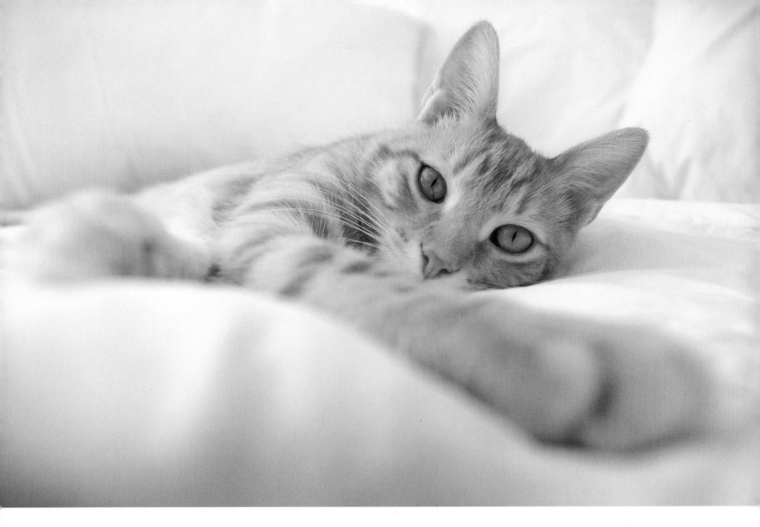

WHY DO YOU WANT TO CREATE PET PORTRAITS?

AM I INTERESTED IN INTIMATE MOMENTS, WORKING ONE-ON-ONE WITH AN ANIMAL AS A PRIORITY?

Perhaps you really love the idea of working individually with animals because it offers you an opportunity to take your time and really get to know them and play with them. Interacting with animals might be a top priority for you as part of your photographic practice. Alternatively, you may love the idea of working with animals along with a team of people to support you in a commercial setting or faster-paced scenario. Maybe one-on-one interaction isn't as important to you, but you love the aesthetic qualities in animals and the visual part of the process is more important. What do you tend to lean toward?

AM I INTERESTED IN WORKING WITH MANY ANIMALS AT ONCE?
Maybe you're intrigued by visually capturing many different characters within one photo session. This can be exciting and provide variety in your portfolio and experience. A few ways this can become a reality are by photographing in an animal shelter or sanctuary, a dog daycare environment, a special event, or a show.

IS IT IMPORTANT FOR ME TO CONTRIBUTE TO MAKING A DIFFERENCE IN THE ANIMAL WELFARE WORLD? WOULD THAT BE FULFILLING TO ME?
Perhaps you have an affinity for rescue dogs or cats and have adopted all you can currently justify. You may also be looking for ways to give back using your creative skills and you have the feeling that collaborating with animal welfare groups is a good fit. This may also not fit into your current vision, which is absolutely fine. Again, this is a good opportunity to gather information for yourself.

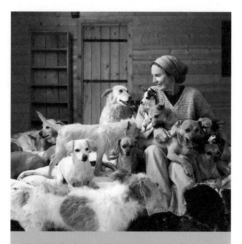

Natalie Owings with the many dogs housed at The Heart and Soul Animal Sanctuary near Santa Fe, New Mexico.

DO I NOT WANT TO WORK WITH PEOPLE ANYMORE?
This one is sneaky. While there are ways to work more heavily with animals than with people in pet photography, it is not possible to eliminate people from the equation (unless we can somehow teach dogs, cats, and horses to email and make phone calls!).

IF I KNEW HOW TO _____, I WOULD FEEL MORE CONFIDENT PHOTOGRAPHING PETS.
Perhaps you already know of a specific direction you'd like to take with pet photography, but you feel that there is something holding you back, either technically or logistically. Getting clear on what might be holding you back can be a huge step forward. Perhaps you feel limited because of lack of experience, technical knowledge, people skills, an understanding of animal behavior, or creativity. Not to worry! I'll be covering all of these potential issues.

WHAT TYPES OF PETS DO I WANT TO WORK WITH AND SPEND TIME
PHOTOGRAPHING?
If the answer is "dogs only," that's perfectly acceptable. If you want to start a
pet photography business but don't want to photograph horses or cats, that's
perfectly fine. If you want to volunteer at an animal shelter and work with cats
only, there are ways to do that. There are no rules about the types of animals
you photograph, and being clear on what you're interested in will help you make
decisions about how to move forward with your process.

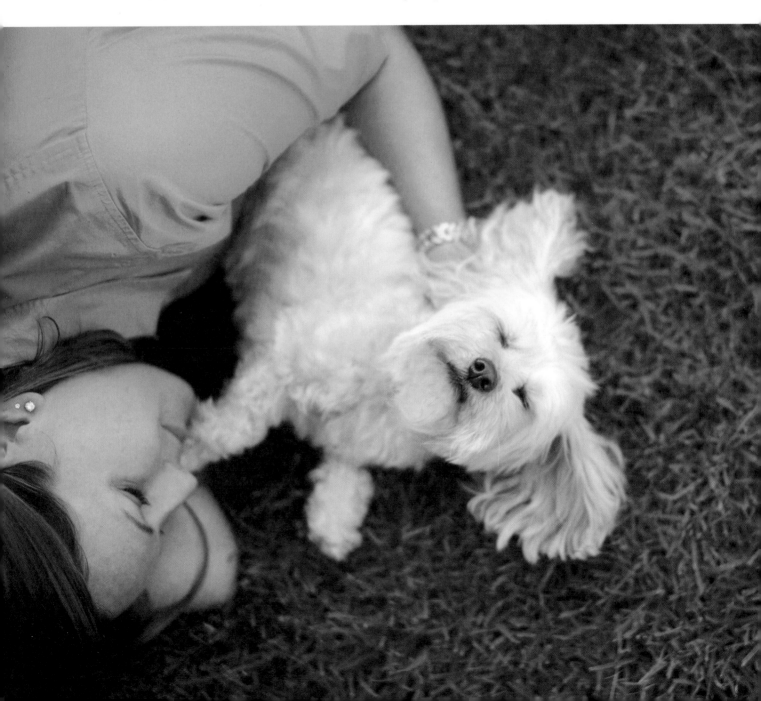

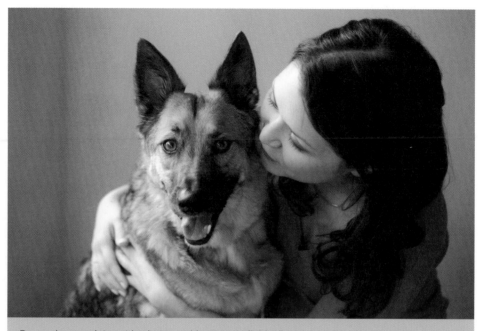

Do you have an interest in photographing pets individually or also with their people?

IS MY PREFERENCE TO PHOTOGRAPH PETS INDIVIDUALLY?

Photographing pets individually is very different from creating images of pets with their people. Maybe you are mostly interested in working with pets individually, but are curious about what it would be like to photograph pets with people. Try to get a sense of what you're more drawn to and start there. If you start with pets individually and begin to feel more comfortable, consider adding people to the equation. When I first started working with pets, I focused on pets individually; now, years later, I have acquired an affinity for capturing the connection between human and animal.

WHAT ARE THE OPPORTUNITIES TO WORK WITH PETS WHERE I LIVE?

If you love photographing horses and you live in the city, you may have to figure out a way to gain access to horse subjects and communities. Are there lots of pet-related businesses in your area? Perhaps you take your dog to a daycare facility and could use that connection to gain access to dog subjects. Are there dog, cat, or horse shows occurring in your city or town? Do you notice a lot of pet-friendly businesses near you? Being aware of what's available to you can help in terms of finding subjects to photograph. If starting a pet photography business is one of your priorities, begin by building some knowledge about your local animal community.

Do I want to earn money with my pet photography?
This question can refer to your need to generate income, but also your desire to include making money as part of the *experience* of photographing pets. Again, there are no wrong answers here, and you may not know the answer just yet. The reality is that while photography has become more affordable and accessible in many ways, investing in good equipment is not inexpensive. Having said that, you may have enough money to buy a decent camera, a laptop computer, and the software you need to edit your images. That's a pretty great place to start. But if you have specific goals in mind, it's a good idea to be aware of the financial aspect. For example, with studio photography, there are significant investment requirements for lighting equipment and modifiers. Updating digital cameras and software and maintaining an online presence have become regular expenses for photographers.

If you decide to photograph for money, you'll need a portfolio of images to represent the type of work you'd like to create for potential clients, and you'll need the equipment to do this. Some of these expenses exist whether you choose to try to generate income with your pet photography or not.

If income isn't a required result (either financially or emotionally) of your pet photography, you may choose to photograph pets as they're accessible to you in order to hone your skills for your own personal growth and satisfaction, or volunteer your services to help animals. This is a perfectly legitimate and honorable direction to take when photographing pets. You may also choose to start out with your pet photography as a hobby, and later feel that you might want to experience working as a pet photographer for income. Sometimes these answers present themselves with time and experience.

Pet Photography's Many Applications

Most of us think of commissioned pet portraits when we hear the words, "pet photography," but there are actually several ways to work with pets and photography. Here are just a few.

VETERINARY HOSPITALS often need photographs to illustrate their varied services for their marketing materials. This work is usually a little less about portraiture in the traditional sense, but still involves animals. The work I have done in vet hospitals has tended to be fast-paced and has taken place during hours when the facility is open. I have been asked to photograph procedures, exam rooms, acupuncture treatments, and portraits of staff members as part of these types of projects. Some hospitals have also requested artwork for display in lobbies and exam rooms.

DOG DAYCARE AND OTHER PET-RELATED BUSINESSES are great ways to work with pets in your photography. All pet businesses need quality marketing imagery. Dog daycares, in particular, provide the opportunity to photograph many faces and characters in one location. I love photographing for dog daycares and find it challenging and fulfilling. Many pet retail businesses enjoy having photo shoots in their stores.

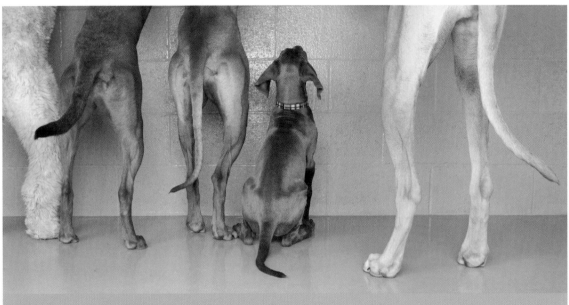

Photographing in dog daycare businesses can be an exciting way to capture variety and gain experience with many different breeds.

STOCK PHOTOGRAPHY is another way to include pets in your photography. While this industry has shifted dramatically from what it once was, the need for strong and creative images still exists.

COMMERCIAL PHOTOGRAPHY often includes images of pets. Photographs from commercial projects are used to sell or market a product or service. Projects can range from large projects for huge corporations via ad agencies to small businesses where the photographer connects directly with the business owner. These types of photo shoots typically involve a lot of collaboration between the photographer and the client to produce very specific images.

This image was created specifically for a stock image library.

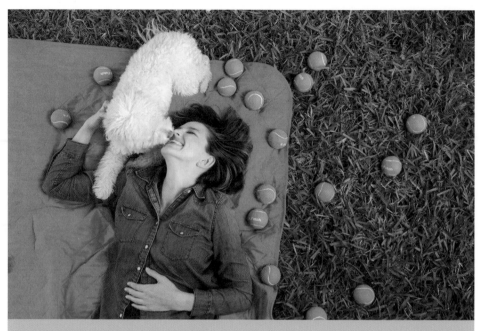

Commercial photograph created for iFetch, LLC, to promote their dog ball–launching product.

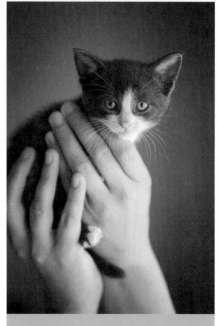

Image of a foster kitten available for adoption.

NONPROFIT ANIMAL-RELATED ORGANIZATIONS, as you'll see throughout this book, provide opportunities for volunteer work, personal projects, and paid and unpaid collaboration on marketing projects.

FINE ART PHOTOGRAPHY involving animals has no limits. I recently started photographing animals specifically for use in my fine art photo encaustic artwork. Creating in this way is quite different from participating in commissioned portraits, animal-related businesses, stock photography, or commercial projects.

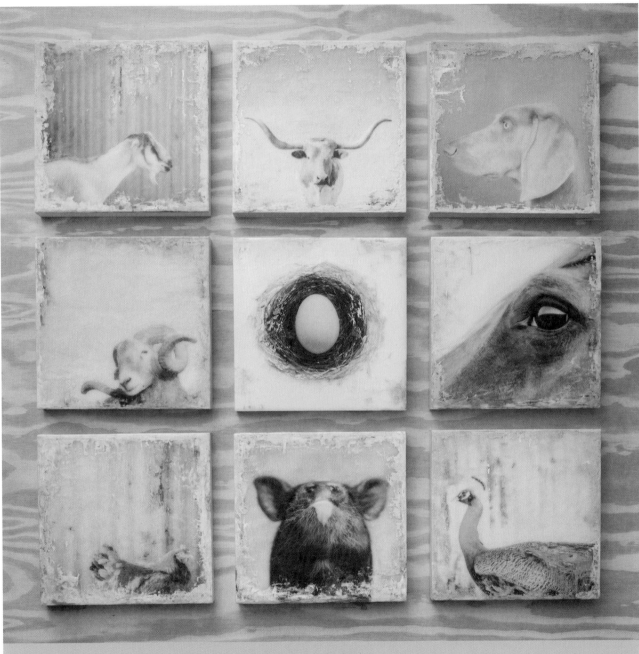

A collection of photo encaustic art pieces I created using images of animals.

Personal
Pet Photography Projects

Regardless of where you decide to focus in your pet photography, I urge you to keep personal projects on your priority list. Personal projects are important for any artist, and pet photographers are no exception. These kinds of projects provide you with the opportunity to focus on a concept, event, person, or animal that interests you on a personal level, and allows you to approach the project with your own creative agenda in mind. The opportunities can vary greatly, and there are no rules about what can become a personal project. These endeavors can be based on personal connection and experience, a cause you want to support, curiosity, or simply a visual aesthetic that interests you.

HOW DO YOU START?

There are so many ways to start a personal project! It can actually be overwhelming and cause analysis paralysis resulting in (drumroll, please!)...no project. So let's generate some ideas to get you started. Not all personal projects need to be grandiose, and sometimes simple is better. Maybe you decide to start by focusing on a particular type of pet, such as brown dogs, senior dogs, retired show dogs, horses, or cats in windows. You could photograph your own pets over a period of time or in a specific place you feel is meaningful emotionally and/or aesthetically. You might want to photograph dogs in front of famous places or landmarks in your area, or dogs you meet in the street when you're traveling.

The most important factors in creating a personal pet photo project are having a curiosity about what you're doing and having the primary reason you're creating it be that you're inspired. There is no client to make happy, and no promises given (aside from prints or images exchanged for participation, or fees for models, if applicable). This is your opportunity to create images for yourself, in your style, on your timeline. Personal projects can become something that you can't stop thinking about. Those are the best ones! But don't worry if you don't become love-struck; not all personal projects have to start with an "aha! moment" in which you know exactly what you want to do, nor do they always result in unabashed connection.

Start with something you have an interest in exploring. This is like a seed you can water by creating some photographs and seeing if that seed turns into a sapling and continues to grow. If it doesn't, just move on and maybe come back to it. Or not. That's fine, too.

PUTTING TOGETHER A PORTFOLIO OF PERSONAL WORK

Personal projects can often help fuel other areas of your creative work in ways you could not have predicted. If you're just starting out in pet photography, you could consider all of your images of pets "personal work," as you're pursuing a subject matter that interests you and building your portfolio of work within your own timeline. If possible, consider asking a professional photographer to review your work and help you with editing to highlight your visual strengths. Have fun with it and notice what you're drawn to.

ADDING TO YOUR PORTFOLIO FOR OTHER OPPORTUNITIES

Many businesses form as a result of what was originally a personal project. Your portfolio creation can serve as an entryway to your pet photography business. For those interested in pursuing a business, consider diving into a project that can potentially result in an incredible sampling of what you could create for a client, either as a commissioned portrait or in a commercial environment.

Exploring an aspect of pet photography for which you have curiosity or that ignites inspiration gives you "permission" to capture images with 100 percent of your own creative vision, using your own unique approach. This exploration is important, as creating portfolio images within your own parameters and time-frame is something that can be harder to achieve when you're working for a client.

Having said all this, try not to place too much emphasis on the end result of personal projects in terms of how they will work for you on a business level, but rather, maintain an awareness of the possibilities.

PERSONAL PHOTOGRAPHY PROJECTS FOR NONPROFITS

It's no secret that photography is a powerful and essential tool for communication. Nonprofit animal-related organizations rely on photography to communicate their message just as much as any commercial business selling a product or service. Quality photography is always in demand! If you have an interest in supporting animal-related nonprofit organizations, you might think about enlisting your photography skills and reflecting on the many ways you can be of support, while at the same time, feeding your passion for photography.

As I'll discuss in Chapter 10, "Photographing For Nonprofits: Giving Back and Collaborating," I am a huge advocate of bringing passion for photography to animal welfare groups. Not only do strong images help the organization by shining a visual spotlight on their mission, but they can also help animals directly. For example, your photography can highlight an animal's character in a shelter while he or she is in need of a forever home, or your photographs can encourage donations for an animal in need of a costly surgery or treatment. Nonprofit animal-related organizations and their programs could also become the inspiration for personal projects, as I experienced when I photographed a personal project I named the *Lifelines Project*, which focused on honoring the bond between the homeless community and their pets. This project was directly inspired by a program run by an Austin, Texas–based animal welfare organization called Animal Trustees of Austin (which has now merged with a national organization called Emancipet). I'll talk more about this project and how it unfolded later in the book.

Photographing for and collaborating with animal welfare organizations has given me a great deal of experience as a photographer and loads of satisfaction as an animal lover. I strongly suggest that you consider using your passion for photography and animals to support individual animals or animal welfare groups, or to generate awareness for causes you support, as this work can be tremendously rewarding.

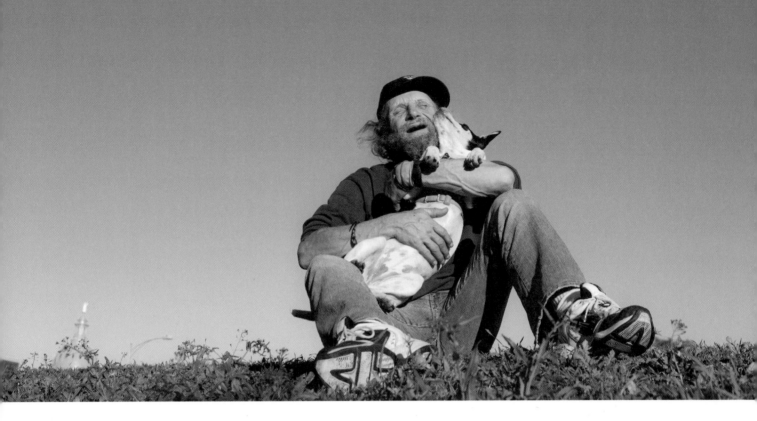

Pops and Wednesday, photographed for the Lifelines Project, a personal project inspired by an animal welfare organization in Austin, TX.

RUNNING INTO CHALLENGES
(BUT THEN JUMPING OVER THEM)

Encountering challenges throughout the pursuit of a personal project is inevitable. While preparing for all difficulties is impossible (trust me, I'm always trying), let's address a few issues you might come across so you have a head start in overcoming them.

SOMEONE ELSE HAS ALREADY CREATED A PROJECT LIKE MINE.
Please don't let this stop you! You have your own unique way of seeing and capturing photographs of animals. No one can do exactly what you're doing, because they're not you. If you find yourself inspired to pursue a project that seems like it has already been covered, try to consider how your interpretation might be different from someone else's—and do your best to stay committed to being yourself.

Rather than spending time on what you are missing, either creatively or logistically, focus on what you *do* have to contribute. You may have different access to a special community or subject matter, you may implement a more documentary style, or you might photograph on location rather than in a studio, or

choose black and white instead of color. Your vantage point might be different, you might incorporate a different style of lighting—there are endless possibilities. If the project is truly important to you and is lighting a spark for you creatively, go for it. Don't stop the parade before it starts. You might be surprised by the direction it takes.

COMMITMENT

While there is no rule for how long you need to spend photographing personal projects, many photographers choose to commit to them for long periods of time—weeks, months, or even years. Your project may involve returning to a specific event year after year or photographing a pet throughout his or her lifetime. Staying committed to the project will enable you to truly explore the concept and allow it to expand and shift over time. Sometimes spending a lot of time on a project will help inspire other projects as well.

Be aware that personal projects often include some level of struggle, such as difficulty with logistics and technical aspects, and lack of creative inspiration or even questioning the project's validity. If you're really committed to developing your project, staying focused on pushing through those less-than-inspired moments is crucial. If you find yourself starting to struggle, it might be a good time to ask why and explore what you can change to help motivate you to move forward. Perhaps you can try a different lens or style of lighting, or talk to someone who can help you find interesting subjects or opportunities that align with your vision. Sometimes taking a break and doing something completely different can also allow you to jump back into creative projects with new energy and perspective.

FINDING SUBJECTS

Ideas for projects might come easily to you, but finding the subjects for your project may not be as simple, at least initially. For example, maybe you have the idea to photograph pugs on porches, but you don't own a pug and you don't know anyone who does. This might be a challenging way to launch a project, but do your best not to let this obstacle deter you from moving forward. A simple Internet search can get you started on developing a list of people and organizations that may have access to pugs. Reach out to individuals, organizations, and businesses that are connected with pugs, and let your connections guide your next steps.

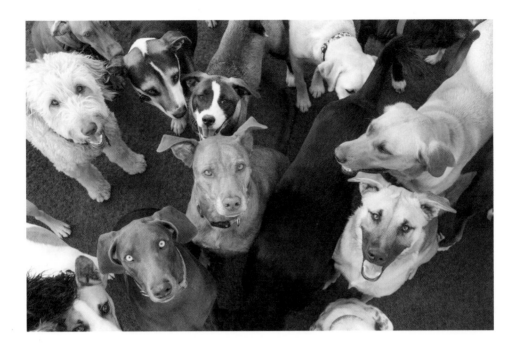

When you start photographing, be sure to mention to those you're working with that you're looking for more subjects to photograph for your project. You might be pleasantly surprised by the efficacy of word of mouth once you begin. The key is to start with finding out who has large-scale access to the subjects you're interested in photographing, and see what happens from there.

Pet Photography as a Collaboration

Creating strong images of pets is a collaboration of all involved, and acknowledging that will help you create stronger images and enjoy the process much more. Connection needs to be made between the photographer and animal on some level so the pet can have a positive experience and engage with the camera (if that's the goal) to create strong photographs. Collaboration also needs to take place between photographer and pet parent or anyone responsible for the animal (as in the case of animal welfare situations). This may involve directly communicating with the pet parent on your goals for the images and how you need them to participate (or not participate), or the energy required

of them if they are being photographed with their pet. Collaborating with nonprofit organizations starts with having a common goal for the images and vision for how those images can become a reality.

Opportunities to Respond

Photographing pets allows for the opportunity to respond to a variety of situations and scenarios creatively. These opportunities support you in developing skills that collectively contribute to a solid "resume" for you as a pet photographer. Let's take a look at just a few ways you can use these opportunities to continue to develop your skills.

ENVIRONMENT AND LOCATION

Creating images on location involves a great deal of problem solving. Location shooting requires a creative response so that the visual chaos can be organized to capture a strong image. In addition to these problem-solving opportunities, you have the chance to navigate how to best include an animal within any given environment in (typically) a finite amount of time. As the environment changes, so does your opportunity to visually problem solve.

MOOD AND ENERGY OF ANIMALS AND PEOPLE

Photographing pets, either individually or with people, offers a tremendous opportunity to practice communication skills. Learning how to engage and react to the energy of your subjects is quite important and a skill that can be nurtured. Not only does the energy affect the experience, but also the results. Later, I will discuss how to navigate these interactions.

ANIMALS AND PEOPLE WHO ARE INTRIGUING

I've met some of my best friends and favorite people as a result of my involvement in pet photography. I've also had the chance to meet and photograph some absolutely incredible animals—what a gift!

DESIGN

As pet photographers, we are invited to visually respond to all of the compositional elements we know and love: light, color, shape, line, texture, and more. Just because we may be photographing a beautiful creature doesn't mean these elements are less important. Instead, they're juggled into the mix! With practice, you'll be able to be more intentional when incorporating design elements into your frame.

COMMUNITY

I strongly value the community I've encountered as a direct result of my life as a pet photographer. Even if you are photographing as a hobby, you're bound to increase your community with both individuals and organizations.

OUTLET FOR CREATIVITY AND INTUITION

Photographing pets is an excellent outlet for cultivating your creativity and intuition. It can be quite satisfying to pre-plan your images of animals with a specific concept in mind. (I am a huge planner!) I typically have a few ideas in mind for all of my sessions, but many of my favorite images were not planned, but became available to me as I responded in the moment. While it can be a little more pressure not to have a plan in mind for all of your images, having the ability to respond intuitively is an opportunity for creative growth.

Finding Flow

One positive side effect or reward of pet photography is experiencing "flow." In my practice, these are moments when I am so focused or tuned in to what I am doing that I lose track of time. During these periods, one action seems to flow into the next with ease. When I am experiencing flow, I find that I am fully present in the moment and in my activity, and as a result, creativity has a greater chance to enter into the equation. Unfortunately, this state doesn't offer itself up as a result of force or pushing too hard. Even though I haven't quite figured out how to *make* flow occur with regard to pet photography, I have noticed the following can help build a starting platform.

LEARNING THE TRICKS OF THE TRADE

We can exchange the word *tricks* for the word *tools*, because really, that's what we use in pet photography. And because animals are so different from one another and their attention spans are shorter than humans', we need lots of tools. Having a strong grasp of the options available to you can not only help you capture the images you're trying to create, but can also bring a lot more ease into the situation. Knowing that you have tools to help allows you to focus more on the creative aspects and allow inspiration and, ultimately, flow to enter more easily.

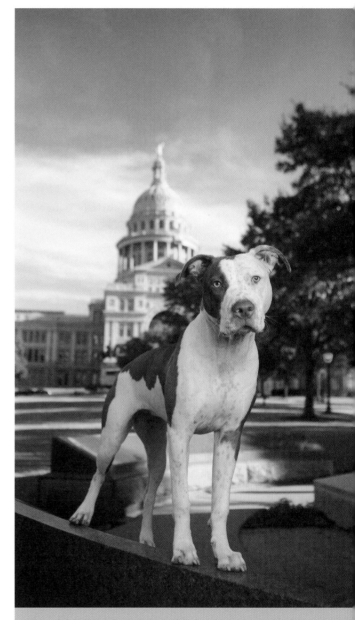

Beautiful Gidget, photographed for a project with Tomlinson's pet food stores in Austin, Texas, definitely inspired flow within my photography practice.

PRACTICE

Knowing which tools are available and knowing how and when to use them are completely different. My hope is that this book will provide you with many tools and ideas on how to use them. These tools will not be of much use to you, however, if they are not put into practice—just like buying a bunch of equipment will do nothing for you if you never learn to put it to use. Learning how to be comfortable directing people and animals takes practice. Photographing subjects who may or may not do what you want them to do exactly when you want them to do it takes practice. Learning how to troubleshoot situations requires repetition and putting yourself in a variety of situations. Pet photography asks that you respond creatively to situations based on the needs of a client (if applicable), the animal's behavior, technical elements, aesthetics, and so on. This all takes practice!

As you start to develop your practice of pet photography, do your best to be kind to yourself and understand that if you haven't had much practice, pet photo shoots might be a bit overwhelming. They will always be challenging on some level, but that is what keeps things interesting.

How should you practice? I highly suggest starting with low-pressure scenarios. Photograph your own pet or a friend's pet, and let anyone you're enlisting know that you're building your pet photography portfolio. Set some parameters for yourself so it's not too overwhelming. Perhaps you want to play with capturing motion outdoors during one session; and then the next time, photograph with a documentary style, implementing natural light indoors; and move to more posed studio-lit portraits during a different session.

Give yourself time and space to make mistakes and try new techniques, because this allows for growth. It has helped me in recent years to think of pet photography as a practice, much like a yoga practice. Just like showing up on your mat in yoga practice is where the transformation begins, showing up with your camera to practice with your tools is an integral part of improving your pet photography.

In my photographic practice, I strive to stretch myself creatively, while at the same time, recognize that if I push too hard with something that isn't working technically, for example, or if the pet isn't cooperating to make my vision a reality, I am not likely to obtain the results I want. If I am forcing the situation or obsessing about getting the perfect shot with no room for flexibility, I will most likely miss out on beautiful images and certainly on the opportunity to experience flow during my photo shoot. Practice directly impacts flow.

EXPERIENCE WITH PETS AND UNDERSTANDING PET BEHAVIOR

The more you understand pet behavior, the more prepared you will be during the shoot to react quickly and appropriately. A knowledge of animal behavior through experience helps make the photo sessions more fun for everyone involved. If we are able to notice the reactions of the animals to their environment, our presence, and our actions as photographers, the more flow can occur.

I learned a great deal about animal behavior (dogs and cats, specifically) from volunteer work in animal shelters. I'll explore this more deeply in chapter 10.

PASSION FOR ANIMALS

I photograph animals because I love and respect them, and when I get to interact with them and honor them visually through my photographs, I am setting myself up to get lost in the moment. I can't imagine getting seriously involved with pet photography if I didn't have passion for animals. Having a sincere affinity for animals is a definite head start to finding flow in your pet photography.

NO FLOW? NO WORRIES

Finding some sort of flow is, in the big picture, a goal for all of my creative endeavors. Ideally, I want to spend my time so engrossed in my actions and creative process that I lose time and space. I want to have so much fun that the hairs raise on the back of my neck, and I can think of doing nothing else in that moment. But…this doesn't always happen. If you have never experienced flow in your work, consider paying attention to those elements that support your ability to get pleasantly "lost" in your pet photography practice.

I hope you are starting to see the many possibilities that exist with regard to pet photography, and perhaps you are already generating some ideas about how you might like to pursue this rewarding genre.

CHAPTER 2: BRINGING YOUR GEAR AND YOUR BAG OF TRICKS

I have slowly acquired a fair amount of equipment and tools over a several-year period. I have invested financially in my gear. I try to purchase equipment that I will use frequently and that is user-friendly, and this ability to invest in my equipment has supported my creative and learning process. I'll be honest, though—I tend to get a bit frustrated by the feeling that I need to get more or new equipment so often it can feel like a distraction. Having said that, my equipment has helped bring to reality the images in my pet photography portfolio, and for that I am grateful.

If you're anything like me, you can get overwhelmed with too many options. This can be challenging in any scenario, but in terms of photography, the digital revolution has also changed the gear game drastically. There is always something new and better coming out from the camera manufacturers, and this can result in "analysis paralysis" when it comes to purchasing. When I started in photography, digital was not ubiquitous, and if you got your hands on a high-quality film camera, it could take you far into your life as a photographer. Times have certainly changed, and with the ever-shifting technology to consider, it's easier than ever to spend money.

But what do you really *need*? In this chapter, I invite you to learn to recognize the distinction between *need* and *want* with regard to photographic equipment.

Before you start to acquire a ton of gear, consider what you already have. Maybe it's not the newest-latest-greatest equipment, but is it enough for you to start practicing with pet photography? Do you have a camera and a lens? If the answer is yes, you're ready to practice. If not and you're shopping for equipment, I'll share with you my criteria for choosing these items and offer some ideas on what to consider in general with regard to pet photography equipment.

Every time I take a workshop or go to a photography conference or seminar, I walk away thinking I need more gear. Does this feel familiar? You may have participated in a workshop or class with someone who seems to have every piece of equipment imaginable. Do they really need all that gear? Are they really using *all* of those tools? Maybe, but maybe not. Granted, having certain kinds of equipment can be a huge help in achieving special creative and technical goals, but you don't *need* it all to begin a practice in pet photography, and you can certainly learn how to create stunning imagery within a smaller budget.

Is the equipment required for pet photography different from what you might need for other types of photography? The answer is yes and no. There are definitely some specific issues to consider when approaching pet photography versus other types of portraiture. With regard to photographing animals, deciding how you want to approach your photo shoots will somewhat dictate the equipment that will be useful and convenient.

The "Best" Camera

I've been asked many times which camera is the "best." Honestly, I often have to think hard about the exact model of my camera (it would be much easier for me to remember if it were named after an animal). All kidding aside, I currently use a Canon 5D Mark III, and although I like my camera (we are close friends), it is my intention to provide you with information that is applicable to you no matter what camera you're using when you read this book.

You may have heard the phrase, "The best camera is the one that's with you" (Chase Jarvis). It may sound cheesy, but it's totally true. This statement refers to the value of simply having a camera with you, regardless of the brand or model. Besides, in this digital world it's very hard to have the "best" for very long, anyway!

I regularly use my phone to create images, because I have it with me all the time and it's lightweight. My phone is great for social media, small gifts, sharing, general documentation, and playing around with compositions. With the phone, I get to respond quickly to anything that catches my eye. This is like my daily workout for photography. I don't spend a lot of time playing with apps and filters, but they're fun, too.

I've also been experimenting and traveling with the Fuji X-E2, which is mirrorless, and thus, smaller and easier to carrier around than my "big girl" SLR. I purchased a wide-angle lens (the Zeiss Touit 12mm f/2.8) for this camera, because I don't typically shoot with a super wide-angle lens and feel that it's a good idea to try out new ideas and ways of shooting when I can.

For client and "serious" work, I currently and consistently use my digital SLR for its high quality, but ultimately, I'm able to see and capture images in a creative way with any camera in my hand. Each of these devices helps me create a variety of images, and each type of camera serves a unique purpose, depending on my goals for the final presentation.

If you don't have the "latest and greatest" camera, don't worry too much, because you can still practice all the techniques of composition, giving direction for portrait creation, working within a location, and utilizing light with any camera model or type.

As a professional, I have specific needs to address when I purchase digital cameras. In my research, I may get enticed by a new feature, but as a baseline, here are the criteria I consider.

QUICK SHUTTER RESPONSE

When I am photographing a pet, I need to make sure I don't miss the shot because of a delay on the camera's part (user error is a completely different element). When I press the shutter, I need the camera to respond immediately. Right now, most high-quality digital SLRs and mirrorless cameras have good reaction time. When I first started photographing with digital, I would press the shutter and the frame would be captured a second later. Let's just say that I got a lot of photographs of tails, and it was more than frustrating.

ABILITY TO CAPTURE LARGE IMAGE FILES

I need the image files to be large enough to be able to maintain a high quality when printed as large wall portraits for my clients and to meet commercial and stock photography needs. While I tend to shoot very intentionally when it comes to my framing, I also appreciate having a large-enough file size that enables me to crop, if needed, without sacrificing quality.

ABILITY TO SHOOT IN RAW

Photographing in RAW gives me the ability to make adjustments and processing decisions rather than having the camera decide that for me. Most higher-quality cameras have this feature.

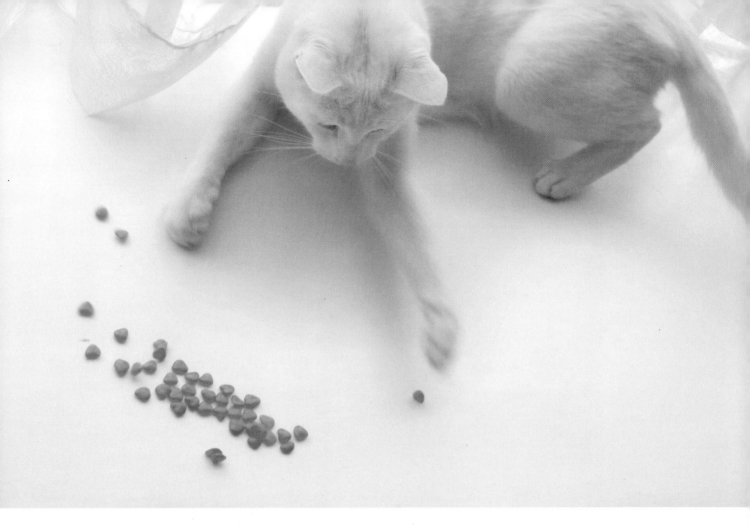

LOW-LIGHT SHOOTING

Because many of my pet portraits are created on location, I want my camera to have the ability to photograph in all kinds of lighting situations. I often photograph indoors, so it helps to use a camera that will maintain a good quality even in lower-light scenarios. This helps me shoot with ambient light and set a shutter speed high enough to stop unwanted blur. If the camera can hold its quality in low-light situations, a lot of creative doors open for me as a pet photographer.

CAMERA WEIGHT

Pet photography can be very physical. Ideally, my camera isn't so heavy that it inhibits me or hurts my body. The first high-end digital camera I had was very heavy, and using it for long periods of time caused me to have physical issues in my forearm and back. Weight matters to me, and you may also want to consider this factor before making your investment.

SIMPLICITY AND USABILITY

When I get a new camera, I do not want to spend time relearning how to change the settings. I appreciate advanced features in camera systems, but my camera needs to be user-friendly and somewhat intuitive so I can work quickly. If this is not the case, it's a deal breaker. If you are someone who loves diving into buttons and dials, you may feel differently.

BRAND LOYALTY

As I mentioned, I currently shoot with a Canon camera, and my mirrorless camera is a Fuji. I don't feel exceptionally loyal to any company, except for the fact that I have basically invested myself *into* brand loyalty. I have spent plenty of money on Canon equipment—I have two camera bodies (one main body and one backup) and a few lenses. If I wanted to switch to another system, the cost would be significant. Trade-in values on used digital cameras aren't great, and I would need to be prepared financially for that loss if I were to switch. This change could very well occur if I have enough incentive to do so, but overall I am not too concerned about who makes my camera—as long as it's living up to my reasonable expectations. It's important to have options when you purchase a camera, and the major manufacturers offer a range of cameras, lenses, and accessories and put a lot of money into research and development. This translates into their ability to improve on image quality and usability of their cameras.

LCD

While histograms provide the most useful information about exposure, having the ability to review my in-camera cropping or framing choices on the back of the camera is very important. I also like to double-check focus on my LCD, and that requires a high-quality screen. I need the screen to be large so I can see it easily and show it to my client, if desired.

DO YOUR RESEARCH

ABOVE ALL, IT'S IMPORTANT TO EDUCATE YOURSELF ON THE CURRENT SYSTEMS BEFORE YOU INVEST. THERE ARE MANY BLOGS AND REVIEWS ONLINE, AND NOTHING BEATS GOING INTO YOUR LOCAL CAMERA STORE TO SEE THE CAMERAS IN PERSON. THIS GIVES YOU THE OPPORTUNITY TO HOLD THE CAMERA AND ASK QUESTIONS OF PEOPLE WHO KNOW THESE SYSTEMS INSIDE AND OUT. BEFORE GOING INTO THE CAMERA-PURCHASING PROCESS, HOWEVER, THINK ABOUT WHAT YOU NEED THE CAMERA TO BE ABLE TO DO FOR YOU. FOR EXAMPLE, THERE MAY BE ONE KIND OF CAMERA THAT FUNCTIONS BETTER FOR PHOTOGRAPHING LOTS OF ACTION, AND ANOTHER MAY BE BETTER AT PHOTOGRAPHING IN LOW LIGHT. OF COURSE, YOU'LL WANT TO GET THE CAMERA THAT WILL FULFILL MOST, IF NOT ALL, OF YOUR NEEDS.

Lens Choices

I'm not going to get super technical here, because there are many resources available to scratch our technical itches. Improvements to lenses are similar (but not quite as fast, it seems) to those in cameras. We tend to desire faster, sharper lenses, and camera manufacturers are constantly working to offer you something else to invest in. I feel similarly to lenses as I do with gear in general; they're vital to the photographic process, but I don't get overly fixated on them or feel the need to collect lenses for the sake of accruing quantity.

The choices for lenses are vast, and I highly suggest that you consider how you like to physically operate before you make your investment. Think about the highest-quality lens you can afford that makes sense for pet portraiture and slowly building your toolbox over time based on your individual needs.

FIXED FOCAL LENGTH OR PRIME LENSES

Prime lenses are generally known for being sharper than zoom lenses. When I photographed with film, I had a couple fixed lenses, and the images created out of the camera and lens combination were very sharp. I had to physically move around a lot with prime lenses, I manually focused (using a Hasselblad), and in general moved more slowly than I do now. Keep in mind, I was also changing film then. There is something to be said for the shift in creativity that seems to occur when you are required to physically move around in order to change your composition and to photograph more slowly. I currently have one prime lens (a Sigma 50mm f/1.4) and enjoy the added challenge of the fixed focal lens, but I'll be totally honest—it is not my "go-to" lens for pet photography. I like it for the wide aperture capabilities but find it difficult to shoot wide open with pets. Often

This image was created in a low-light situation with my 50mm lens at an aperture set to f/1.4, which created a soft environment around the cat and very limited depth of field.

I find myself lying on the floor or standing on a ladder, and when the animal moves out of the frame, I occasionally miss what I am aiming to capture when I use fixed lenses. Sometimes while using this lens, I notice an opportunity for creating a good photograph, but I am not able to get close enough, quickly enough, to capture the image.

This image of Shadow was created with a 50mm fixed lens set to an f/1.4 aperture, which helped simplify the image and create a soft, abstract feel.

ZOOM LENSES

While maybe not quite as sharp overall, zoom lenses work wonderfully for me when photographing pets. As I started to seriously invest in my digital SLR equipment, I purchased a 24–70mm f/2.8 professional zoom lens. For a long time, this was my only lens and to this day it is my work horse. This lens allows me to shoot fairly wide angles in order to include a lot of environment, if desired. When I am lying on the floor or standing on a ladder and I want my frame to tighten on the dog or cat, for example, I can quickly zoom to 70mm and capture the image without having to physically move my body. Often this can really make the difference between getting the shot and missing it as a result of the animal moving positions, changing expressions, or leaving the space entirely. The other aspect of this lens that I love is that it can focus very closely on details due to its macro abilities. This is an excellent feature for photographing details like a dog's muzzle, cat's whisker, or horse's eye.

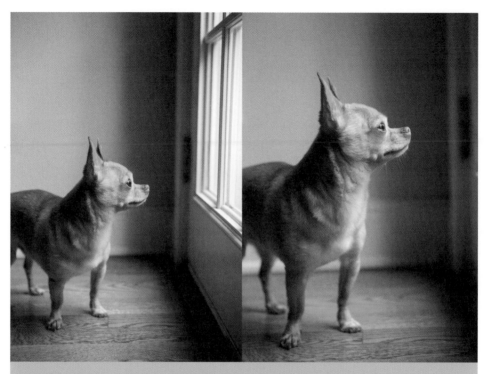

I loved the way Rocco was being lit by the light of the door in the image on the left and decided to keep the door in the frame for reference and environment. Rocco wasn't interested in staying in that location for a long time, so I was glad to have a zoom lens (my 24–70mm) on my camera, which allowed me to capture a tighter frame of Rocco just before he stepped away from the door. I might have missed this shot if I had to move physically closer with a prime lens.

When photographing pets, saving time—and as a result, animal and human energy—is very helpful. Another reason I like zoom lenses is that if I were shooting with a 24mm prime lens and then a 50mm prime lens, I would have to spend time changing lenses as I felt inspired or motivated to use different focal lengths.

Physical proximity directly impacts the quality of my images, and using a shorter lens (versus a longer telephoto) helps me to connect with whomever I am photographing. If I am working alone and need to adjust a pet or person's position, for example, I can more easily do this when I am physically closer than if I were using a long telephoto lens.

Zoom lenses are definitely the way to go if you have any physical limitations keeping you from moving quickly or comfortably. Something to keep in mind when purchasing zoom lenses is how fast they are; be aware of the widest aperture you can use while the camera is set to its longest zoom length. Some cameras are limited to f/4, which works if it's what you can budget for, but this

may become limiting in low-light situations or if you're looking to really play with shallow depth of field. If you can afford it, think about investing in a fast lens.

One disadvantage of zoom lenses is that you can find yourself getting a bit lazy creatively, and because you don't necessarily have to move around to capture another frame, you don't. This can make for stagnant, repetitive images and missed opportunities for photographing from a different perspective or angle. Building an awareness of this can help fix this potential issue. Another disadvantage I've noticed is that with continued use of this lens and all of its moving parts, I have, on occasion, needed to have my camera recalibrated for focus. This may not be an issue across the board, but it's something I have encountered.

LENS HOODS AND FILTERS

In addition to helping block unwanted lens flare, using a lens hood is a smart way to help keep your lens slobber-free from dog, horse, and cat noses getting too close for comfort. Lens hoods have also saved my lenses from damage on several occasions as my camera has knocked into things accidentally. (This is probably a good time to share that I am a bit clumsy.) Lens hoods are typically not very expensive, and it's always a good idea to have them on your lenses.

I typically just use a good-quality UV filter on my lenses, primarily for protection. Occasionally, I use a polarizing filter to intensify a mediocre-looking sky.

TELEPHOTO LENSES

The next "go-to" lens in my bag is the 70–200mm f/2.8 zoom. I enjoy this lens for many reasons. It works well for photographing pets from a longer distance than the 24–70mm and, at wide apertures, can create beautifully soft backgrounds. Many portrait photographers love this lens because of the compression that can occur between subject and background. Images created with this lens have a distinctive feel, and I certainly appreciate the aesthetic.

The 70–200mm lens works well for photographing pets in action, because I am able to more easily anticipate activity from a distance and physically move my lens as needed to capture the action as it occurs. If I am too close, the action can easily take place outside the edges of the frame, and I may not have enough time to adjust physically and still focus.

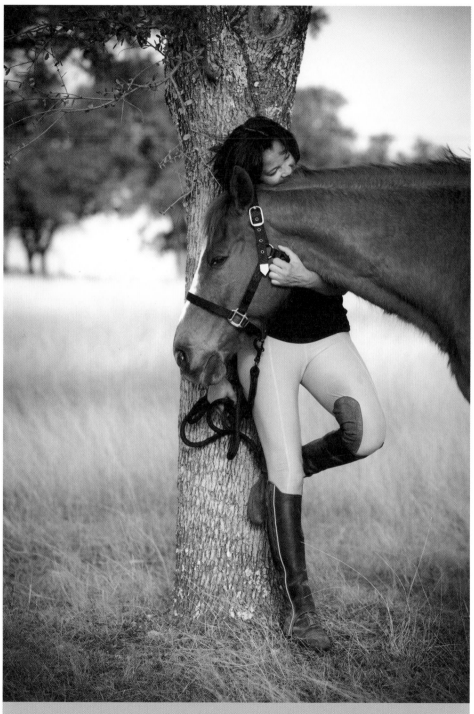

The 70–200mm telephoto lens used in this image (set to 150mm at f/4.5) created a soft background.

Longer lenses are heavier than shorter ones. One of the challenging aspects of this lens is that when handheld, it requires a higher shutter speed for even stationary portraits than a smaller, lighter lens requires. These higher shutter speeds are necessary for hand-holding long telephoto lenses to prevent potential camera shake by the photographer. It can be challenging to work with higher shutter speeds if you are in a low-light situation, especially if you need a wide depth of field. As mentioned previously, pet photography can be a very physical activity, and longer lenses require more energy to carry and hold.

LENSES AS CREATIVE TOOLS

Fun lenses like fisheye and tilt-shift lenses can be great tools for adding a creative spark to your images. You might find yourself in a small space wanting to capture lots of environment and decide to utilize a really wide-angle lens. These tools support you in making your vision a reality, and there isn't one choice for all photographers and all photographs. For pet photography, a wide-angle lens used closeup on a dog or horse can create distortion and become almost cartoon-like, which can be really playful. A Lensbaby can give you the chance to photograph a pet and transform the scene into a dreamlike environment. When I look at photographs, I don't want the lens choice to become distracting or the first thing I notice; I want whichever lens I choose to be fully supportive of the image as a whole.

Spend some time learning and playing with how and when to use these different tools. Explore the many options before you invest (rent a lens or two for a day), and consider what works for you based on what you know to be true creatively and physically about yourself as a photographer.

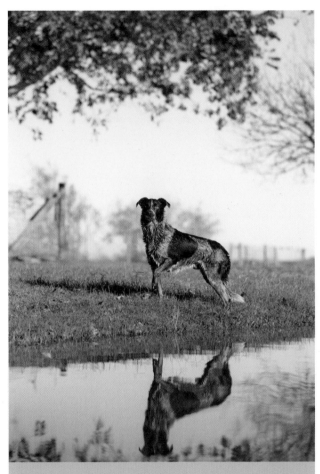

I was able to photograph Oliver from across the edge of the pond with my 70–200mm lens.

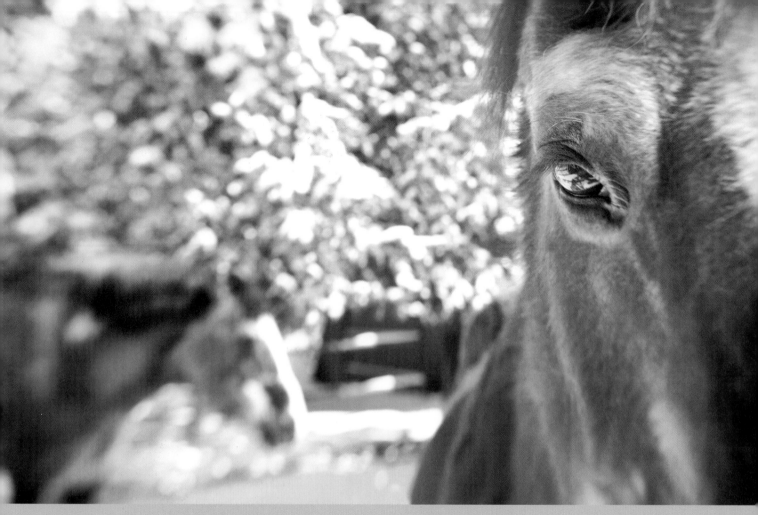

This image was created with a Lensbaby, which helped produce a dreamlike feel for this horse portrait.

Tripods

I typically do not use tripods when I photograph pets. I might use a tripod to prevent camera shake when trying to capture pet images that involve low light or when I am trying to pan. Otherwise, I find using a tripod a bit limiting, because I have to close it up and reset it when I want to change positions or move around within the location. I feel a little stagnant when I shoot portraits using a tripod.

EQUIPMENT AND SAFETY

I CARE ABOUT MY EQUIPMENT, AND I HAVE WORKED VERY HARD TO BUILD MY TOOL-BOX. HAVING SAID THAT, I WORK WITH PETS THAT OFTEN SLOBBER, SHED, POOP, PEE, SIT ON, JUMP ON, AND PLAY AROUND MY STUFF. I TAKE ALL POSSIBLE PRECAUTIONS TO ENSURE THE SAFETY OF MY EQUIPMENT AND, OF COURSE, OF THE PEOPLE AND ANIMALS I AM PHOTOGRAPHING.

I USE SANDBAGS TO WEIGH DOWN MY LIGHT STANDS, I CLOSE MY CAMERA BAG SO THE FOUR-LEGGED DON'T SHOP AROUND IN MY BAG OF TRICKS OR PEE ON MY GEAR, AND I KEEP OTHER BAGS AND EQUIPMENT OUT OF REACH AS MUCH AS POSSIBLE.

Postproduction

I love photography, but I don't love spending time on my computer. But kudos to those of you who love to dive in and spend days editing and retouching. I do appreciate the powerful software programs we have available to us as digital photographers, and by no means do I take those programs for granted —I need them!

By looking at the images in my portfolio, you can likely tell that I am not heavy-handed when it comes to retouching, manipulation, or compositing. I do, however, strongly rely on a couple of programs to help get my images looking clean and polished, and to achieve any other specific creative goals I may have.

ADOBE LIGHTROOM

There are many excellent books and tutorials on Lightroom, so I won't go into too much detail here. But I love using Lightroom for my pet photography for so many reasons, and at this point I cannot imagine my workflow without it. This software allows me to organize my images easily, cull them, make helpful adjustments both on a global and individual level, and export them at appropriate specifications for sharing—either personally or for client review. Here are some highlights about the software as they specifically relate to my workflow.

LIBRARY MODULE

I import directly from my memory card into Lightroom and may choose to add a few global keywords during that time. The Library module is perfect for comparing images from my photo shoots to determine which images make the cut based on my goals. I have definitely gotten faster at this process over time and find that choosing images can take as long as I allow for it. Lightroom does make things easier to choose, though, as I can easily compare two images of a dog and check for focus side by side, view multiple images of a cat tiled

on the screen to pick out my favorites, and label my favorite images in a way that helps me stay organized (a term with which I don't always identify).

DEVELOP MODULE

What I love most about working in Lightroom is that it is extremely intuitive, and navigating the Develop module feels a lot like how you might take an image from negative to print form in the darkroom.

Getting creative with your images in Lightroom is quite easy, and experimenting with different looks for your images via virtual copies can get addictive. In the end, however, most of my images are processed in a straightforward way. I check for focus and adjust the exposure, contrast, vibrancy, and clarity on most of my images. I cannot tell you how much I love the "sync" feature in the Develop module, as it saves a great deal of time. This feature allows me to make needed development adjustments to one image and then synchronize any other image created under the same conditions, such as light and color balance. I love this feature!

Cleanup and adjustments are really straightforward within Lightroom using the individual adjustment tools, but if I need to really clean up a dog's face from debris or eye boogers, or clean up a cat's eye in a detailed manner, I will open the file in Photoshop directly from Lightroom and save it. This process is seamless and painless.

Lightroom has so many excellent features to explore, and the program is constantly being improved. I highly encourage you to investigate and invest in this software, whether you are an avid hobbyist or professional-bound.

ADOBE PHOTOSHOP

Photoshop is an incredibly powerful program. I use Photoshop for images when I need to fine-tune details that I'm unable to change in Lightroom. I primarily use Photoshop when I am producing final images that are being published in some way—either in print or online. For culling and selection purposes, I adjust in Lightroom only, unless I absolutely need to make a change I can't make within Lightroom.

> **SYNCING IN LIGHTROOM SAVES TIME**
>
> I LOVE USING THE AUTO SYNC FEATURE IN LIGHTROOM DURING MY POSTPRODUCTION OF PET PORTRAITS. FOR ANY GROUP OF IMAGES CREATED UNDER THE SAME CONDITIONS, YOU CAN ADJUST ONE IMAGE TO YOUR LIKING AND THEN SYNC THE REST WITH JUST A FEW MOUSE CLICKS.

COMPOSITING

On occasion, I take advantage of the opportunity to composite pet faces, ears, and eyes in situations where I love everything else about the image but can't quite make the "perfect" image happen in-camera. I accomplish this through masking. This scenario is most likely to occur when I am photographing more than one animal at a time or when I am photographing animals and people together. For images of groups where there is not enough light to allow for great depth of field, I may choose to focus on one plane of subjects for one frame and then refocus on the other plane of subjects with the intention of compositing later. This means more time on the computer for me but can be quite handy.

RETOUCHING

I use Photoshop for more detailed retouching and cleanup. To do this work, I use a Wacom tablet and a pen, which I find very fluid and easy compared to using a mouse. This took some practice and time to get used to, but I love it now.

The primary purpose of retouching for me is to make my images look cleaner and more "finished" by removing distracting elements, lines, wrinkles in material, lint, unwanted or unruly pet hair, eye boogers, pieces of dirt, or other flaws that weren't removed while the photographs were being created. When I photograph people with pets, I smooth out skin and hair as needed, but try to maintain a realistic look.

CREATIVITY AND RETOUCHING

I want my images to evoke an emotional response before the viewer notices a particular technique. My opinion on post-processing is the same as it is for lens choice: I don't want to be distracted by a filter, plug-in, lens, composite, poor retouching, or oversaturation in an image.

I am not suggesting that your images look like mine or that you shouldn't use plug-ins and filters, or create dramatic and fantastical composites, but rather, I encourage you to consider whether your adjustments and add-ons support your image and vision as a whole. If the image calls too much attention to the "process," might the viewer miss out on what you're trying to say with your work?

Experiment, play, and learn what works for you and your unique vision. If you haven't done so already, spend some time learning the basic tools in Lightroom and Photoshop so that you can start to make these creative decisions for yourself. Software should serve a supportive role in your workflow.

Lighting Modifiers

Lighting modifiers are helpful for creating a variety of effects, and which ones you need will depend on your goals. You can modify available or natural light, as well as light from small flashes and larger studio strobe lights. Many photo-dedicated modifiers are available for purchase, and inexpensive household items can work brilliantly, too. You can read more about lighting modifiers and how I like to work with them when photographing pets in chapter 5, "The Light."

POP-UP REFLECTORS

Pop-up reflectors are a must-have for every pet photographer's tool bag and are an economical investment for anyone starting out in pet portraiture. I love using reflectors (mostly the white—and the silver, on occasion) for bouncing light back onto my subjects or into the scene in general. This bounced light helps make the animals and people stand out visually and can add a nice catchlight to eyes. Reflectors can also help increase the overall light, potentially allowing you to increase your shutter speed or decrease your aperture. They are convenient for pet photography, because they fold into smaller, flat shapes and are easy to carry around while on location. I have a variety of sizes ranging from smaller triangle-shaped reflectors (Lastolite TriGrip reflectors) to 4x6-foot panels.

I enjoy the multiple-use reflector panel kits that come with the sleeve, allowing you to use the silver, gold, black, and white sides with the option to remove the sleeve, which reveals a transparent diffusion material. I'll talk more about this in chapter 5.

If budget is a concern, take a trip to the local art supply store and purchase some 1/4-inch white foam core pieces. Purchase the largest size you can find that fits in your car. You can then cut them into smaller pieces, as needed. I love using large pieces.

SOFTBOXES AND UMBRELLAS

When I am using my larger strobe systems (I currently use Elinchrom strobes) for pet portraits, I use a variety of softboxes to soften the light. For smaller flash units, I love using Joe McNally's Lastolite Ezybox, which is specifically designed for use with a small flash unit.

I always keep some material in my bag to help diffuse harsh light. I carry Ripstop nylon material I purchased from a fabric store and also a 6′ x 6′ silk diffusion material made by Matthews.

Bag of Tricks

I literally bring a bag of tricks to every photo session. This bag contains squeakers, toys, treats, leashes, lint rollers, and many other objects that help me during a session with pets. I discuss the specific contents of my bag for each type of pet in their dedicated chapters. The bag of tricks is something that can be developed over time, as it can take a while to gather a wide variety of items. The bag I currently use was purchased from a craft store and contains lots of pockets and compartments, allowing me to keep my tools separate and easily accessible. (Although I admit that often the items end up collecting in the main area, and I find myself shuffling around for them—definitely something I recommend *not* doing during your session!)

Small Flash Units

Small flash units are an incredibly helpful tool to keep in your bag. Regardless of how you implement your pet photography (business, personal, volunteer, hobby), I highly recommend having at least one small flash unit and a general knowledge of how to use it.

WHY I LOVE THEM

Small flashes are cordless, which is really handy when working with pets. Animals move around a lot, and for simplicity and safety reasons, having no cords is a big benefit. Because they are battery-powered, you can use small flashes outdoors and anywhere else you'd like to without having to worry about plugging them into an outlet. The ability to move around quickly and easily offers a lot of room for creativity on location. Small flash units are also an excellent way to add just a little bit of fill light by bouncing or diffusing.

The power on small flash units can be set much lower than larger strobe units, which can really be helpful if all you want is a little fill light. Small flash units take up less space in my camera bag, are lighter-weight, and are generally more travel-friendly than large strobe units.

They have a few other perks as well. System-dedicated flash units communicate directly with your camera and can offer many options for automated exposure choices. Small flashes can sometimes cost less than large strobe lights. And small flashes can effectively be turned into larger light sources by bouncing them off a ceiling or wall. Pretty great!

SMALL FLASH LIMITATIONS

While small flashes have a lot to offer, I don't always love them for pet photography. Because they are powered by small AA batteries, the recycle time (time between flash output) isn't very fast when you are using them at full power, which means you might miss the most adorable expression on an

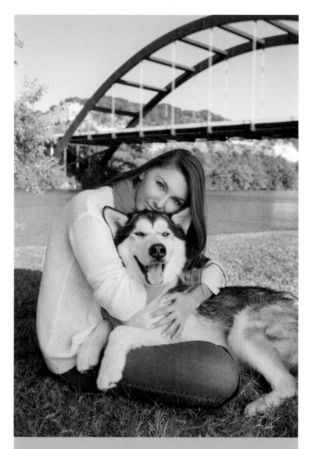

This image of Renata and her beautiful pup, Kyra, was created with my Ezybox and an additional diffusion panel with a small flash Canon 600EX-RT speedlite. I was working alone, and using a small flash was pretty reasonable because of its cordless and lightweight features.

animal's face. Extra battery reserve systems (many AA batteries linked to the flash unit) help, but this attachment makes for more weight to carry around during a session. I currently use the Canon CP-E4 Battery Pack and also have a Bolt brand version that has the same function.

Small flashes do not tend to work well for photographing stopped action because of the recycle time, flash duration, and sync speed of the flash. You'll need bigger strobes with short flash durations to capture studio-lit action without blur.

Even though the units themselves are small and lightweight, you still need modifiers, light stands, and sandbags. Yes, these systems are cordless, but

the reality is that you still need many items that accompany the small units to modify the light.

When I photograph with small flash units (or large, for that matter), I sometimes find that in focusing so much on the technical aspects and fussing around with equipment, I can miss important moments with the animal. Of course, this issue has lessened as I've gained experience, but regardless of experience, working with lights adds a lot of variables to the equation. Be sure to spend time getting to know your equipment so you can spend as little time as possible dealing with buttons and dials.

If you're photographing with the flash off-camera, you'll need a transmitter and receiver that is reliable and easy to use. Currently, my Canon uses the ST-E3-RT to transmit to the speedlites, and I find it to be reliable and fairly simple. Sometimes I use PocketWizards to trigger my small flashes and larger strobes. They are great, too, for implementing flash in a manual setting (versus a TTL), but the cords required for them make for extra variables that can come unplugged or lost, or malfunction. This is something to keep in mind. I usually carry a set of PocketWizards and appropriate cables as a backup to my regular transmitter device.

Larger Studio Strobe Lights

I use Elinchrom brand lights and have used Dynalites in the past, but there are many fantastic brands and models to choose from.

WHY I LOVE THEM

Large strobe lights are fantastic in many ways, and while not totally necessary for every pet photographer, they can be huge assets for your toolbox.

Studio lights are helpful for when there just isn't enough light indoors or in-studio to capture animals and the environment properly. On countless occasions, I have photographed inside a client's home and found that there wasn't enough available light, either because the house was dark in general or because of cloudy or rainy weather.

If I need to photograph multiple pets or pets and people together, large strobe lights have enough power to allow me to photograph with a greater depth of field so that I can have everyone in focus (if that's my desire).

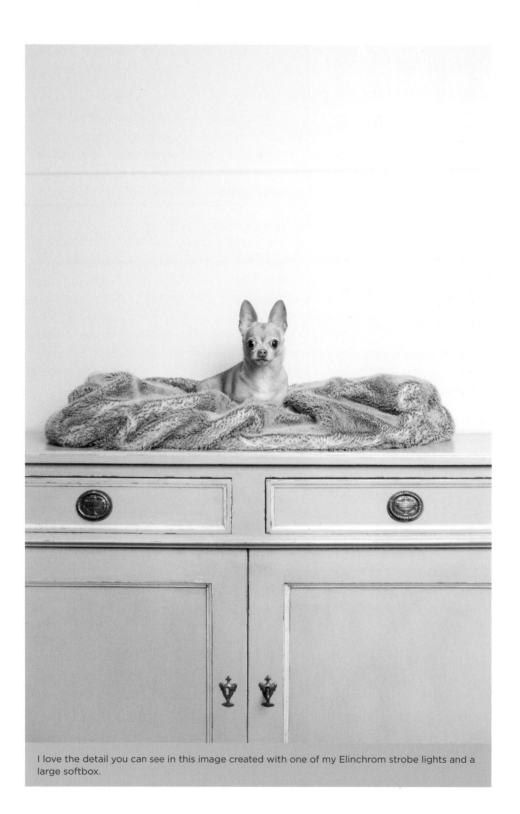

I love the detail you can see in this image created with one of my Elinchrom strobe lights and a large softbox.

Because of the extra power in a studio strobe, I can use a lower ISO, and as a result I can see an extreme amount of detail in the pet's fur or eyes if I use a smaller aperture. Studio strobes are great for getting the details to shine through.

Because these bigger units are typically plugged in, I don't have to worry about running out of battery power or having the recycle time change due to batteries losing their power. Large studio lights that are battery-powered are also really handy, because I can use them outdoors and don't have to worry about plugging them in. Manufacturers are rapidly improving battery longevity and performance overall, which is very exciting.

WHY I DON'T LOVE THEM

Large lights tend to be heavier, bulkier, and more expensive. As technologies advance, they are getting lighter and smaller, but at this point they're still typically heavier than small flash units. Because of this weight and bulkiness, I find it more difficult to be spontaneous during a session when I am using them. Once I have set up my lights and tweaked them to where I am happy, I tend to feel pretty committed to staying there for a while. Moving the setup takes time, which is really valuable during a pet shoot.

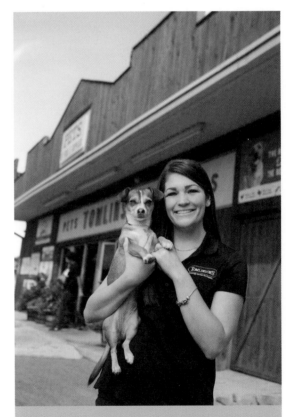

This image was created with a battery-powered Elinchrom strobe and softbox. This shoot took place on a really windy day, which made things challenging, but fortunately, I had an assistant to hold my light in place.

The higher amounts of light power contained in large strobes make it more challenging to add a subtle amount of light behind a dog sitting on the couch, for example. Because of the high power and sync speed (required for most lighting systems), it is more difficult to photograph with a wide aperture, which can feel limiting to me during pet shoots if I'd like to create a blurred background.

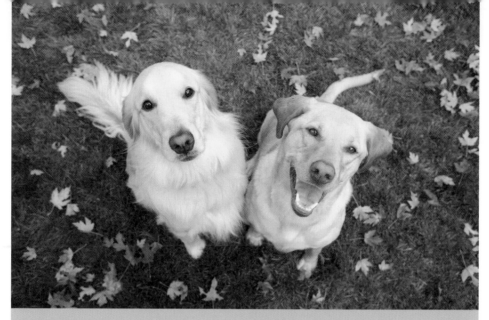

I loved the color contrast of the leaves and grass in this image. Because I had a ladder with me, I was able to change my perspective to surround the pups with just this background.

I always try to consider the balance of time during my sessions. I evaluate as best I can whether the scene I am lighting is worth me using the time and energy of the pet and the pet parent to light it with studio strobes. Don't get me wrong, I love studio strobes and use them often in my pet photography. There are just some things I love about them—and some things I don't. If you're considering investing in studio strobes, I highly recommend renting a set to play with before you commit.

Working Alone

When I first started photographing pets, I worked alone (and sometimes still do), without an assistant. Here is some of the equipment I've used and methods I've adopted to help navigate working solo.

PET PARENTS: Often it can be helpful to enlist the help of a pet parent during the portrait session. They can help hold reflectors or draw the attention of a pet using a treat, noise, or gesture. This will require you to give proper and polite direction, which I'll discuss further in chapter 6.

LADDER: I always bring a (very lightweight) ladder with me to photo shoots, because it can serve many functions. Ladders are great for photographing different angles and can also help support reflectors or bounce cards.

"A" CLAMPS: If I need to hold up a bounce card, either to a ladder or another support, an "A" clamp purchased from a hardware store helps keep the card in place.

LARGE FOAM CORE AND LARGE REFLECTORS: These are easier to use than small ones, because you can lean them up against tables, chairs, your ladder, the wall, or a tree, and they don't necessarily require an extra set of hands.

TRIGRIP REFLECTORS: If you are using small reflectors by yourself and are good at holding your camera with one hand, this is a great option—Lastolite's TriGrip reflectors are specifically made to hold with one hand.

YOUR MOUTH: If you are holding a camera and a reflector *and* trying to get an animal's attention, you'll benefit hugely from learning to use your mouth to make noises. Using your mouth to get an animal's attention will help keep your hands free for other actions.

SANDBAGS AND TAPE: It is imperative that you keep yourself and your subjects safe during your photo sessions. Sandbags should be used to hold down light stands, and Gaffer's tape works well for securing loose cables.

Gear Overwhelm

When considering your equipment needs, develop your list around what would be nice to have and what you feel might be necessary to take your work to the next level or reach certain creative goals. Your Priority group of items might include a camera, lens, computer (for editing and reviewing your work), and some kind of reflector to begin your pet photography practice.

Do your best to focus on what is available to you now, and learn how to create images within those parameters. Have fun exploring the options with regard to new lighting, cameras, and software, but try not to get dragged down by the choices. There will always be "better" and newer gear out there, and trust me, you don't *need* all of it to create meaningful, authentic pet portraits.

PRIORITY LISTS FOR PET PHOTOGRAPHY EQUIPMENT

IF YOU FIND YOURSELF OVERWHELMED WITH THE OPTIONS FOR EQUIPMENT, AS I KNOW I HAVE BEEN, CONSIDER MAKING A LIST AND DIVIDING IT UP BY PRIORITY.

Jiffy the puppy moved around quickly, so I photographed this image at 1/500 second, f/3.2 with an ISO of 200 to keep noise levels at a minimum.

CHAPTER 3: EXPOSURE FOR PETS: GETTING IT RIGHT IN-CAMERA

In spite of the freedom digital photography has brought to the world of photography, it *is* important to capture well-exposed images. There are definitely some specific considerations to keep in mind when exposing for pet portraits. In this chapter, you'll find direction on pet-specific camera settings for achieving accurately exposed images.

Why Should You Care About Accurate Exposure?

In the days when every photographer used film, proper exposure was essential for achieving the highest-quality color and black-and-white negatives; and it was critical for positives (slides). Poorly exposed film meant a lot more work in the darkroom, and if the exposures were really bad, you might not have been able to pull together a decent final print. Although we have far more leeway with digital than we ever did with film, the same scenario is true: a properly exposed digitally captured image will produce a higher-quality final result than a poorly exposed one.

When I'm photographing pets, one of my many goals is to capture well-exposed images. I'll tell you a few reasons why.

TIME SAVINGS

The more accurate you can get your exposures, the more time you will save on the computer in postproduction. For me, this is hugely valuable. I'd rather be photographing animals than tweaking my exposures in Lightroom.

QUALITY

While digital is more "forgiving" than film, there is a limit. If you under- or over-expose your images and make extreme adjustments for them in postproduction, quality can be sacrificed. This could mean a lot of noise or a "muddy" look on a dog's fur if it is severely underexposed, or no information on a severely overexposed cat's face. Learning how to properly expose your images and read your histogram is a valuable practice that will absolutely pay off in quality.

OPPORTUNITY

There are many issues to consider when you're photographing pets. You may not get a second chance with a special expression or body position of an animal, so if your exposures are way off, you may miss an opportunity. For this very reason, be sure to test your exposures as much as you can before positioning any of the animals.

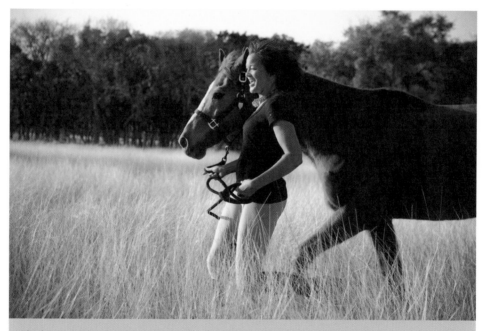

I had to consider the high contrast so as not to overexpose the highlights in this image—as well as pay attention to stopping the action. Settings: 1/1250 second, f/4.5, ISO 400

Which Setting Is "Right" for Pet Portraits?

Fortunately (because that would be boring) and unfortunately (because options can complicate things), there isn't one particular setting that is right for pet portraits. I shoot in Manual mode, many photographers shoot in Aperture or Shutter Priority mode, and others photograph in fully automated program modes. Each photographer needs to make a decision about how to photograph that best suits his or her needs on a technical and creative level. Having said that, I certainly have opinions and suggestions based on what works for me, as well as what I have learned to be true for others.

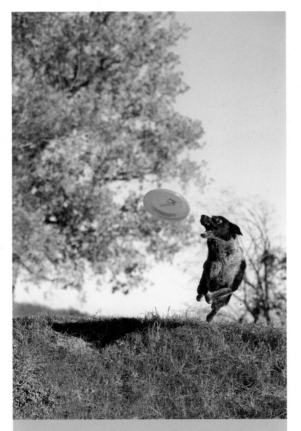

In this image, my priority was to stop the action of Oliver catching the Frisbee, so I had to prioritize a fast shutter speed. Settings: 1/3200 second, f/4, ISO 400

There are times when I look back at my images and wonder why I used a particular shutter speed, aperture, or ISO and cannot for the life of me explain my choices. In the moment of photographing pets, we make the best decisions we can and try to move fluidly while thinking creatively and technically. There's a lot to think about. Sometimes we forget to change our ISO or make another seemingly random decision we're not in love with, and that's totally OK—it's part of the experience. Just try to continue to be more intentional about your choices moving forward and learn from your experiences.

When I teach pet photography, one of the concepts I emphasize is prioritizing. I encourage you to approach each scenario by thinking about what is most important to you technically and, ultimately, creatively in the image. It doesn't matter whether you're shooting in a program mode or Manual, just that your actions are based on this factor: "What is my main goal for this image?"

STOP ACTION

Do you want to freeze action of a pet in motion? Perhaps you're looking to stop the action of a horse running, a dog chasing a ball, or a cat swiping for a toy. Or maybe you're photographing a very young puppy who doesn't want to hold still for very long. If so, you'll want to start with setting your shutter speed high enough to consider this priority.

SHOW MOTION

Are you interested in capturing movement of a dog's tail, showing a blur of a cat's figure as it struts by, or panning a horse as it runs? If so, make this a priority and set your shutter speed accordingly.

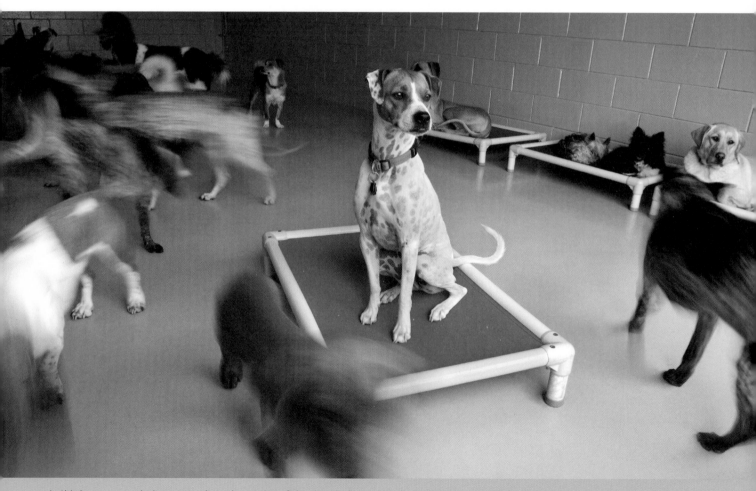

In this image, my priority was to show the motion of the dogs in Santa Fe Tails (a dog daycare in Santa Fe, New Mexico). I used a tripod to eliminate camera shake and took several images to get this image of the dog in the center holding still. Settings: 1/5 second, f/16, ISO 100

BLUR THE BACKGROUND

Is the background of your scene very busy, or would it look more interesting as just a block of shapes and color? Do you want to make sure the viewer is immediately directed to the pet in the frame rather than pay attention to other details? If so, your aperture setting will take priority.

INCLUDE LOTS OF DETAIL

Are you photographing a beautiful cat, and you want lots of detail in her whiskers? Do you have more than one animal in your image, and you want to have both or all in focus? If so, your priority will be to set your camera to allow for lots of depth of field.

As your priorities and creative ideas start to flow, you will want to change your settings to support those needs. I find that starting out by thinking about my creative priorities, I can more easily make technical decisions.

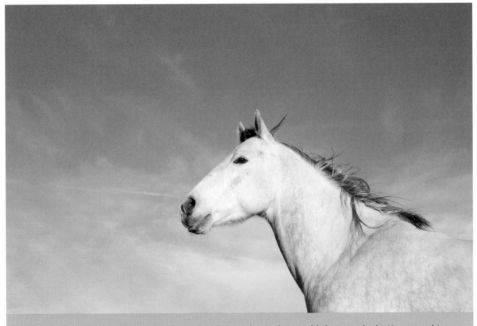

My priority in this image was to show detail, but also to have a high enough shutter speed to stop the action of the horse's blowing mane. Settings: 1/1000 second, f/7.1, ISO 320

Manual Mode

I choose to manually adjust my exposure settings on my camera, for a few reasons. Throughout my formal education (which started way back in ninth grade), I was taught to set my exposures manually. My first professional camera required me to set the exposure manually. I've practiced in this manner ever since. Therefore, I can quickly adjust my exposure settings without having to spend a lot of time thinking. Manually setting my camera's exposure gives me control over the technical and creative side, rather than giving the camera the option to choose a setting for me. For some photographers, using a program mode is faster and makes more sense, but this is how I work. I always recommend that you, at the very least, have a solid understanding of shooting in Manual so you know what's happening when and if you shoot in a program mode.

I shoot in RAW format and typically use my camera as a test for exposure. I use my histogram to help me get a sense of what my exposure looks like, given the particular scene and color of the pet. I used to use a light meter but don't typically use one in my pet portrait sessions. I've found that if I am switching scenes quickly or don't have a lot of time to set up, the camera can provide helpful information I need. I always take tests of the lighting and settings I've chosen before the pet is in place or "ready," so I don't waste their energy.

My "go-to" setting for shutter speed while photographing pets is 1/250 of a second. I find that this is the lowest shutter speed I'm comfortable regularly using even while photographing more static or posed pet portraits. If I am photographing a dog sleeping on a couch, I could certainly use a slower shutter speed (1/125 or even 1/60 if I am really holding still) but dogs, cats, and horses generally tend to move frequently, and my results are more consistent for pet portraits when I start at 1/250. Even subtle movements of an animal or camera shake if I move too much can show up as blur when I use slower shutter speeds.

REVIEW YOUR SETTINGS

I HIGHLY RECOMMEND REVIEWING THE SETTINGS YOU'VE USED TO CREATE YOUR IMAGES. IF YOU'RE USING LIGHTROOM, PRESS THE LETTER "I" KEY WHILE IN THE LIBRARY OR DEVELOP MODULE (PRESS IT MULTIPLE TIMES TO SEE DIFFERENT INFORMATION) TO EASILY VIEW THE SETTINGS YOU USED TO CREATE THAT IMAGE. THIS IS REALLY HELPFUL FOR LEARNING!

FOCUS

I use auto focus 98 percent of the time while I am photographing pets. Dogs run, cats pounce, and horses gallop far too quickly for me to be able to manually focus. Most of the time auto focus works well, but occasionally, I'll switch to manual focus, for example, if the camera is having trouble with auto focus due to low contrast or light. In general, I don't see any added value to using manual focus.

For non-action pet portraits, I typically use the single focus point (or points) in the center, lock the focus, and reframe my image. This is just how I've practiced for years and it's comfortable for me, but of course, not necessarily the approach for everyone.

A focus-tracking mode (the names vary depending on the camera system) is definitely needed for capturing action photographs. I'll go into further detail on capturing pets in action in later chapters.

I tend to use my light meter in-camera as a starting point. I use an evaluative meter setting on my camera most of the time. After many years, I've learned to read the lights and darks in a scene visually so that when I look at my histogram after I take a test shot, I can adjust accordingly.

Aperture Priority Mode

A lot of photographers use Aperture Priority mode, which can be an efficient way to photograph pets.

PROS

Using Aperture Priority mode can be a quick way to work when photographing pets in lighting situations that are constantly changing. For example, photographing a horse in a field on a partly cloudy day when the sun is popping in and out from behind the clouds can really be difficult in terms of exposure, because it shifts so much. Setting the aperture and allowing the camera to select the proper shutter speed can help you work more quickly and focus on other elements.

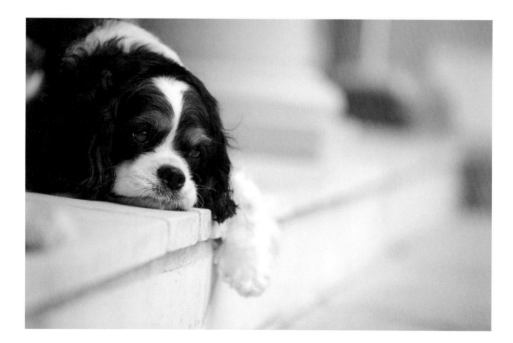

When I am photographing a pet, I can get very focused and caught up in the flow of the experience. If I am using Aperture Priority mode, I might set the aperture to f/5.6, and based on the lighting conditions and my current ISO, the camera may select a shutter speed of 1/30 of a second. I might spend five minutes photographing with these settings without realizing that the shutter speed is not high enough to stop action or to avoid producing blur from camera shake. This can get frustrating, and I've seen this impact my students many times.

Even though the camera is selecting what it believes to be the appropriate shutter speed based on the overall scene, the scene may still be too dark or light. In this case, I'll need to set the exposure compensation, which works well but can take longer for me to change than if I were photographing in Manual mode. Again, if you are practiced in this program mode, you may have a different experience.

Shutter Priority Mode

When using Shutter Priority mode, you're telling the camera you'd like to decide which shutter speed to use while it selects what it senses to be the best aperture for the pet and the scene.

PROS

If I had to pick a priority mode, I would use Shutter Priority for pet portraits, because it's very important to me that my images do not have undesired movement or blur in them. As long as my ISO is set appropriately, using Shutter Priority with scenes in which the lighting is changing often (like the cloudy day I mentioned) can be quick and effective. This mode feels less "risky" to me than Aperture Priority mode, because my aperture will flash as a warning when it doesn't seem to have enough light to make a proper exposure based on the selected shutter speed. At least in my camera, I don't see the same "warning" signal when I am using Aperture Priority mode.

CONS

Similar disadvantages apply for Shutter Priority as with Aperture Priority mode.

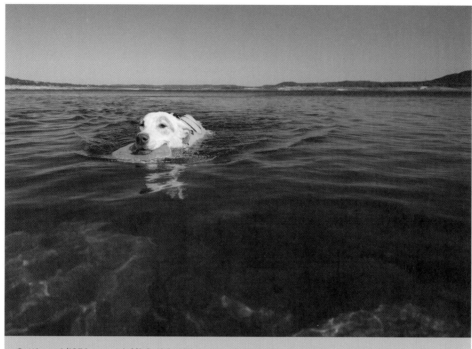

Settings: 1/1250 second, f/2.8, ISO 400 (created using Shutter Priority Mode)

ISO

ISO is something I definitely keep in mind when I'm photographing pets. As I mentioned in chapter 2, "Bringing Your Gear and Your Bag of Tricks," I love working with a camera that provides high quality in low-light situations, primarily because it allows me the freedom to keep my shutter speed high enough to photograph active dogs, cats, and horses without sacrificing quality.

Capturing the detail in an animal's fur is very important to me, and I've found with my current camera that if the situation calls for it and I can get my exposures spot-on, I'm comfortable photographing with up to 1600 ISO.

You probably already know that lower ISO is going to give you higher image quality. This is always important to keep in mind as you're photographing pets. Sometimes, however, it can be a little confusing to know where to start with your ISO settings.

In the next section, I'll share some starting points and considerations for ISO. It is not unusual for me to change my ISO multiple times in a single pet portrait

session, because the ISO I choose is dependent on the lighting scenario and my creative goals. These settings are based on my camera system, so be sure to test out your system and perhaps keep some notes on what you discover.

INDOOR LOCATIONS WITH NATURAL LIGHT

There are many factors to consider, but when working indoors in a very brightly lit interior space, I typically start with an ISO of 400. I find that my eyes can give me the impression that a room is much brighter than what the camera detects. If I'm working with a pet in a more dimly lit interior space, I will start my ISO at 800, because I know I am likely going to need the extra light sensitivity.

Because I like to set my shutter speed at a minimum of 1/250 or, at the very least, 1/125 for posed portraits, I need to select a high-enough ISO for these interior lighting conditions in order to do so.

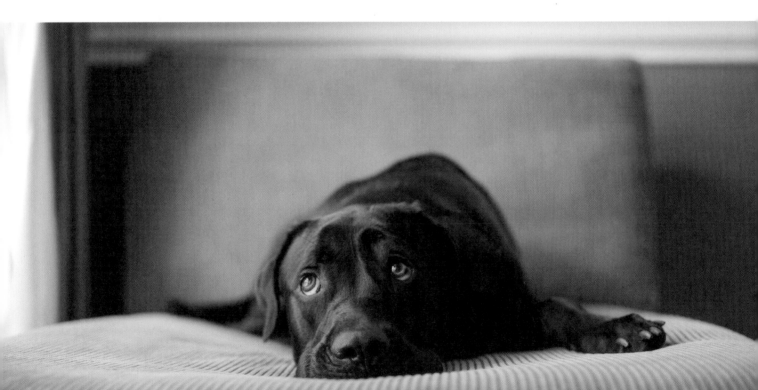

The room was fairly dark while I was photographing Otis, so I used a higher ISO to get my settings where I wanted them. Settings: 1/250 second, f/2.8, ISO 1250.

INDOOR LOCATIONS WITH SMALL FLASH AND LARGER STROBE

In order to save battery power for my small flash unit, I typically set my ISO to 400 when working indoors. This ensures that the flash does not have to work too hard and enables me to shoot more quickly, since I will not have to wait as long for the flash to recycle. Flash recycle time is very important when working with pets, because you can easily miss a sweet expression or action if the flash fails to fire.

Larger strobes that are not battery-powered typically have a faster recycle time, so I will work with them at 200 ISO as a starting point when photographing an animal indoors.

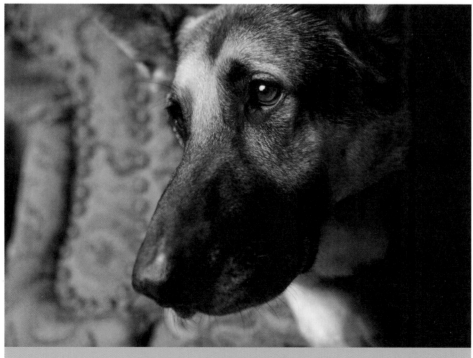

This photograph was created indoors with a large strobe light. Settings: 1/125 second, f/3.2, ISO 160

If I'm photographing posed portraits outdoors on a sunny day, I'll begin with a low ISO, usually 200, in order to keep the image quality high. If I am photographing stopped action in the same scenario, I may start with my ISO set to 400, because I know I'll need to get a very high shutter speed.

When I'm creating portraits outdoors on a cloudy day, I'll start with an ISO setting of 400. If I find myself working in extreme shade, I'll initially set my camera's ISO to 800.

Cameras Aren't Creative

The important thing to remember when it comes to exposure is that cameras aren't creative beings; they allow for creative action, and they are "smart" in the sense that they can react based on the settings you choose. But the camera doesn't know anything about your goals as a pet photographer. Your camera doesn't have any opinions about whether the background should be sharp or blurry, whether you are underexposing a white dog or overexposing a black horse. It's up to you to decide what's important in your images and to set your camera in a way that gives you creative control.

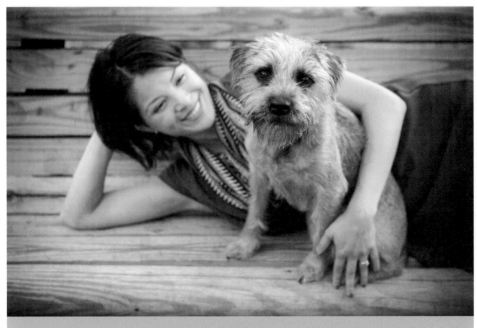

An intentional choice was made to focus on the dog and let the woman fall out of focus. Settings: 1/500 second, f/3.2, ISO 800

Dark Pets Versus Light Pets

Even though cameras and built-in meters are becoming increasingly sophisticated, photographing very dark-colored and light-colored pets can be technically challenging.

DARK-COLORED PETS

As you probably already know, photographing dark pets can be difficult. One of the challenges is that dark fur absorbs light, so when we are photographing a black dog, the image can be underexposed because there just isn't enough light bouncing off him. When I am photographing dark animals, I know immediately that I will need to make sure I have enough light falling directly onto that dog or cat. If the dog, cat, or horse has shiny fur or hair, I'm in luck because the light bounces off that shine and provides a nice surface for capturing detail. If there is little or no shine, I have to make even more effort to bring light directly onto the fur.

My dog, Otis, is pure black. When he is being photographed, his fur requires more light than a white dog's fur, but because his fur has sheen to it, the light bounces off the black and creates highlights that give dimension to his face and body. Reflectors (I typically use silver or white) can often help reflect an animal's fur quite nicely.

Another potential challenge when photographing dark animals is the camera's built-in meter. If I am metering off of a dark dog with evaluative metering, for example, my camera will want to provide an overall exposure that is an 18% gray, and as a result, the dog will be overexposed and look more gray than black. If this situation occurs while I am in Manual mode, I will have to decrease my exposure in some way via the shutter speed, aperture, or ISO. If I am using a priority mode, I'll have to decrease my exposure compensation or adjust the ISO in order to lower the overall exposure. In order to really ensure that values are falling where I want them, I look at my histogram.

Another potential challenge with dark animals is that if I am photographing a low-key scene (dark animal and a dark-toned background), my camera can sometimes struggle a bit with auto focus. The camera needs contrast to focus, and if everything is dark, my camera might sometimes become confused.

Try not to be intimidated by photographing dark animals, but do expect that they might need a little more technical attention than other pets.

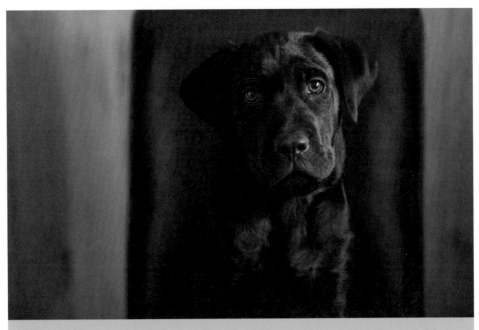

This image of Otis was created with a large strobe light, which you can see reflecting in his shiny fur. Settings: 1/160 second, f/3.2, ISO 200

LIGHT-COLORED PETS

When creating images of light-colored pets, you may run into a similar, but slightly different, challenge as with dark pets. Your camera's internal meter may see a bright, white dog and want to make that white an 18% gray. To do this, your camera may underexpose the white fur, causing it to look gray rather than white. This situation is definitely more noticeable for me when the animal's

fur and body are filling the frame and when I'm using a priority mode. If you run into this problem, you'll want to use your exposure compensation and dial it to +1 or another positive increment to give the image more exposure and essentially override your meter's suggestion.

Overexposing light-colored pets can also become an issue if I'm not paying close enough attention to my exposure compensation and settings in general. I don't want to blow out any highlights if I can

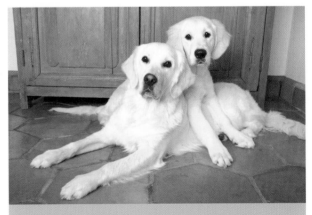

These two beautiful dogs were photographed with a large studio strobe. Settings: 1/125 second, f/11, ISO 200

help it, especially on an animal's face, because that is often not recoverable in postproduction.

DARK- AND LIGHT-COLORED PETS IN THE SAME FRAME

Photographing dark- and light-colored pets in the same frame can sometimes be a challenge. A good plan for this scenario is to try to position the light-colored pet away from the main light source and the dark pet closer to the light. I may also use a bounce card or reflector to add light to the dark-colored pet in order to help balance the light for both animals. In worst-case scenarios, I may take two separate exposures—one for each pet—and then composite later in postproduction.

Dynamic Range and Understanding Contrast of a Scene

When creating pet portraits, having a strong grasp of the information your camera is capable of recording, as well as the contrast of a particular scene, can be very helpful for both technical and creative purposes.

CONTRAST OF PET VERSUS BACKGROUND FOR EXPOSURE

Dark pets against light backgrounds and light pets against dark backgrounds have high contrast and may require some extra technical considerations. When I use the terms "dark" and "light," I am referring to both the color of a scenario or animal and the amount of light in a given situation. For example, a white wall can appear dark compared to a foreground if there isn't much light on the wall, or if the foreground in comparison is much more illuminated.

If your objective is to capture detail in both the pet and the background in high-contrast scenarios, you'll need to make sure you're being realistic about how much information your particular camera can capture at once—this is the dynamic range. As a reminder, dynamic range is the difference between the lightest light and the darkest dark in your image.

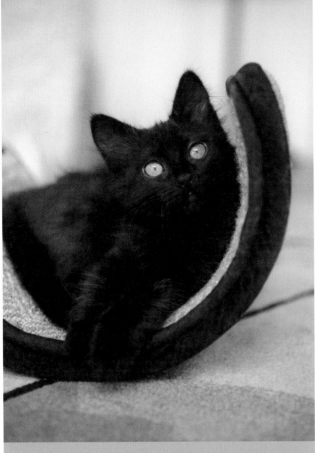

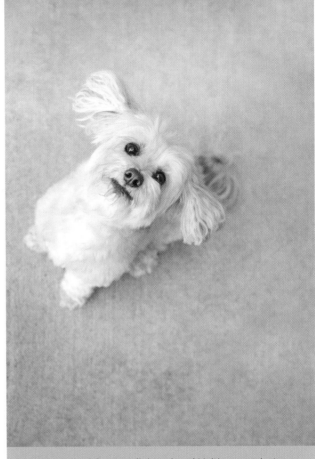

This black kitten photographed against a bright background created a high-contrast scene. Settings: 1/180 second, f/2.8, ISO 400

I photographed Gracie, a light-colored Maltipoo, against a fairly light-colored flooring, which is a lower-contrast, more "high-key" situation. Settings: 1/320 second, f/4, ISO 800

Photographing a light dog on a lighter background (a high-key image) will be easier for the camera to capture than a high-contrast scene, because the contrast is lower. Dark dogs against dark backgrounds will be simpler for a camera to expose.

One challenge with low-contrast scenes is making sure that the pet and background have separation. Neither high nor low contrast is necessarily better; they're just different. If you're struggling while photographing a high-contrast scene, try to make a note of whether you're being realistic about how much information you're asking your camera to gather. Practice noticing which backgrounds you're choosing and how they compare in contrast with the pets' fur so you can make some intentional choices.

USING CONTRAST TO CREATE STUDIO-LIKE LIGHTING

You can use a high-contrast scenario with pet portraits to your creative advantage. For example, if the proper exposure for a dimly lit, dark background is 5 stops of exposure more than the necessary exposure on the cat or dog in the

foreground, you will have to decide which takes priority. This is because of the limited dynamic range I mentioned earlier. If you need detail in the background, you'll have to add light to the background or lower the light from the foreground in order to decrease the overall contrast of the scenario. The contrast in the image I'm describing is too great to accurately expose both for detail without making some adjustment. No worries, though—you can use this kind of scenario to your advantage and just let the background fall dark, which can result in a more studio lit–looking image.

I used this method in the image of Neema, the cat. I noticed that the beautiful window light allowed me to photograph detail in both the cat and the background if I had my back to the window. I saw a television stand to camera right in the same room and knew that if I repositioned myself and the cat just slightly, I could expose the cat properly and let the television stand fall into darkness.

In this situation, I knew that the dynamic range of the camera was not great enough to capture details in both the cat and the background, because the difference in exposure was too much. (Note that if the contrast weren't extreme enough, I could potentially increase the distance between the cat and the background in order to increase the contrast.) This approach resulted in a more studio lit–looking image.

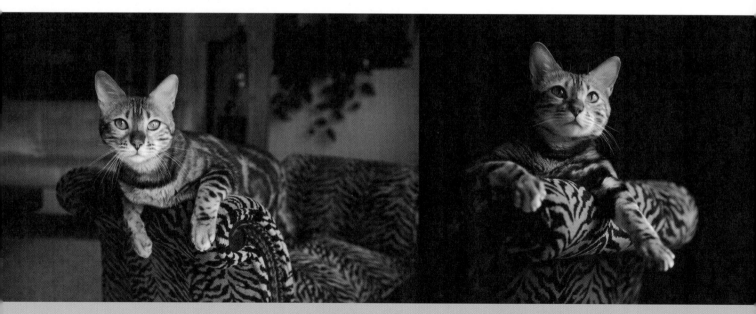

Neema, a gorgeous Bengal cat, photographed indoors with natural light. I used the contrast of the scene to create lighting that looked similar to studio lighting. Settings: 1/250, f/4, ISO 640; and 1/400, f/2.8, ISO 800 (for the second image)

Keep these kinds of opportunities in mind as you're assessing your locations for pet portraits and comparing foregrounds to backgrounds, and think about how you can use contrast in lighting to create drama or variety.

In-camera Versus Retouching Later

Getting things right in-camera is always my intention. If I say to myself, "I'll fix that later," it's for a good reason. In chapter 2, I discussed my philosophy of retouching, and in this chapter, I'll address the subject a bit more with regard to how I make these decisions when I am actually in a photo shoot with a pet.

As I mentioned, I don't consider myself to be a heavy retoucher, meaning that I don't typically use a lot of plug-ins in Photoshop or Lightroom, and I don't usually create a lot of special effects with my pet images. While I am pretty traditional in terms of how I finalize my images, I encourage you to find a style that works well for you and that excites you.

I typically use Lightroom and Photoshop to enhance my images by cleaning up the pet or the scene in general, or to make changes that lead the viewer's eye to the pet as much as possible via masking.

When I am photographing a dog, for example, I try to get as much right in-camera as I can, given the specific situation and animal. I try to make sure things are clean and orderly with the background and that any props involved are looking organized and intentionally placed. I make sure large items are where I want them and the dog looks clean and presentable. If something major is out of place within the scene or on the dog and I have the time and dog's energy to fix it, I will.

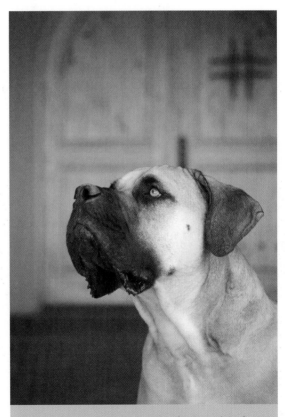

A little drool isn't worth stopping for, but a lot of drool is a different story and totally worth a pause in activity to get it right in-camera. Settings: 1/500, f/2.8, ISO 500

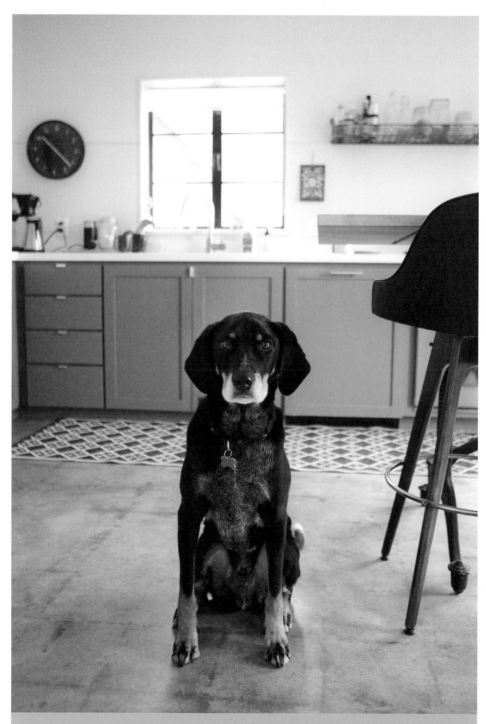

I could have removed this dog's collar before I photographed her, but I loved the way she was sitting in the kitchen and didn't want to risk moving her. If I later found the collar distracting, I would remove it in Photoshop. Settings: 1/125 second, f/2.8, ISO 1600

WHEN TO RETOUCH, WHEN TO GET IT RIGHT IN-CAMERA

CONSIDER RETOUCHING IN POSTPRODUCTION: ELECTRICAL OUTLETS AND SWITCHES (IF I LIKE THE LOCATION, I WON'T MOVE BECAUSE OF AN OUTLET), SMALL AMOUNTS OF DROOL AND SLOBBER, EYE BOOGERS (IF RUNNING SHORT ON TIME AND PET ENERGY DURING A SHOOT), VERY SMALL ITEMS IN THE BACKGROUND, TREAT SCRAPS ON THE FLOOR, SMALL AMOUNTS OF HAIR/FUR ON CLOTHING AND ENVIRONMENT, AND SMALL BITS OF FOOD ON PETS' FACES.

GET IT RIGHT IN-CAMERA BY FIXING DURING THE SHOOT (WHEN POSSIBLE): COLLARS, GENERAL GROOMING, FURNITURE AND OTHER LARGE ITEMS, LIGHTING, LARGE AMOUNTS OF DROOL OR SLOBBER, DIRT, FRAMING AND CROPPING, AND THE CAMERA BAG YOU FORGOT WAS IN THE BACKGROUND.

I like to take the time to be intentional about what I am including in my frame and confident in the set overall when I capture images, but sometimes I have to let it go and know that I may have to fix these issues in postproduction. For example, there are instances when it is better for me to fix a dog's collar or clean food off its face in postproduction than take up time and the dog's energy during the session, because if I choose to stop and adjust something small, I may miss the moment or lose the dog's attention entirely. I make these decisions based on the individual pet and the flow of the photo shoot. But overall, I'd rather be photographing or making other art than sitting at my computer retouching something I could have easily moved or adjusted during the session.

MULTIPLE FACES

If I am photographing more than one animal at a time and the goal is to have every face looking straight into the camera, I will do my best to get every face aligned in-camera just the way I want, but I realize I may have to composite two or three images together. Again, I am considering the amount of time and the animals' energy that it takes to get everything to align in one shot versus saving their energy to be used in the creation of other fun images.

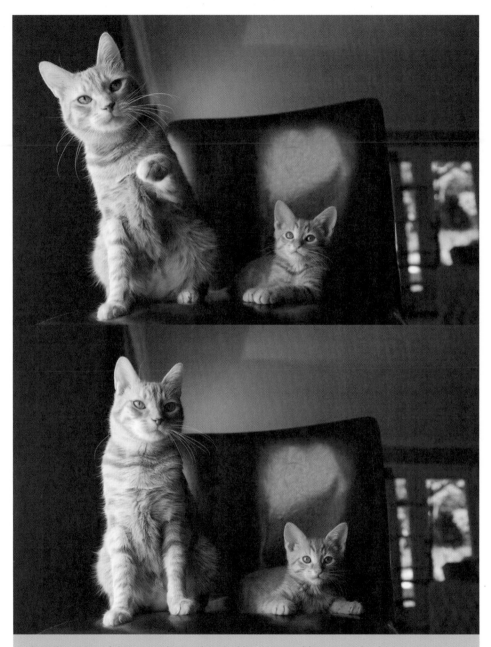

I love the action of the cat on the top, but the kitten is out of focus. I might choose to composite these two images to get the action on the top and an in-focus kitten if sharp focus on both were needed. I always try to get action and focus exactly how I want it in-camera, but with multiple faces and bodies, I occasionally choose to composite in postproduction. Settings: 1/250 second, f/5.0, ISO 400

LIGHTROOM VERSUS PHOTOSHOP FOR RETOUCHING

In terms of retouching, I use Lightroom for graduated filters, exposure adjustments, color balance, clarity, contrast, and a small amount of spot removal. I also play around with virtual copies to see how images look with varying degrees of adjustments or in black and white.

I open images from Lightroom into Photoshop for more detailed retouching. I remove excessive amounts of slobber and drool, eye boogers, stray hairs, and debris in Photoshop. Occasionally, I'll swap a face or eyes out from one image and transfer it to another in Photoshop. This is helpful if I wasn't able to get the parts to align in-camera, as mentioned earlier. I also love making detailed selective adjustments using layer masks to keep the viewer's eye focused where I want it, which is something you can now do pretty well in Lightroom, too.

How the final product looks is important, and precisely how you arrive there is entirely up to you as an artist. Increasing your attention to detail and practicing getting your pet portraits very close to the final product in-camera will not only help you continue to train your eye and skills, but also save you time on the computer. Knowing *why* you are making decisions in-camera, as opposed to letting the camera make selections for you without that knowledge, will help you make more intentional and creative choices.

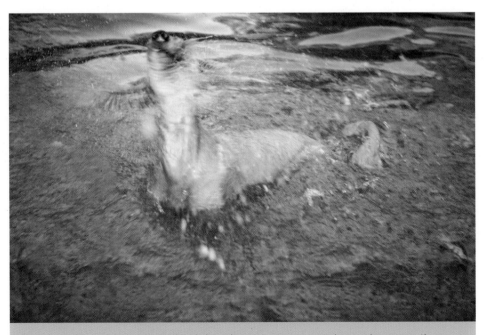

The more you can become intentional about how you capture your images in-camera, the more freedom you'll find to enjoy playing around.

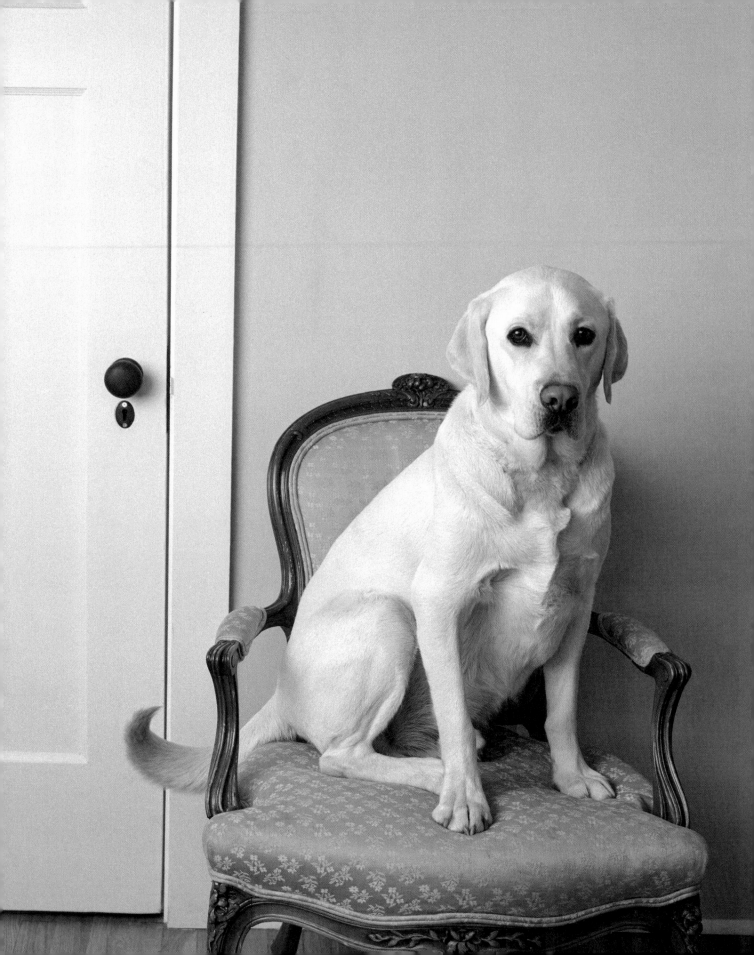

CHAPTER 4: COMPOSITION, COLOR, AND CREATIVITY

In this chapter, I'll be diving into a discussion of composition, color, and creativity in pet portraits. Each of these topics plays a supportive role to the others, and while they all apply to other genres of photography, specific considerations with regard to pet photography are well worth exploring.

Composition

Whether you're creating a photograph, constructing a painting, designing a building, or even decorating a room, composition plays an integral role to the overall aesthetic of the final product. Composition should play a role in your image and your goals for that image, no matter what kind of photograph you're creating. Pet photography may seem "cutesy" to some, but I assure you that successful images require the same considerations of composition as any other form of art—with animals added to the mix.

Paying attention to composition and making intentional choices about what to include (or not include) in your pet photography will help make you a stronger, more successful photographer. Learning the rules of composition is a really helpful way to train your eye so that when you create a successful image, you know what contributed to its success and you can create more. Later, you can decide to break the rules as much as you want, but do so with intention and understanding of why you're making those choices.

RULE OF THIRDS

One of the compositional challenges I notice in pet photography is the "head-shot" look. This completely symmetrical, centered closeup image of a dog, cat, or horse gets the job done in terms of recording a particular animal, but it does very little, aesthetically, for the viewer of the photograph. Headshot images of pets can also be creatively limiting for the photographer. Keeping the rule of thirds in mind can help solve this problem.

You may remember that the rule of thirds is the concept of imagining a grid that divides the frame into thirds both horizontally and vertically, leaving four cross-section points. By placing a point or points of interest in one of the cross sections, you are already adding dimension to the image.

Placing an animal's face or body a little off-center gives the viewer's eye more breathing room in the other parts of the photograph. It can also be more interesting than a straightforward, symmetrical image that looks like a headshot. This isn't to say that all images need to be off-centered and that no symmetrical images with a pet's face or body centered are beautiful or impactful.

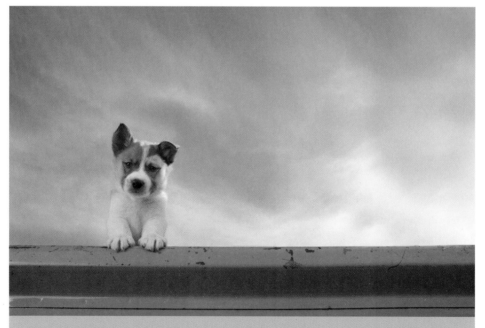

I framed the puppy by implementing the rule of thirds with both the position of the pup and the horizontal section of the truck.

Because the rule of thirds divides the frame into thirds both horizontally and vertically, you can be intentional about composing your frame to align vertical and horizontal elements of your image with these sections. For example, if you're photographing a dog in a field, the horizon line doesn't necessarily have to be centered in the frame from top to bottom. The photograph can actually become more visually balanced if the horizon is aligned in either the top third or bottom third of the horizontal grid.

Try to pay attention to where you are choosing to place an animal's face in the frame, and see if it happens to fall in line with one of the intersection points or divisions that apply to the rule of thirds. If you have time as you're photographing, reframe your image in different ways to experiment with variations on the rule of thirds. As you review your images in postproduction, notice how placing the pet at these intersection points changes the overall composition.

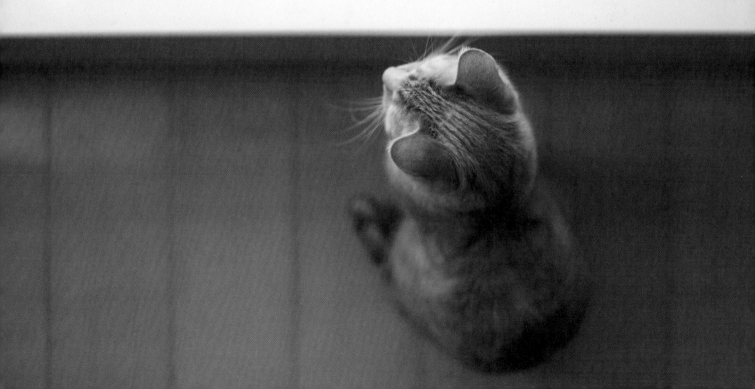

In this image, the cat's eye and focal point fall into the top third of the frame, according to the rule of thirds.

CROPPING INTENTIONALLY

Choosing exactly what you want and don't want to include in your pet portraits is a big one for me. When you're cropping in-camera, make your decisions very intentional. I often remind my students to "crop on purpose." Here's what I mean:

Begin to develop the practice of scanning the perimeter of your frame to see if everything that's included in the frame is supposed to be there (according to you, of course). When you're photographing a dog, do you want to include their ears and tail in the frame or not? It's up to you to communicate visually with the viewer of your image by deciding which elements make the cut. If you only crop off the very tip of the dog's ears, for example, it can look like you weren't sure if you wanted to include them or not, or that you didn't even notice them. Handling these kinds of details in this way can become visually awkward and feel unresolved.

The image on the left includes the dog's entire ear, and it is obvious to the viewer that I intended to do so. It is not clear in the next image whether I wanted to include the ear or not; thus, it looks visually unresolved. In the third image, there is no mistaking my effort to crop out much of the ear. The difference may seem subtle, but these details make a big difference in your images.

When it comes to cropping legs and arms of animals in-camera, I recommend not cropping right at the joints, as it can become visually uncomfortable. I sometimes love cropping out heads, and when I do, I make sure I go all the way and crop out a head completely, rather than leave a small part showing.

If I crop out a tail of a horse, dog, or cat (or any animal), I am sure to crop out a significant portion of the tail to make it look as if I did it on purpose. Just cropping out the tip of a tail makes it appear as if I didn't pay attention to the edge of my frame or couldn't decide whether to leave the tail in or out of the photograph. My philosophy is to either crop out a lot of the ears, tail, legs, and head, or include it all with some breathing room.

Whatever you decide to do with regard to cropping, going far enough in either direction will help indicate to the viewer that you did it intentionally. Of course, you can always make these cropping decisions later, but if you crop out a piece of the pet, you won't be able to get it back in postproduction. Also, if you always shoot wide and crop in postproduction, you are sacrificing file size.

The more you practice making cropping selections in-camera, the more you are training your eye and the more quickly you'll be able to make these decisions in-camera.

WATCH YOUR BACKGROUNDS

When we are in the moment of photographing pets, we have a lot to think about. We need to pay attention to posing, exposure, lighting, environment, behavior, communication, composition—and so much more. It can be easy (and I know, because I've done it all) not to realize that your camera bag is in the background of your horse portrait, a line in a chair is cutting through a cat's head, a shape or block of light is creating a major distraction in the background, or your horizon line is super crooked.

Similar to the way that giving attention to the perimeter of your frame is valuable, so is building more awareness of what's happening in the background of your images and how it connects (or disconnects) visually and contextually with the pet in your image. These factors all add up and can contribute greatly to your final image.

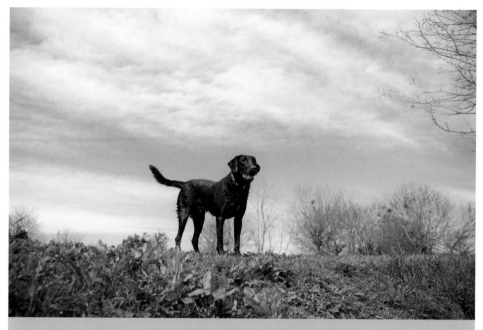

I love to keep my backgrounds simple and ensure that what I am choosing to include—or not include—is intentional!

In order to be able to detect unwanted elements or distractions in your pet images, it can help to take a moment to pause after a few frames to look at your LCD with the specific intention of looking at your backgrounds. Make sure that everything in the image is "supposed" to be there, and then continue photographing once you've made any necessary adjustments.

FRAMING

You can greatly add to the interest of your pet portraits through the use of creative framing devices. They help guide the viewer of your image to the important elements—the pets! Anything can act as a framing device, but here are a few ideas to get you started.

NATURAL

Natural framing devices are a great way to lead the viewer's eye to the pets in your images. Tree branches, grass, rocks, and even light can serve as excellent natural framing elements in pet portraits. If you're photographing a horse, you might be able to nicely frame the horse's shape with a group of trees or the edge of a dry riverbed. A dog can be framed by a bunch of tall grasses. A cat

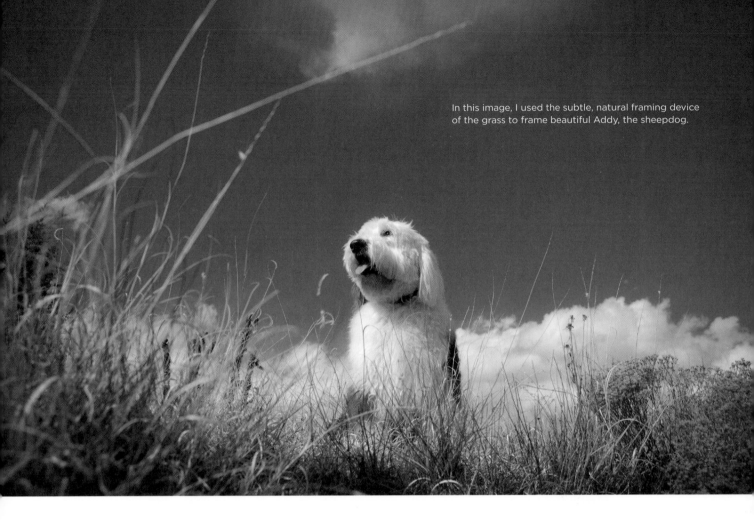

In this image, I used the subtle, natural framing device of the grass to frame beautiful Addy, the sheepdog.

can be framed by a colorful bed of flowers. There are many options for naturally occurring framing devices, and they will be highly dependent on the specific location in which you're photographing. Be on the lookout for framing devices as you are figuring out where to start photographing.

ARCHITECTURAL

Implementing doorways, gates, archways, windows, shelves, walls, and curtains and furniture can be a fun way to visually frame pets. Photograph a dog in a colorful or textured doorway so that the shape of the doorway frames the dog's body. Position a cat against a brightly colored couch cushion to use the color and shape of the cushion as a framing device. Create an image of a gorgeous horse surrounded by the framing lines of an entranceway to a barn or stall. It can be really fun to look for places as you photograph and think to yourself, "I could put an animal in there!"

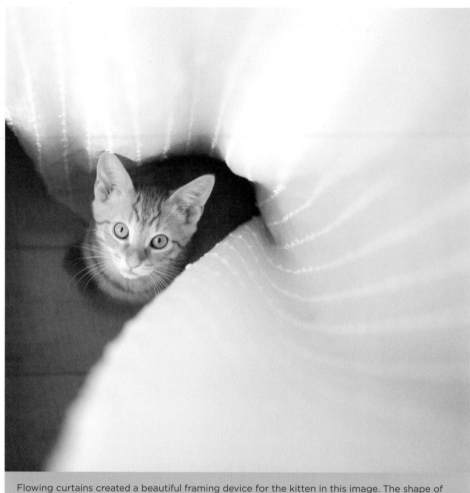

Flowing curtains created a beautiful framing device for the kitten in this image. The shape of the curtain leads the viewer's eye right to the subject.

LEADING LINES

Leading lines provide a guide for the viewer's eye to follow and can help increase the overall interest of a pet portrait. They do not always need to be straight lines and can even be a line of color, like a row of green trees.

As a few examples, consider placing a dog in a pathway so that the viewer's eye travels along the lines of the pathway leading right to the dog, or photographing a cat in a windowsill by positioning yourself so the window and curtains create lights that lead right to the subject. A stream of water leading up to a horse and rider can illustrate the concept of leading lines really nicely.

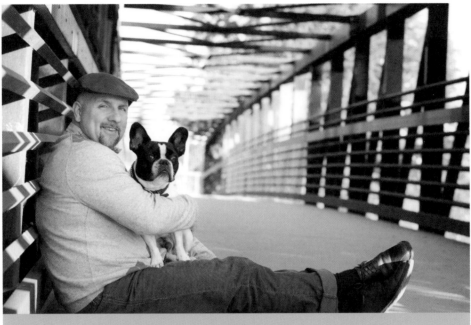
The lines in the bridge help lead the viewer's eye right to the pup and his person.

While including leading lines isn't something you'll be able or necessarily want to do for every photograph, it is another compositional tool to help you build strong pet portrait compositions.

NEGATIVE SPACE

Personally, I love clean and simple images, and these usually involve some amount of white or negative space in my photographs. By placing an animal in the frame and leaving white space, we are providing the viewer's eye visual "breathing room." While including lots of information and details within our photographs can sometimes be effective and interesting, it is not always necessary. Less can really be more.

As a general guideline, if a pet is looking to the right or the left, I like to leave the white space in the direction the pet is looking. This helps the image appear compositionally resolved and gives the pet somewhere to look rather than having them look into the edge of the frame.

Because the dog is looking camera right, I left the negative
space in the direction of the dog's glance.

PERSPECTIVE

This is a huge one! You have such creative power with regard to your vantage
point as a photographer. Pet portraits can be created from any perspective,
and the impact dramatically changes depending on even small shifts in physi-
cal point of view. Emotional impact can change greatly with perspective, your
backgrounds can be dramatically affected, and even the pets themselves can
look different depending on your camera's point of view.

The best way to figure out your perspective options is to try them on for size. Physically put yourself into different positions, and move your body around to change how your camera sees. As you make these physical changes, you will start to notice how different your photographs look from one another.

Here's an example of exploring perspective with a dog as your subject.

PHOTOGRAPHING A DOG FROM YOUR EYE LEVEL is a perspective from which you and I are all used to seeing dogs. This is more of an "everyday" view. There is nothing wrong with photographing a dog from this perspective, but because it is more expected, it may not be the most dynamic approach. If you do choose to photograph from this level, consider also trying some other options just to see what happens.

IMAGES CREATED FROM THE DOG'S EYE LEVEL can create the feeling that the camera is another dog interacting with that dog, or perhaps even a child at the same height of that dog. When a dog looks right into the camera at eye level, it supports the connection between the dog and viewer and almost begins to feel as if the dog is looking into your eyes. This requires a bit more physical activity on your part as a photographer; you may have to lie down on the floor or position yourself at various heights to get the camera and dog at the same level.

PHOTOGRAPHING A DOG FROM BELOW, WHILE LOOKING UP, can evoke a little humor and curiosity, or create a feeling of play if distortion occurs as a result of a wide-angle lens. Animals, just like people, look very different when photographed from below. This perspective is not necessarily the "go-to" for every pet portrait, but it can serve as a fun tool in your compositional bag of tricks.

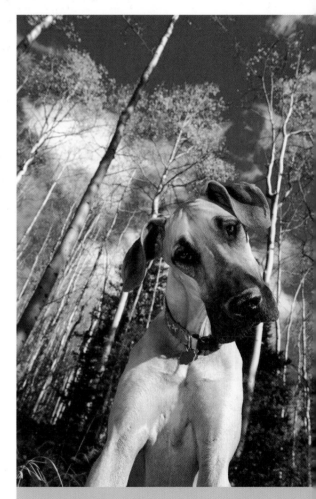

I got down to the ground for this image, so I could photograph Kiya looking down at the camera and include the trees in the background.

I took this image from a high vantage point, above the dog looking down, and she appears to be smiling.

WHEN YOU POSITION YOURSELF LOOKING DOWN ON A DOG, the feeling of that image is quite different from other perspectives. Some people say that it can make the animal look intimidated, but I think this depends entirely on the pet's demeanor. If the dog has a shy personality, photographing from above might accentuate this trait, whereas a happy-go-lucky Labrador may look up and appear to be smiling. Again, if you find yourself bothered by a feature in the background when using your eye-level perspective or from the dog's eye level, you can get on a ladder or stool and change the composition of your frame entirely.

There are plenty of viable options when it comes to perspective, and it's often easier to move your body and camera around than it is to reposition an animal. So keep moving! If you find yourself struggling with less than dynamic compositions, perspective can be a quick way to make a big shift.

DEPTH OF FIELD IMPACTS COMPOSITION

Depth of field can shift the viewer's eye to different areas of the frame, just like other elements of composition do. Your compositions can drastically change depending on your depth of field choices. A horse, dog, or cat in sharp focus in the foreground can create a very different image compositionally than an out-of-focus animal in the foreground.

You can use a shallow depth of field to bring attention and focus to a dog's nose, a cat's whiskers, or a horse's eye as you allow the background to blur. If you don't love a particular background, you can use a shallow depth of field to remove unwanted details that will become simpler shapes. In this case, you are simplifying the background and changing the composition, ultimately bringing attention to the pet in your image.

On the opposite side, greater depth of field provides more information and details throughout the image and will impact the composition as a result. With more elements in focus, you need to be very intentional about how you highlight the pet in the composition. For example, a cat in focus with a background that contains a lot of detail will need to be positioned in the frame so that compositionally, the viewer's eye is still drawn to the animal. The challenge with greater depth of field is that a scene with a lot of details in focus can become overwhelming to the eye, and the pet can get "lost" within the image.

There is not generally a right or wrong way to use depth of field as you develop your compositions. Just keep in mind that your aperture selection is another tool to help guide the viewer's eye within your images.

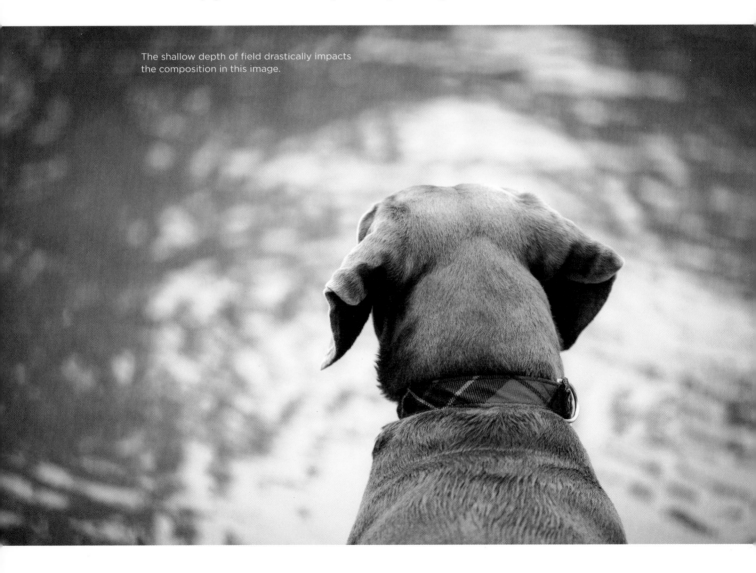

The shallow depth of field drastically impacts the composition in this image.

Color

I love color! I appreciate so much about color in photography—the complexity, both subtle and bold use of color, contrast of colors, and the emotional impact of color in imagery. Color can be used in so many ways to create dynamic images in pet photography.

I have learned to pre-visualize in color (versus black and white), and seeing in this way took some training of my photographic eye. I have practiced noticing color, how I respond to it, and how to use color in my pet photography. I look for color whenever I am photographing, similar to how I look for light.

COLOR CONTRAST

When you look at the choices in backgrounds in relation to the pet you're photographing, it's valuable to notice the color contrast of the scene. Color contrast can be intense or really low and quite subtle. Neither is necessarily better, but noticing these values will give you more creative control and technical insight and will help you become more intentional when you're composing your pet portraits.

The red in the dog's fur and the pet parent's hair complement the green in the background.

USING COMPLEMENTARY COLORS near or next to one another in the frame can be pleasing to the eye and make for dynamic pet photographs. Images with very low color contrast, even monochromatic images, can also be quite beautiful.

COLOR SHOULD PLAY A SUPPORTIVE ROLE in your pet photographs, rather than act as a distraction. Try to use color in your pet portraits to enhance the feeling of the scene or to help bring attention to the animal.

Too much of one color can feel unbalanced in the image and take the focus away from the pet. A dog on a hot pink blanket, for example, can become visually overpowered by the colors if there is a lot of material showing.

My attempt in this image was to highlight the small size of the puppy in comparison to the large couch. Because there is so much red, it becomes too overwhelming and distracting. If this couch were subtler in color, I do not think this would have been an issue.

BRIGHT COLORS CAN BE BROKEN UP if you place the pet in the frame in a way that allows the eye to breathe and the color to surround the pet. Bold colors like red and blue can be very effective even in small amounts and don't necessarily have to take up a large portion of the frame to be impactful. Subtle, less intense color can be used to create beautiful, elegant portraits.

Color has a tremendous impact on our emotional response, and you'll want to utilize this in your pet portrait compositions. Not all color elements have to be bright and bold. Remember, the objective of composition is to support the message or feeling you want to convey in the image and to help direct the viewer's eye toward the pet. We want our compositions to feel complete so that no one particular tool or technique stands out more than another. If the colors in the image are the first thing the viewer notices, you may find that you're doing a disservice to the pet in the image, because the pet appears to be a visual afterthought.

CONNECTING OR LINKING COLORS is another way to use color to create dynamic pet portraits. This concept was something that became a fun, creative game when I started practicing. Repetition is pleasing to the eye; by repeating colors throughout the frame—for example, foreground to background or subject to background—you can keep the viewer's eye engaged.

I used the red wall as a background in this image, and because the dogs' bodies visually interrupt it, the color is not as distracting as with the previous image of the puppy on the red couch.

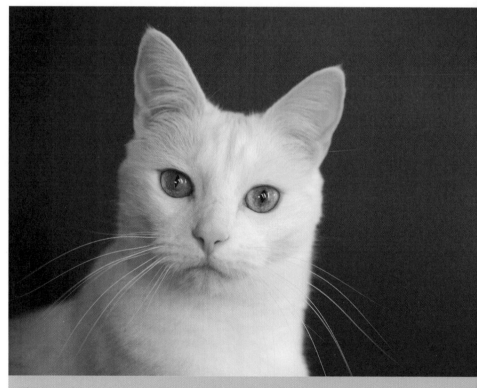

This beautiful cat's green eye links perfectly with the green background.

A dog with blue eyes can look great against a blue-sky background in the same way that a green collar can really pop against some nice green grass. Challenge yourself to pay attention to the colors available in the frame, and see if you're able to create color connections within your pet portraits.

For this studio image, I chose a pink background to tie in with the pink tone of Mika's nose.

Creativity

As I mentioned, I love creating pet portraits that go beyond the "headshot" and start to elicit something more personal to the pet parent and viewer, while also exemplifying my work as an artist. Discovering the ways to get creative with your pet images will require some exploration. Consider the following as you continue with your practice.

TELLING A STORY

Visually telling a story with your images is part of what makes photography such a powerful medium. The element of story can be incorporated into pet photography just as it can with any other genre of photography.

This dog loves to make tunnels as she runs through the greenery in her backyard. Photographing her in this space added an element of story to the image.

As a pet photographer, you may choose to visually tell the story of a pet's personality, their interests, their relationship with their pet parent or another pet in the family, a specific event or adventure, a special talent, or even their journey at the end of their life. Perhaps you are photographing your own pet; if so, think about the story you'd like to tell about him or her. How can you tell that story visually, with your camera?

Story can be conveyed in your pet portraits in many ways. Details like pet toys and beds can be sweet additions to create a reference for a viewer. Interior home environments or backyards can also serve as a reference point to a time and a physical space.

Even when the environment is not very descriptive, the story you're sharing with the viewer can be as simple and beautiful as a moment of connection between pet and owner. The story of your images doesn't always need to be dramatic or deep. It can be all about honoring the grace of a horse, the beauty of a dog's profile, or the sweet mischief of a kitten. The primary consideration when telling a story with your pet portraits is to be clear about the story you are trying to tell. This clarity will help you create more dynamic, authentic pet portraits.

PHOTOGRAPHING IN LAYERS

Photographing in layers can be a fun way to capture portraits of pets and their world. What you choose to include in the foreground and background layers can really turn into a creative endeavor. For example, if you are photographing more than one dog, you can position one of the dogs in the foreground and then either wait or position the second dog in the background to allow the viewer's eye to travel deeper into the frame.

If you're photographing pets and people, you can photograph a layer of pets in the foreground and then a reference to people in the background layer for context. Consider the concept of building your photographs and using layers to add dimension.

VISUAL CONNECTORS help you photograph in layers and can be a fun way to tell a story or add depth to your images. There are multiple ways visual connectors can be used to "connect the dots" within your images. Connectors can be aesthetic in nature, as in the color linking mentioned previously, or in referencing a particular environment or sense of place. As an example, if you photograph a horse in the foreground of a barn, the viewer will connect the two elements visually.

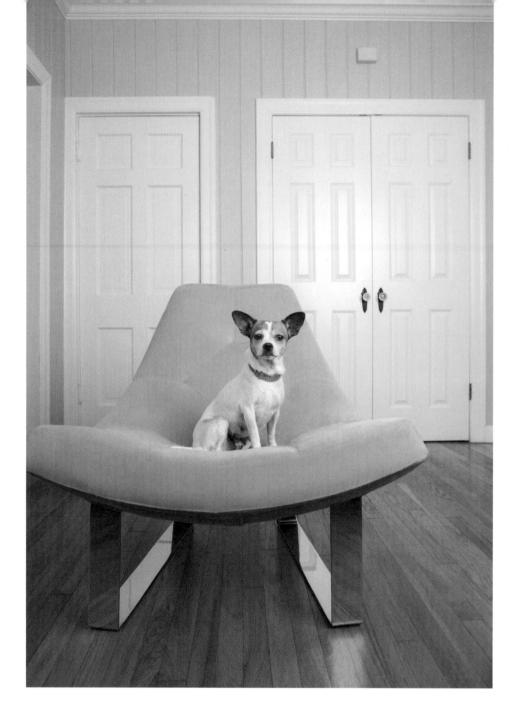

INSPIRATION

As I begin to photograph during a pet session, I may not initially feel inspired by the location, the light, or the colors in a scene. But I often notice that once I start, ideas and inspiration start to arise. Be open to the possibility that inspiration for your pet photography can develop as you shoot.

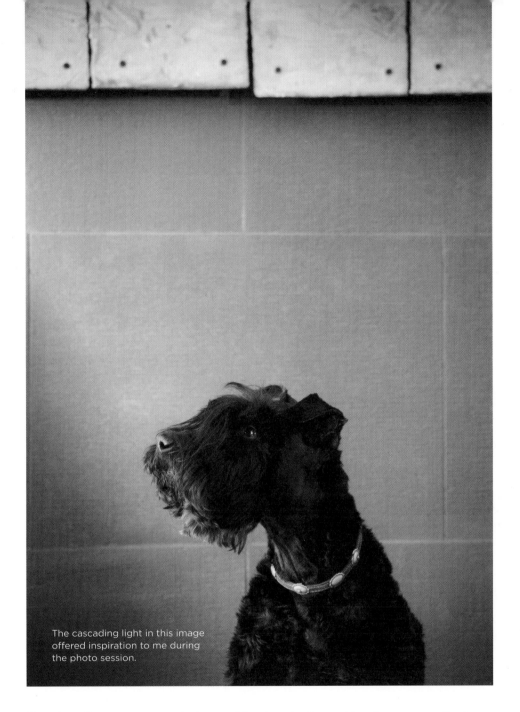

The cascading light in this image offered inspiration to me during the photo session.

Pay attention as you are photographing to what's working for you creatively and what could use a change. You can even pull together small elements that you feel are strong in your image and use them as a platform to build on. For example, maybe you notice a beam of light on one side of the dog against the wall, and as you continue to photograph, you create a series of images in which the light falls directly on the dog in a dramatic way. This is an example of something you may not have been able to plan before the session but that provided you with inspiration in the moment.

Looking at other photographers' images can be really helpful in generating ideas as you start to draw elements from multiple artists (pet photographers or any other kinds of photographers and artists, for that matter) to inspire you to create your own unique work.

Discovering Your Style

I like to use the phrase, "discovering your style," with regard to pet photography, as opposed to "creating your style," because I don't think your authentic style as an artist can be forced or even generated on a conscious level. There are many pet photographers in the world—certainly many more than there were when I started in the genre many years ago. While some photographers may have a similar style to yours, no single pet photographer is exactly the same. You are the only one who can do what you do.

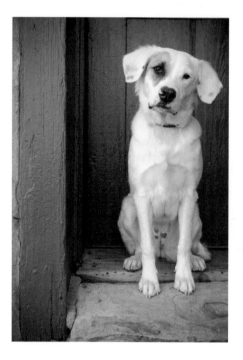

If you are just beginning in pet photography, try not to rush into defining your style too early. Give yourself plenty of room to explore and experiment without limiting yourself to a certain approach or aesthetic. As you continue photographing pets and gaining experience, it may benefit you to start to get a sense of your creative style. To do this, I suggest that you pay close attention to your tendencies and develop a sense of your work overall. Create lots of portraits of pets— your pets, your friends' pets, your family's pets, shelter animals—all of them. After you have built up a collection of images, cull your favorites, perhaps creating a Lightroom collection or a folder on your computer.

Once you've culled your images, you can examine what you seem to be drawn to as a pet photographer. You might notice an element that tends to recur in your photographs on a fairly consistent level, for example, bold color versus soft color, high contrast versus soft light, details versus abstraction, profiles versus full body, or stopping action versus highlighting movement. You may notice after you've had the chance to photograph pets in different scenarios that your preferred approach is one of a documentarian rather than playing an active role in posed portraits.

If you have access to a professional photographer whose work you respect, have that photographer review your images and provide constructive feedback, pulling the strongest images out of the group to make a smaller collection of really great shots. If possible, have that photographer share with you what they believe to be your strengths. Having someone else critique your images can be a very helpful process, because it is easy to become emotionally attached to your work and lose impartiality when judging them. This attachment can hold you back from being objective about the strength of your work, and ultimately, from improving. The "stepping back" exercise can provide tremendous insight on the types of images you tend to create and what type of aesthetic you are drawn to. This is how you start to recognize your style and to develop it.

Build on what you love and on what lights a spark in you as you create pet portraits. Your style can and will evolve over time, just as you do. I've noticed that my tendency to create simple, clean images has remained fairly consistent throughout my years as a pet photographer, but my style and techniques have evolved.

If you've already been working as a pet photographer and are looking for a "reset," consider putting together a portfolio; creating or updating a website is an excellent way to reconnect creatively. This process is also a great opportunity to consider what you feel might be missing from your work or a new approach you'd like to explore.

POINT OF VIEW

Your creative perspective or point of view as you're making pet portraits can vary drastically, has no limitations, and is a direct representation of your style as a pet photographer. Your perspective is unique to you.

My point of view has evolved slightly over time, but for the most part I tend to create contemporary, yet timeless, colorful and simple images of pets and their people. I consider myself a portrait photographer versus a documentary photographer, and in the last few years I have been more drawn to capturing the connection between people and their pets than I have in the past. Occasionally, I will create images with humorous qualities, take on a more documentary approach, or even create a dramatic feel to my work, but for the most part my point of view is to create images that evoke joy.

HUMOROUS IMAGES of pets can be really fun to create. Perhaps these images involve silly props, or wide-angle lenses to exaggerate or distort physical features. Or maybe you use Photoshop to combine illustrations with your photographs. You might choose to create studio sets with pets and add humor or capture a pet in unusual settings or situations.

DRAMATIC IMAGES can be more serious in nature. If you like to photograph in this way, you might enjoy more dramatic lighting, maybe even studio lighting. Black-and-white photographs of pets can often convey a sense of drama and emotion. The drama, whether created with light, location, or in postproduction, will directly impact the emotional response of the viewer.

FINE ART IMAGES of pets might involve a specific style of lighting or a unique treatment in Photoshop or other postproduction technique (via printing or processing) that results in a final product.

CONTEMPORARY OR MODERN PET PORTRAITURE will evolve over time, but this style currently involves creating portraits that have a lifestyle element to them. They are often created in modern-designed spaces, and usually feel fresh and clean in style.

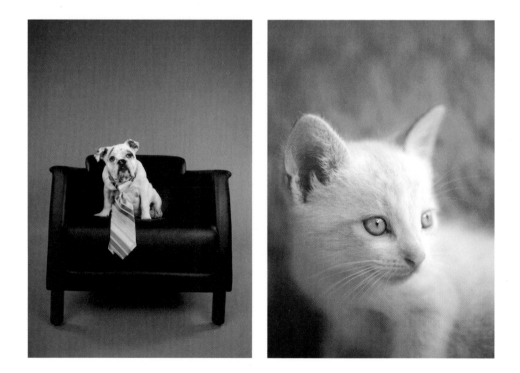

DOCUMENTARY-STYLE IMAGES, wherein you act as a "fly on the wall" creatively recording action and activity, can be quite beautiful. Moments captured without your presence being known to the pets can produce very interesting results. With a documentary approach, you can also shoot from the hip, literally. Many people prefer this way of working, and you may love the experience of photographing pets in this way. While the majority of this book does not focus on the documentary style, it is a completely valid way to create pet portraits.

HAVING FUN

Pet photography can be hard work, but it is integral to your creativity that you are having fun on some level when you are creating. Sure, it can become overwhelming to consider all that is involved with regard to composition, color, and many other factors in a way that brings all the elements together in a final product. At the same time, this challenge can be very rewarding.

The more awareness-based practice you have, the more quickly you'll be able to make compositional decisions, and in time, you will develop your own creative style. Try your best to learn from what you've created, build on it, and enjoy the process.

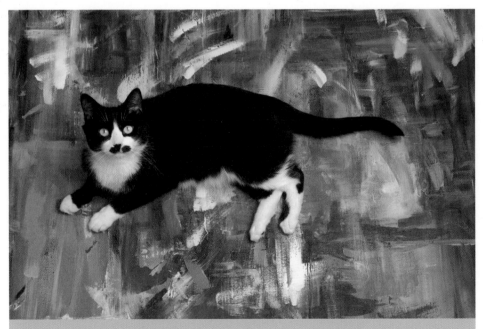

One of my acrylic paintings made for a fun, colorful background for this beautiful tuxedo cat.

Working on location requires responding to many different kinds of lighting. In this image, Kiya is being lit from the sunshine above, and I noticed that I could create a dramatic feel with a little lens flare from light coming directly into my camera.

CHAPTER 5: THE LIGHT

Good lighting is key to the success of your pet photographs. While on location, I look for light that draws my attention, and while I'm always looking for the most pleasing location and lighting combination, I will often choose nice light over a perfect location.

While in many ways lighting techniques can be applied to all genres of photography, there are specific issues to consider when lighting for pet photography. Your lighting choices will not only directly impact the emotional and aesthetic quality of your images, but also the overall experience for you and the pets and people in front of your lens. There is a lot of value in becoming aware of the many options for lighting so that you can make conscious decisions for your individual pet portrait experiences.

In this chapter, I'll address my favorite kinds of light and my insights on what works for me. I'll share how I approach a variety of lighting solutions during my pet portrait sessions. Remember that this is one perspective, and I encourage you to explore what resonates for you, both on a technical and aesthetic level.

Light Quality

The quality of light in your pet portraits can affect your images on many levels. Light can create a sense of drama or mood in an image, accentuate details in an environment, or highlight a pet's physical features. While working on location, you can incorporate studio strobes or small flash units, use available light, or choose to modify the available light. As you determine which light is best, you will need to take many factors into account, including your goals for the feeling of the image, the time available to you, the animal's energy level, and how much you're looking to accomplish during the shoot.

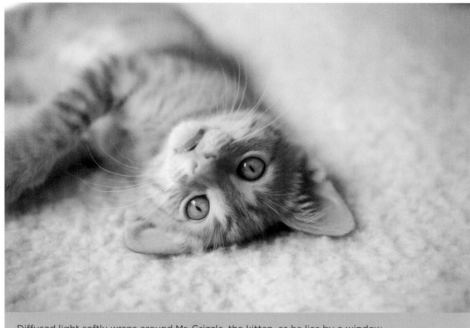
Diffused light softly wraps around Mr. Grizzle, the kitten, as he lies by a window.

DIFFUSED LIGHT

Diffused light, whether occurring naturally or created from studio or small strobes, can be a very effective and beautiful light for pet portraits.

MY FAVORITE QUALITY OF LIGHT

Diffused light is my favorite quality of light for pet portraits, and is the type of light I most often use. Diffused light occurs when light is passed through a translucent material of some kind or when the light is reflected off a surface and bounced onto the subject.

I am drawn to photographing with diffused light because of its softness. The shadows from diffused light are soft, and the light wraps around the subjects as I photograph them. This type of light is flattering to both people and animals and is appealing to the eye. Working with diffused light helps me develop the fresh, clean aesthetic I'm after.

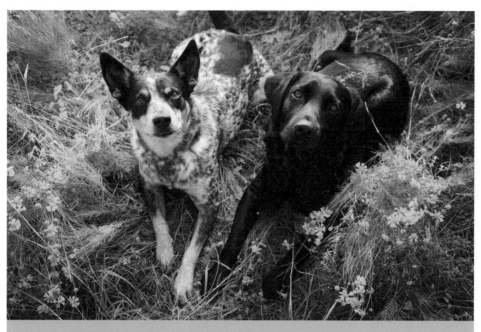

The light falling on these pups was initially very harsh and direct. I chose to create an area of soft, diffused light with a diffusion panel.

Photographing in a large area of diffused light is ideal for pet portraits. In this scenario, I have the freedom to allow the animals to move around without concern that they will step out of the light. This freedom allows me to work faster and, ultimately, photograph more. When the animals have a little "wiggle room," I can focus on capturing sweet expressions and play with posing and composition. This flexibility makes a big difference in both my experience and the pet's experience of the session, and allows both of us to maintain our energy during the shoot.

FINDING DIFFUSED LIGHT

There are plenty of places to find naturally occurring diffused light sources for your pet portraits. Keep in mind that even when light is diffused, there is still a main light source, and you'll want to have your pets and people illuminated by this source for the best results.

OVERCAST DAYS when the sun is behind the clouds, yet still producing a small level of brightness, are a great source of naturally diffused light. Although darker, stormy days offer diffused light, they do not contain quite enough illumination to create my favorite kind of light quality. On an extremely overcast day, the lighting may feel flat and dimensionless.

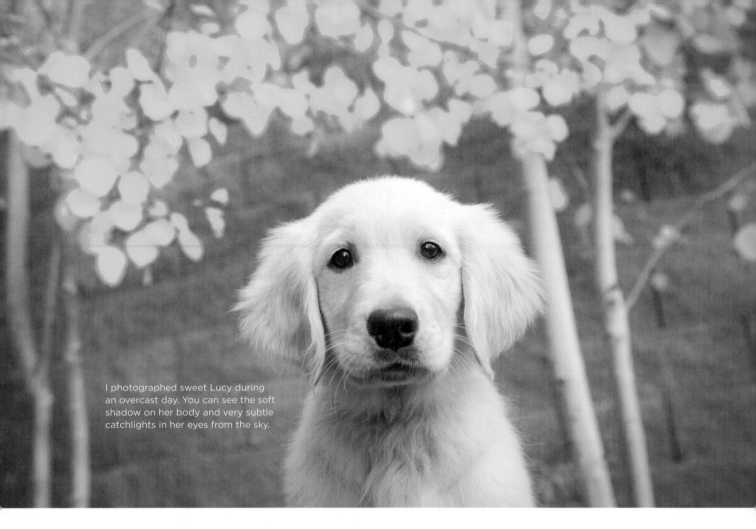

I photographed sweet Lucy during an overcast day. You can see the soft shadow on her body and very subtle catchlights in her eyes from the sky.

Remember, on fairly bright overcast days, even if you can't actually see the sun, you can still take advantage of the brightness of the sky. For example, you will likely want to have the pet facing this light source so you get light on their face, or maybe even a small catchlight in their eyes.

LIGHT BOUNCING OFF INTERIOR SURFACES, such as walls, doors, furniture, a tabletop, or even bedding, can be gorgeous. Light that enters through a window and bounces off the floor can softly illuminate a dog or cat and the surrounding space. This kind of diffused light quality can create an area large enough for you to photograph a pet with the freedom and flexibility I mentioned above. With the light being diffused in many places, you'll be able to allow the pet to move around a little and still be in the main source of soft light.

The soft, diffused light is bouncing off an exterior patio and then bouncing around the room off the light-toned walls, ceiling, and floor.

I love photographing my pets in the afternoon in the front of my home, because the light streams in through the window and bounces off the floor and walls and creates beautiful light in the entire room. The light wraps around my cats and dogs so nicely in that space. I wish I could have access to this type of light in every space, for every pet portrait session!

OPEN SHADE can be a wonderful way to take advantage of diffused light as it reflects off any brightly lit exterior area. As long as your pet subject is positioned right along the edge of the shaded area before they are directly hit by the sun's light, you'll see that they are beautifully illuminated by diffused light bouncing off the grass, adjacent buildings, patio, or pavement in front of them. The trick with this kind of light is that the pet has to be in the shade but facing the direction of the light source (not necessarily the sun).

HOW TO CREATE DIFFUSED LIGHT WITH NATURAL OR AMBIENT LIGHT
Sometimes there might be a small amount of diffused light in a space but not quite enough to keep my shutter speed where I want it or my ISO low enough for my preferences. In these cases, I'll often use a large piece of white foam core or a 4x6-foot panel to reflect available light onto the subject to increase the intensity of the light.

The sleeping pup in this image is being illuminated by the window light, and also from the light bouncing off the floor, walls, and a large piece of white foam core. This is a high-contrast scene, but the light on the puppy is still very soft and diffused.

Foam core is awesome, because it's not very expensive and it's pretty sturdy. I buy the biggest piece that will fit in my car and always pack it for each session in case I need it. The larger the piece of foam core I use, the more surface area will reflect light onto the animal and scene. Keep in mind that foam core is very light, and if you're using it outdoors it can fly away and scare animals (and people, for that matter). You'll either want to have an assistant hold onto the foam core, or secure it to a ladder or other support with some clamps or tape.

Multiuse panels are a great option for reflecting and creating diffused light, because I can bounce the light off the white side or use a panel with diffusion material to let the light pass through and soften before it falls onto the pet.

Sometimes windows have a lot of bright, direct sunlight streaming through them, and the light falling onto my subject will be harsher than I want. In such circumstances, I'll either attach my 6' x 6' silk or my large piece of Ripstop nylon to the windowsill or door.

Diffusion material will always decrease the intensity of the light on some level, and this loss of light may become an issue for my shutter speed and ISO require-ments. The amount of light I "lose" as a result of the diffusion material, whether the light is traveling through a Lastolite panel, a Ripstop nylon piece, or a

Matthew's silk, will vary based on the thickness of the material. If I feel that I am losing a lot of light, I may decide to bounce additional light back into the scene with a foam core or other reflector. I will also want to be sure my subject is as close to the light as possible, while keeping my background elements in mind.

Remember that all animals will respond differently to large pieces of material, foam core, diffusion panels, and reflectors, and you'll want to remain mindful of their reaction to these items as you move forward with the shoot. Keep them secured as much as possible. You can create the most beautifully lit scene in the world, but it won't do you a lot of good if the dog, cat, or horse is terrified.

CREATING DIFFUSED LIGHT WITH STUDIO AND SMALL STROBE LIGHTS

If I am lighting my pet portraits with a studio strobe, I almost always diffuse the light in some way. I soften the light quality by either bouncing the light off a neutral-colored surface (wall, door, floor, or ceiling) or passing it through a diffusion material just like I would with harsh window light. I typically use softboxes or silks when I am working with large strobes. I like to use large softboxes, because the larger size helps create an even softer, broader light source that can light the pet and sometimes the environment around them simultaneously.

The light on these puppies was first diffused with a panel, and additional light was added with a small speedlite unit attached to a small softbox (Ezybox). Without this modification to the light, the puppies would have been lit by very direct, harsh light.

Bouncing small speedlites off ceilings and walls is a quick and easy way to diffuse light from this type of light source. This action spreads the light before it falls onto the pet and effectively turns a small light source into a larger one. Small softboxes that can attach to my speedlite also work really well to soften the light. In general, the softboxes used for a single speedlight are smaller, and the light produced is not quite as diffused as it is with large softboxes used on larger strobes. I love the Lastolite Joe McNally Ezybox setup for using softboxes on small speedlights.

Both small and large strobes effectively work the same way and will require some kind of light modification to diffuse the light, if that is your desire.

Diffused, soft light is not the only way to light pet portraits, but it is my preferred look. You get to decide which quality of light appeals to you and helps you communicate the feeling or message of your photographs.

FOCUSED OR DIRECTIONAL LIGHT

Directional, more concentrated light is very different from diffused, broad light. A directional "beam" of light streaking across a wall or a floor from the sun shining through a window, or a gridded strobe light creating a focused area of light in the center of a room, can be very dramatic and can create a different mood than soft, broad light.

When I notice this kind of light occurring naturally as I enter a home, or as I see the light shifting at any location during my session, I will absolutely make an attempt to position the subject so that the light beautifully falls onto them or frames them nicely. The high contrast between light and shadow can create a very dynamic effect or can generally support the mood of your pet portraits.

Working with a narrower, directional light for pet portraits can be logistically challenging and will require very specific placement of the pet within the light. As an example, if you place a dog's face in a beam of light coming in through a window, you may be able to see bright catchlights in her eyes and really highlight her fur. If the beam of light is narrow and she takes a step to the side or moves even slightly in one direction or the other, she may be in the shadow and you've lost your photograph. These are the kinds of photos I tend to try to capture when I notice the opportunity, but because of the narrow "window," I do not find value in spending a lot of time on them during my sessions.

The directional light coming through the window beautifully lit Kiya's face and brought a sparkle to both eyes in the image on the left. She moved slightly for the next frame and her face was out of the patch of light.

You can use your strobe lights, large or small, to create a more dramatic feel with focused or directional light. (Note that directional, focused light can either have a soft, diffused quality or appear more direct and harsh.) Setting up lights for this effect can work really well if you've got a very specific idea in mind for creating a more dramatically lit portrait. Be sure to give yourself extra time and patience for these kinds of images. You're not photographing still life!

Extremely spot-focused light isn't very conducive to action shots, because it can be very difficult to align the desired action with a small amount of light. Having said that, this approach isn't impossible and has a lot of potential for a really amazing look. By all means, feel free to give this kind of special lighting look a try, and if you do so be aware of the inherent challenges that come with this scenario.

If I am setting up a directional or more focused light, I will be sure to take lots of test shots before the pet is in the scene to give myself the opportunity to tweak the light as much as I need to before asking the pet to cooperate.

For this image, I used a beauty dish covered with diffusion material. The light was positioned from above to create more of a spotlit, directional effect.

Directional light can really support your ability to tell a story and add dimension to your photographs. While there can be a lot to manage during the creation of pet portraits, it is integral to pay attention to what is happening with the light, either naturally occurring light or the light you create using strobes. If the light does have a naturally occurring direction (rather than being bounced around the room more evenly), I usually try to have the pet gaze in the direction of the main light source. This will help illuminate their eyes and visually makes sense to the viewer .

As you look at my portfolio, you may notice that I do not tend to photograph many images with dramatic focused or directional light. It is not my "go-to," for a couple reasons. One is that it's just not what I'm aesthetically drawn to for pet portraits. The other is that I don't usually want to take the time and energy away from the pet to set up a scenario with very focused light. It takes more energy from the pet to have them in a specific location, and while the results may be gorgeous, it can limit the variety for the overall shoot. If my goal were one or two final images, I may choose to commit to this approach.

I encourage you to find out if working in more dramatic and focused light speaks to you for your pet portraits. Experiment looking for naturally occurring dramatic lighting scenarios, both indoor and out. In addition, think about setting up some of your own lighting scenarios that include both a very directionally lit pet portrait and a portrait that incorporates a very focused, narrow light source.

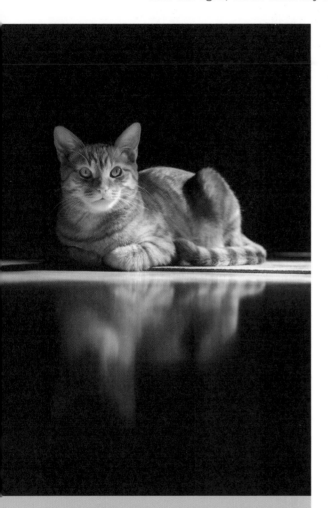

I noticed the kitten bathing in this pool of light and took advantage of the opportunity to capture a more dramatically lit image with some nice reflection. Creating this opportunity would have been a bit more difficult than responding to it.

DAPPLED LIGHTING

I often find myself in a dappled lighting situation when I am photographing pets. This type of lighting most often occurs outdoors but can appear indoors as well. For example, I might photograph a dog in a backyard and find that the light streaming through the trees and plants casts really bright spots of light on one part of the dog's face and not on others. In another scenario, I might be photographing a horse in a grove of trees and find that the horse's face is in full sun or open shade but that spots of light are falling on the horse's body.

The highlights and shadows of dappled lighting can, in effect, create dramatic contrast, but because it's usually happening in very small areas, it can be difficult to navigate both technically and aesthetically. You may find yourself photographing your cat indoors by the window in beautiful full sun that is traveling through the trees outside and causing spots to fall onto the floor and your cat's face and body. This can be gorgeous light, but if you find yourself struggling, know that you're not alone.

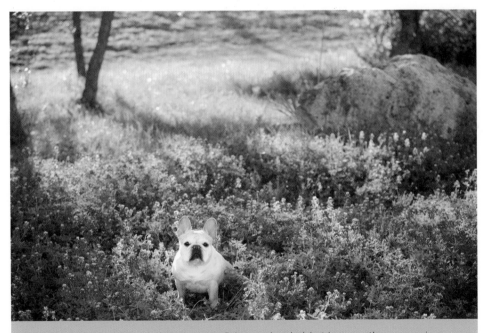

The light streaming through the trees onto Brie was dappled, but because the sun was in a fairly low position, I was able to have Brie lit from behind and not greatly affected by the spotty light.

The dance between the highlights and shadows caused by dappled lighting often creates a distraction. Exposing for dappled light can be tricky, because the contrast can be too high to capture both the highlights and the shadows properly. Even if you are able to expose accurately, the brightest areas demand the viewer's attention.

So, what do you do about dappled light? I recommend avoiding it when possible, but this isn't always the best option. Sometimes you can find the perfect spot to place a pet within dappled lighting, it works beautifully, and all you need is a slight modification in postproduction. Other times you'll struggle to the point of missing the shot (and other opportunities). If trees are causing the dappled effect, the wind might blow, moving the trees around and causing the highlights and shadows to do the same. In this scenario, you may discover that you're spending a lot of time chasing the light, using up valuable pet energy in the process.

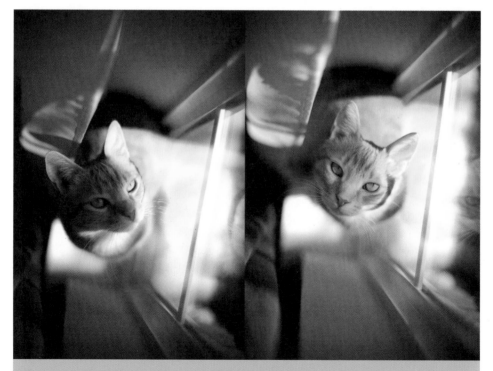

The trees outside the room were moving in the breeze, causing the dappled light to move position on the cat's face. I had to be patient and wait for the trees to fall in the right position so that the cat's full face was in the light—and simultaneously direct the cat's attention toward this small area of light.

If the best location for your pet portraits happens to involve dappled lighting, try not to worry! See if there is an opportunity to diffuse the dappled light with a silk or other diffusion material to soften the highlights and decrease the contrast of the light. You also might be able to move or tie up a tree branch, plant, or whatever is causing the dappled lighting effect to fix or help alleviate the issue. Whenever I find myself in a dappled lighting situation, I see what I can move, diffuse the light if possible, and then if nothing works and I'm committed to capturing some images in that exact location, I prioritize the pet's face. If I can get the pet's face either consistently lit or have the highlights fall just on the eyes (for dramatic effect), I will do so.

BACKLIGHT

Light falling from behind the pet you're photographing can create an exquisite and unique look. What is most beautiful about backlight is the rim of light that creates an outline around the animal. This kind of light can feel very warm to the senses and can work quite nicely for pet photography.

This image is being lit from the sunlight behind the dog, and the sun traveling directly into my lens caused some flare, which I really liked. I had to add contrast to this image in postproduction.

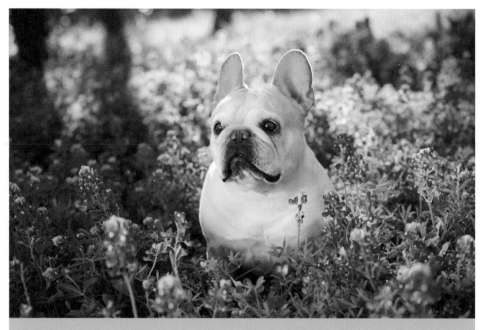

This image of Brie in the flowers was backlit, resulting in the nice rim light. I also added a pop of light to her with a reflector.

To capture backlit images with the sun outdoors, you'll want to create images when the sun is low in the sky (either early in the morning or late in the day), as it will be easier to capture the sunlight falling directly behind your pet subject at these times, as opposed to when the sun is directly overhead. Because the sun will be coming directly toward the lens, the possibility of camera flare does increase. Lens flare isn't necessary bad, as it can be really pretty and create variety for your pet images, but you may decide that you don't care for it and choose to eliminate it by blocking the light that falls into the lens.

One of the challenges of photographing backlit pet portraits is that because the light is falling directly into the lens, the light on the pets can look "muddy" in terms of contrast and color. Adjusting the contrast levels in postproduction can help to resolve this issue. Often I'll try to block the light that streams directly into my lens with a black card and add light back into the subject with a reflector, in effect decreasing the contrast of the scene and helping to create a more defined subject with the light I'm adding. If you're working alone and want to play with backlight using fill light, place a reflector on the ground in front of you or lean it up against a stepstool or ladder to help get the proper angle.

You can also choose to include a fill flash to add a bit more light to your pet subject while the sun is doing the heavy lifting of the backlight. I find that if I can

provide a small amount of fill light, I'm able to improve the muddiness in an image. If I use too much fill flash, it overpowers the effect of the backlight, and I miss out on the objective of including the backlighting altogether. Because backlit (at least naturally occurring) opportunities typically occur during the morning or late in the day, the light changes quickly. This light shift requires me to frequently adjust my position, global exposure, flash power, and the position of the pet so that they continue to be lit by the sun from behind and lit gently from the front.

Because backlight is a form of focused and directional light, photographing backlit stationary portraits of pets requires the pets to remain in a specific location, and this can take some extra patience and persistence. Therefore, backlighting is not necessarily my go-to choice for lighting. Having said that, if I find myself on location early in the morning or late in the day, I will absolutely take advantage of this kind of light.

Backlight can also work beautifully with studio lighting (small and large strobes) for pet portraits. The big advantage to working with studio strobes versus using the sun for backlight is that you can be consistent with the location of the light and not have to worry about that variable. You do still need to consider the pet's physical location a bit more than with a broader light source.

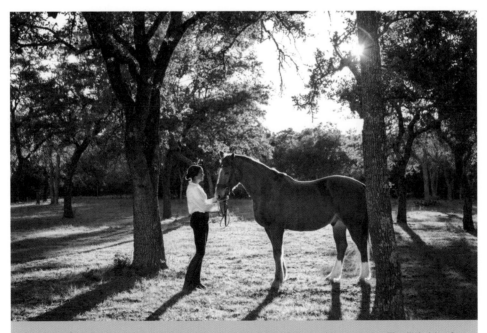

The light at the end of the day can help you make beautifully backlit portraits. The little bit of lens flare in this image helps create mood.

Choosing the "Right" Light

The process of lighting your pet photography can really be a game of compromise and constant assessment. Some of the questions I tend to ask myself include:

- What type of light currently exists naturally in the location?

- Do I like the quality of light?

- Is the quantity of light enough for the settings I want to use on my camera, such as depth of field and shutter speed?

- Do I want to change something about the natural light? Do I need to diffuse it, add to it, or modify it in some way to change the quality or quantity?

- Does my vision for the portraits include studio lighting and the effects I can achieve from setting up lights?

- Do I have the time and pet energy to set something up now? This might change depending on whether I've just started photographing or if I am nearing the end of the session.

- Is the animal comfortable with studio lighting?

- Is the light quality in the image supporting the feeling I'd like the viewer to experience, or do I need to prioritize something else based on my situation? (Maybe the dog is nervous, the horse is jumpy, the cat has settled in one particular spot on the couch, the sun is going down, and so on.)

- Am I in a situation where I need to make the best out of a tough lighting scenario?

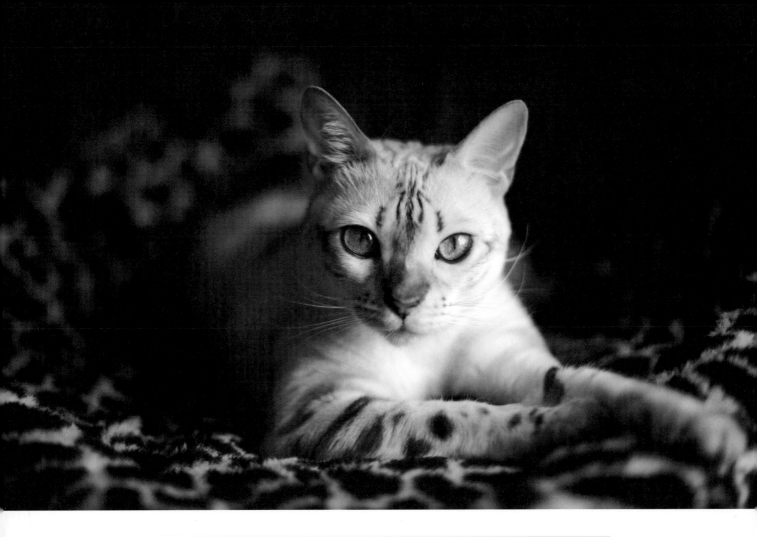

Troubleshooting Low Light

Sometimes you may find that you like the quality of the natural light in your location, but there isn't quite *enough* of it to keep your shutter speed where you want it or keep your ISO low enough to maintain the desired quality based on your camera's capabilities. Let's go over your options.

I always start with a reasonable ISO (as discussed in Chapter 3, "Exposure for Pets: Getting It Right In-camera") and consider my priorities as I set up my camera for exposing. If I am determined to work with natural light for the portrait, I'll try to see if I can bring more light into the scene before I increase my ISO to a really high number. This isn't always possible, but sometimes if I slow down and really look around, there are elements I can change.

When I am working indoors and find the quantity of light lacking, I open all the doors, windows, curtains, and blinds in that space and see if I can increase the ambient, general light of the room. Sometimes this can gain me an entire stop or more of light. Once a window or door is open, I may notice a beam of light falling onto the floor or a nearby wall. I will then make efforts to take advantage of that light by placing a reflector on the floor or leaning it on the wall to bounce that additional light into my scene and onto the pet I am photographing.

If I've opened the windows and doors and raised the blinds, I'll move anything in the room that is blocking the light from falling onto the animal. If I do all of this and my exposure still isn't satisfactory, I will increase my ISO as needed. If I need to increase my ISO over 1600, I may decide either to light the scene with strobes (small or large) or move to a different location with more natural light. If the photographs have to be created in that space for any reason, I may bump my ISO to 3200 if I feel that I can get an accurate exposure.

If I am photographing an outdoor scene in natural light that is low, my options are a little more limited when it comes to increasing the light. I will pay the most attention to the direction of the light and make sure I have the pet positioned so that the most light is falling onto him or her. I will set my ISO high to begin with and make sure I am not sacrificing my shutter speed. I will sometimes use the silver side of the reflector, which has more contrast than the white side, to bounce light onto the pet. Silver reflectors in low light or overcast days can work surprisingly well to increase exposure and add a subtle pop of light.

I've learned to acknowledge the reality that there either *is* or *isn't* enough light to work with, based on my needs. If there isn't enough light, I'll need to harness it, bringing light physically to the scene or adjusting my settings. Compromise is often necessary when photographing pets on location, and it's important to be realistic and make a quick decision about how you're going to proceed.

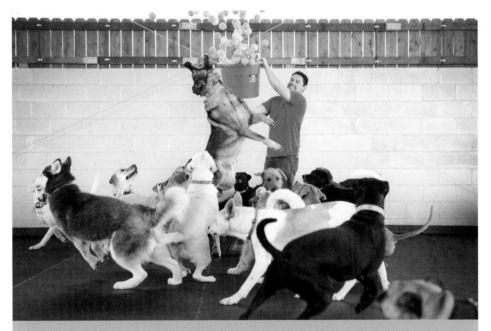

I wanted to stop the action in this image, and to do that I knew I needed a quick shutter speed. The ambient light was not quite bright enough for both a low ISO and a high shutter speed, so I needed to compromise and set my ISO to 2000. Settings: 1/1000 second, f/3.2, ISO 2000

Natural, Available Light Versus Studio Lighting

My pet portraits are created with both natural light and studio light. You don't have to necessarily choose between the two for all of your portraits, and having a working knowledge of the pros and cons of both solutions will help you make decisions based on your specific situation.

NATURAL LIGHT PROS AND CONS

Photographing in natural light can allow me flexibility when I am photographing pets. What I mean by flexibility is that I can move around within a location with a pet more freely, thus experimenting with multiple backgrounds and scenes during a single shoot. While I am required to adjust my exposure frequently as I move about in multiple spaces filled with varying degrees of natural light, the amount of time required for these adjustments is less than with studio lighting. When working in naturally lit environments, I am not dealing with much equipment beyond my camera, my attention-getters, and perhaps some reflectors or diffusion materials.

Natural light has a quality that is very difficult to replicate with studio strobes and has a very specific feel to it. It can be exquisite. Many painters attempt to replicate the quality of natural light in their artwork, and we photographers are drawn to the same beautiful characteristics as we create our photographs.

One of the biggest challenges of working with natural light is that there often just isn't enough of it when working indoors. While low light may not be a problem when photographing a person who can sit very still, for example, an animal tends to move a lot and thus demands specific camera settings. Photographing multiple animals in a naturally lit scene can require even more light, which can often become challenging. Another challenge of natural light pet portraits is that natural light is weather-dependent and can change often and quickly. You may have a portrait session scheduled, and it ends up being dark and rainy, dramatically impacting what you are able to accomplish. If you're photographing outdoors on a partly cloudy day with wind, the sun will go in and out of cloud cover, which can add exposure challenges. You might love the light at the end of the day just before the sun sets, but that light doesn't last very long.

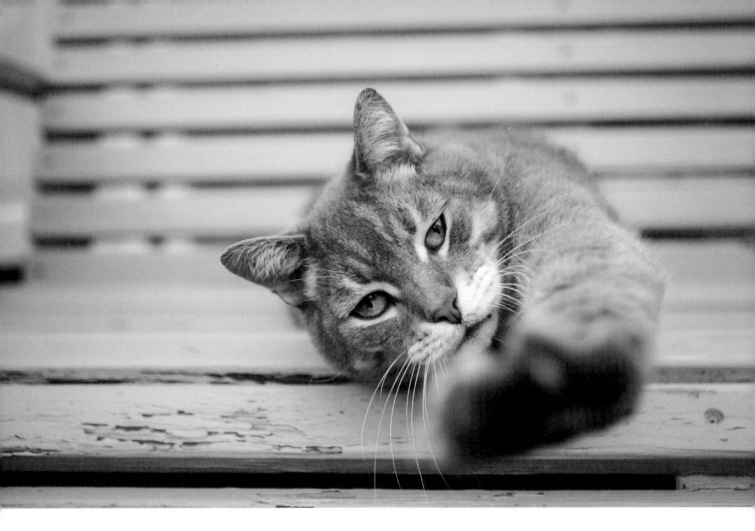

In spite of these potential challenges, I love photographing in natural light and use it for my portraits whenever possible. I would definitely say that natural light is my first choice for pet portraits on location. And as mentioned before, photographing in natural light can be less disruptive for some pets than working with studio lighting.

STUDIO LIGHT PROS AND CONS

Studio light can be an excellent solution for times when there isn't enough natural light for my needs or if I am aiming for a specific look and feel for my images. Sometimes I fall in love with a location, but there isn't enough natural light, no matter how many windows and doors I open or reflectors I use to illuminate my subject. In these situations, I am really thankful to have the option of using studio lights.

Studio lighting is consistent, so once I have the lighting how I want it, I can photograph as much as I want without having to worry about the light changing. Studio lights can possess the power to illuminate dark spaces and expose tremendous detail, which may be something I want. Because of the consistency of studio light, a lot of creative control can be gained in terms of shaping and adjusting the quality of light to my needs. I can move the lights throughout a given location, thus opening up more options and, ultimately, allowing me to create more variety for my clients.

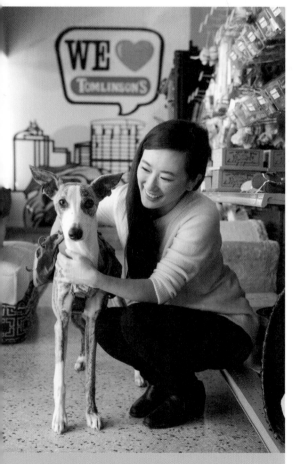

This light was created with large strobes placed outside the store window and through diffusion material, with reflectors filling some of the shadows.

One way I love to light an interior space is to light from the outside inward. This setup will work if I am photographing indoors where there are large windows or sliding doors that allow me to flood light through them. I will set up a couple large studio strobes with umbrellas on stands outside of the window or door, diffuse the light through a silk or nylon material into the interior space, and then bounce that light off reflector cards inside. If the window has sheer curtains or blinds, I may directly diffuse the light through those instead of my material, simply because it's a faster setup. Setting up the lighting in this way can create a very natural feel for the light and can help increase the general brightness of the room and allow me to photograph with smaller apertures than if I were solely relying on natural ambient light. This situation also gives me more space to move around indoors, because the lighting equipment isn't in my way.

Other times I might bounce light from a strobe light onto a wall or ceiling or simply feather it so that the softest edge of light falls onto my pet subject. There are so many options for working with strobe lights and an endless number of modifiers and ways to use them. Studio lighting can be really fun and creative.

The soft quality of light in this image was created with a small flash unit bounced off a white ceiling. This was the quickest solution to the lack of light in the room.

I will emphasize, however, that photographing with strobes (either large or small) takes longer to set up and test, and as a result, makes me feel more locked into a specific area on location. I may find myself passing on an opportunity to set up strobes during a session, because I don't feel the dog or cat (or pet parent) has enough energy left to wait for my setup time. If I know I am going to light something with studio strobes, I will usually prioritize that before the natural light images as a direct response to the pet's energy conservation.

Having pointed out the challenges of studio lighting with regard to pet portraits, it's important to share with you that I frequently use strobes, and they've allowed for some creativity that just isn't possible with natural light. However, I do not believe that owning studio strobes is necessary for creating stunning pet portraits. There are pros and cons to using both types of light, and having a working knowledge of how to implement both in your pet photography can only serve as an asset.

I'd love to have all the time in the world to create and tweak elaborate lighting set ups while on location, and then position a pet in the exact spot necessary to create perfection. I would love to have this freedom but realize that situations are rarely ideal. I have learned over time that pet photography can involve a lot of juggling and on-the-spot decisions, and it's my responsibility to keep as many balls in the air as possible. This has taken—and continues to take—a lot of practice.

I encourage you to remain open to the many possibilities for lighting your pet portraits and explore how light quality impacts not only your images, but also your experience of creating pet portraits.

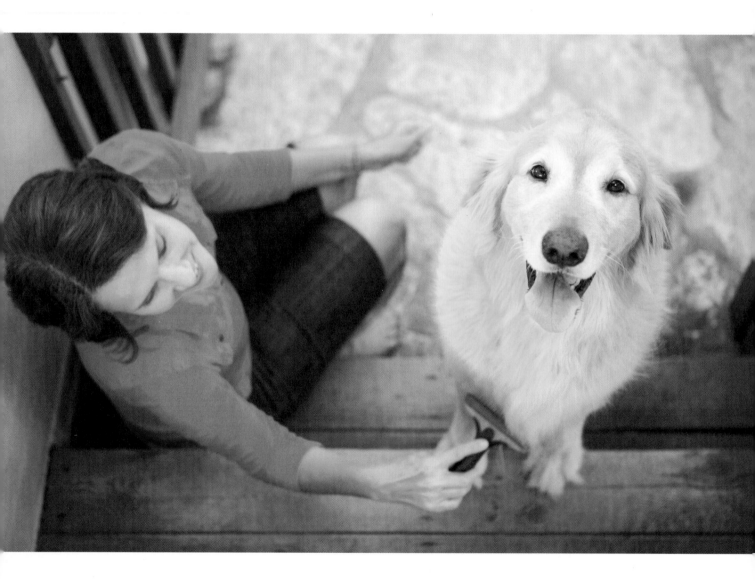

CHAPTER 6: THE PHOTO SHOOT

The next step in the process of pet photography is to take a look at how to manage the overall experience of the photo shoot from beginning to end. While it is important to have specific approaches for exposure, composition, lighting, and creative choices, putting all of these elements together in a photo shoot is a whole different story. Photo shoots with pets can be a little over-whelming, as there are so many variables and elements to take into account. Not to worry, though! We've got this.

Preparing for the Shoot

There are many benefits to preparing for your pet photo shoot, specifically, when you are photographing other people's pets. Making sure that you bring the appropriate equipment, understanding the expectations of the person and animals you'll be interacting with, scouting, and gathering information on your subjects are all part of the process. Because we are talking about photograph-ing animals (who often do their own thing regardless of our best efforts), our preparation may seem to get thrown out the window during the session. But I've learned that both mental and physical preparation greatly improve the final results.

GATHERING INFORMATION

When someone contacts me to photograph their pets, I ask a series of questions to try to get a sense of the pet, the pet parent, and the location of the shoot. This information is extremely valuable and absolutely helps with the ultimate success of the photo shoot and the experience overall.

GETTING TO KNOW THE PET

Some of my questions are answered in an initial phone conversation or email, and others are answered in person before the shoot. People tend to like talking about their animals, and it's important to listen to what they have to say. You may generate ideas from what they tell you or discover something integral to the success of your shoot.

For dog and cat portraits, I may ask a combination of the following questions leading up to the photo shoot.

- What is your dog's or cat's name, sex, breed, age, and general size?

- What color is your dog or cat?

- What physical attribute do you love most about him or her?

- What is your dog's or cat's general demeanor?

- Does your dog or cat know any commands like sit, stay, or down?

- Does your dog or cat like treats, and is he or she able to have treats?

- Are there any specific words that get his or her attention?

- Do you happen to know if your dog or cat is camera- or flash-sensitive?

- Is your dog or cat comfortable with strangers? Have you ever had any issues with him or her biting strangers?

- Does your pet need to be on-leash outdoors?

- Would you like to be photographed with your pet?

- Do you have any rules about your dog or cat spending time on furniture in your home?

- What is most important for me to capture about your dog or cat in these photographs?

SCOUTING AND PLANNING

I typically photograph my pet portraits in and around the pet's home, but occasionally, I photograph at other locations. I used to show up to a location on the day of a photo shoot, look around for ten minutes or so, and then start the shoot, but I discovered that this approach can be limiting in many ways. There is already enough to juggle during a pet portrait session that adding the pressure of assessing a location on the spot isn't ideal. I really care about providing my clients (and myself, to be honest) amazing photographs and a positive experience. I find there to be tremendous value in scouting a location before a photo shoot, for multiple reasons.

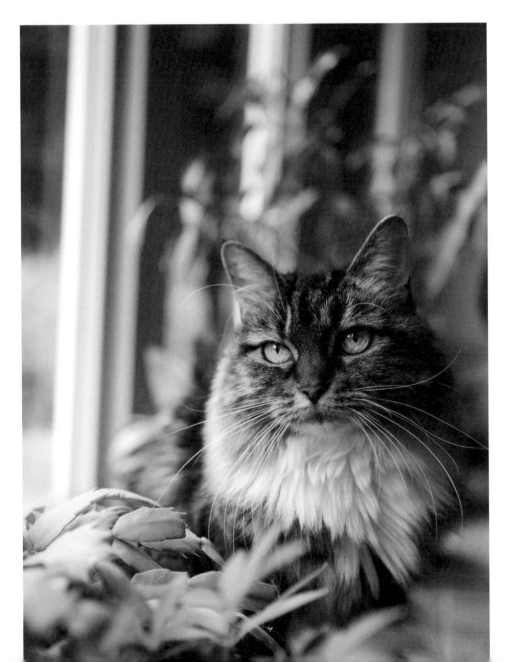

Scouting offers me the chance to build rapport and start to develop a relationship with my client. I am a "people person" and really value relationships. When my client feels comfortable with me, they will be more comfortable during the shoot, and the photographs will be stronger (if they are included in them). If they're not being photographed, the pet parent will just be more relaxed, which helps everyone during the session. When I've had a chance to connect with pet parents before the shoot, I am also more comfortable and feel confident that the session is more enjoyable for everyone as a result.

Scouting also enables me to connect physically with the pet before the photo shoot day. I can start to get personal experience with their demeanor and let them check me out as well. That way, the day of the shoot isn't the first time they've met me, which can help move things along more smoothly.

Physically visiting a location is the best way to get a sense of what's happening with the light. I try to scout during the time of day that I think the photo shoot will be scheduled. If we will be photographing indoors, I try to schedule the shoot for the brightest time of day, in the most photo-friendly area or areas. If I am not able to visit the location prior to the shoot date, I will often ask the pet parent about their home in detail to get a sense of the space and may even ask them for photos of the interior and exterior of the home.

The last major reason I love to scout is to start generating ideas. I do a walk-through of the location with the client as I chat with them and start to get to know them and their pet or pets. I photograph different spaces and rooms as a kind of note-taking so that I can start to think about how I will approach the shoot on a creative level.

During the consult, I ask the following questions:

• Is there a special activity that the two of you love doing together?

• What is most important to you about these photographs?

• Is there a special place in your home (or other location) where you'd really love for me to photograph?

• What is your ultimate goal for the photographs?

I strongly recommend scouting your locations ahead of time for more ease and success on the day of your shoot. I always make notes and take snapshots with my phone to help me start to generate ideas.

BEING PREPARED THE DAY OF THE SHOOT

Once you've had the necessary conversations and meet-and-greet opportunities with the pet and pet parent, it will be time for the shoot. You'll want to show up prepared and ready for success, both physically and mentally.

DRESSING APPROPRIATELY

Recognize that you are likely going to be extremely physically active during your portrait shoot, so it's important to dress comfortably and appropriately. I highly suggest keeping your dangling jewelry to a minimum, as it can get in the way while you're photographing and can also become a distraction for animals.

Consider wearing clothing that can move with you and allow you to get down low, climb on a stepladder, bend down, or even lie on the ground. Keep the weather in mind, and dress accordingly. I do not suggest wearing hats, as they can get in the way and sometimes intimidate animals (especially dogs and horses). I recommend wearing pants even in the summer to keep from getting scratched.

Knee pads or gardening pads are a great way to stay comfortable if you are going to be photographing on the ground or floor. Apple boxes or small crates of different heights can come in handy if you know you'll be seated for a long time.

BRINGING YOUR GEAR

It's a great idea to keep a running list of the items you want to bring to your pet photo shoots. If you're using studio lighting, it can be easy to forget things, which can have a challenging impact on the shoot experience and your ultimate success.

Bring your bag of tricks as you accumulate it and anything you think might come in handy based on your prior conversations with the pet parent. For equipment, I suggest bringing anything you might use that fits in your car. Although it can be more work to load and unload if you bring more, you don't want to be in the position of having a great idea that requires a reflector or ladder that you own but didn't bring. You can always leave extra stuff in the car.

WORKING ALONE

I spent years working solo on my pet portraits, and you can certainly do the same. Working solo can be a bit more demanding on a physical level and can be more limiting in terms of what you can achieve during a shoot.

If you don't have an official assistant, you may want to ask the pet parent for help in order to make the shoot go more smoothly or for a bit of lighting assistance. I try to give a heads-up to pet parents before the day of the shoot, and most are happy to help. If I know I will be working without an assistant, I will do my best to keep the lighting equipment to a minimum and limit my pet parent's work to reflector-holding and attention-getting. I don't have my clients set up or move lights and don't allow them to help me carry equipment!

If you choose to ask a friend or relative to help you out, be sure to set the expectations up-front about what you want them to do so there's no confusion on the day of the shoot.

Maintaining realistic expectations about what can and cannot happen if you are working alone is important. As you continue to gain experience with pet photography, you will start to develop a better understanding of what you can achieve, both alone and with an assistant.

MENTAL PREPARATION

We all have expectations, whether we are the pet parent trying to capture images or we are photographing someone else's pet. As you begin each session, realize that you will likely not get the images exactly as you see them in your mind but that something different—possibly better—will result. I am a "super planner," but pet photography has taught me again and again that, while the planning part is imperative, so is the need for adaptability and thinking on my feet.

I am not saying to give up easily on an idea you are trying to bring to life, but rather, try to give yourself the mental space to adapt and remain open to what *is* rather than what is *not*. This will open you up for a better experience and more creative opportunities.

Photographing on Location

I love photographing on location. I enjoy experiencing the different environments, and by photographing in and around people's homes (for the most part), I can create something that is personal to pet parents. Pets are also generally more comfortable in their own surroundings, and this helps me capture strong imagery and get lots of variety.

MAKING YOUR PORTRAITS PERSONAL

It's important for me to create images that have personal value, beyond the subject matter, to the pet parents. A pet's home offers the opportunity to make portraits that include personal elements not typical of a studio environment. While I love the look and feel of studio-based images, they often lack a personal element, both in the photographs and the experience of creating them. Including personal elements helps make the photographs even more meaningful, as they can trigger memories and provide a sense of place that is integral to the pet parent's experience of their pet.

I photographed Florence and her puppy in front of a barn at her home. Even though there is not a lot of environment in this image, I love the texture and color and the way it serves as a reference to her home environment.

So, how do you make pet portraits personal? Whenever possible, find out about the likes and behaviors of the pet you're photographing, and do your best to exemplify these in the images. Perhaps the dog loves to lounge around and cuddle or is obsessed with looking out the window by the front door. There might be a special chair that a cat loves to curl up in. Maybe the dog or cat has a favorite toy they love to play with. Perhaps the pet parent has a particular sense of style that you can include to make the images more meaningful.

Keep in mind that some personal elements may not necessarily photograph as well as others. It is your job as the photographer to determine how to incorporate the elements in an aesthetically pleasing or interesting way. Use your judgment and choose to spend time on what you think will translate well into photographs. If you find yourself in a situation where the pet parent wants to include an element that you don't think will photograph well, I encourage you to either to take a photograph quickly for them or simply be honest and tell them that it doesn't render well on a photographic level and that you don't think they would love it. Remember, they are counting on you to make the aesthetic decisions!

When I learned about Simon's obsession with his beloved toy frogs, I decided to create a portrait that included this personal detail for his pet parents.

TIMING CONSIDERATIONS

Timing can be critical for the success of your pet portraits, for a few very different reasons—especially when it comes to light. When I work on location, I use my scouting time (as discussed earlier) to help me identify the most photo-worthy spots within that location so I can come up with a game plan for how to approach the session from a time perspective. Choosing the right time of day to create your portraits is a very important decision.

Ideally, I suggest that you schedule portrait sessions for a time in the day when the pet has no other obligations. This is essential, because if the pet has recently been stressed (either positively or negatively), it will likely be more difficult for you to get the desired results.

The other consideration with regard to time is that I give myself *enough of it.* One reason that I think people tell me my portraits look genuine and real is that I dedicate significant time to the process. This doesn't mean that you need

This portrait was created at the end of our session, just after the sun went behind the horizon. It is one of my favorite images from the session. I couldn't have captured this image if I had scheduled the session for a different time of day.

to spend all day photographing, but the more you can absorb yourself in the process, the more you can build connection with the pet and pet parent, and the more ideas will arise and the moments you capture actually *will be real.* Having said that, animals don't have an endless amount of energy and attention, so you'll need to take this into account and be realistic. I tend to push the envelope and photograph for a long time (portrait sessions usually last around three hours between setup and breakdown), but I feel that the time I spend contributes to the final results.

OUTDOOR LOCATION TIMING tends to revolve around the light. Outdoor spots generally have better light early in the morning or at the end of the day before sunset. The light during these times isn't generally as harsh, and you have a little more to work with in terms of backlighting, reflecting, and so on. When the sun is directly overhead, by contrast, you tend to have fewer options for modifying the light. Keep in mind that if you are working in an area with a lot of trees or mountains, you can "lose" light earlier than in more open areas. Even if it's more convenient to photograph at the dog park at noon, you most likely won't

be as happy with the images at that time, as opposed to going earlier or later in the day.

INDOOR LOCATION TIMING can vary more and offers more flexibility. Sometimes the best time of day to photograph indoors is in the middle of the day when the light from outside is bouncing through windows. If you're using studio lighting, the time of day won't impact you very much unless you have trouble overpowering bright light streaming through a window. Each location will be different, and once again, a location scout will help out tremendously.

Even after all of your preparation, you will likely run into challenges with timing at one point or another. Know that you'll be able to navigate through issues as they come up and that you will learn from them. With experience, it's absolutely possible to troubleshoot during each unique situation.

OUTDOOR LOCATIONS

I love photographing pets outdoors, and I'm often asked to do so. Here I'll go into some of the advantages and challenges that you should consider in your pet photography.

I love this image because of the fall colors and beautiful contrast. This session required a lot of regrouping the dogs, because the trails were bustling with flying leaves, other dogs, and people. Although this situation was a bit challenging, I was happy with the results.

ADVANTAGES

Outdoor locations usually enable pets to feel in their element if they are accustomed to spending time in the outdoors and will generally allow for interesting imagery with a natural environment and backgrounds. Horses, for example, spend a great deal of time outdoors, and most often I photograph them in fields, open spaces, or near or in a barn. Although it is possible to photograph horses in a studio environment (which can be beautiful), they are not typically found in this type of setting.

If you are photographing during a specific time of year, it can be fun to include seasonal elements of the outdoor environment in your images, for example, photographing a dog jumping into a lake in the summer or rustling through a pile of leaves in the fall. Depending on your location and the time of year, photographing outdoors can help you introduce tremendous color to your pet portraits. Urban locations can be quite lovely and a great way to show an edgy side in your pet portraits or highlight a pet parent's lifestyle. Also, outdoor locations are generally more conducive to capturing pets in action, as the pets have more space than when indoors.

Another advantage is that if you are photographing in natural light, you have the option to move within the location fairly quickly using a variety of backgrounds in a relatively short period of time. Outdoor locations generally have more light than indoor locations, which helps ensure that you have the light you need for properly exposed images.

CHALLENGES

Outdoor locations can be difficult for photographing pets if containment is important. Outdoor rural areas can be stunning—but challenging if the animal tends to wander or run away. The outdoor spots I find myself in when photographing dogs, such as trails, dog parks, and fields, often include a lot of distractions, usually other dogs or people. In addition, photographing dogs in urban locations can be dangerous if you are near streets or busy areas, and they can be limiting in terms of photographing off-leash. Because of these factors, I find that photographing outdoors in the animals' backyard seems to work quite nicely.

Weather can change quickly and can dramatically impact the images in both lighting and animal behavior. For example, windy days can cause animals to grow more intense or on edge. Rainy, dark days scheduled for outdoors will likely need to be rescheduled. Extreme weather conditions can add to the challenges. I know that if I am photographing a dog in Texas in the summer, I need to do it in the morning unless I'm planning on photographing the dog in water.

If I photograph a dog outdoors, he or she may overheat and also pant a great deal, which isn't always the look I want. Of course, if people are going to be a part of the photographs, heat or cold will also affect their comfort, and this will show in the final images.

INDOOR LOCATIONS

Shooting indoors has its advantages and disadvantages as well. Here are some considerations to keep in mind with your pet photography.

ADVANTAGES

Photographing inside a pet's home rather than outside can be easier, mainly because indoor spaces are more contained, making it less likely for small pets to wander off. Most pets are used to being indoors and are very comfortable in their own environment. The animal's comfort greatly impacts the experience of the photo session for them, the pet parent, and you as the photographer.

As mentioned, photographing at the pet's home also enables you to include personal elements for both the pet and the pet parent.

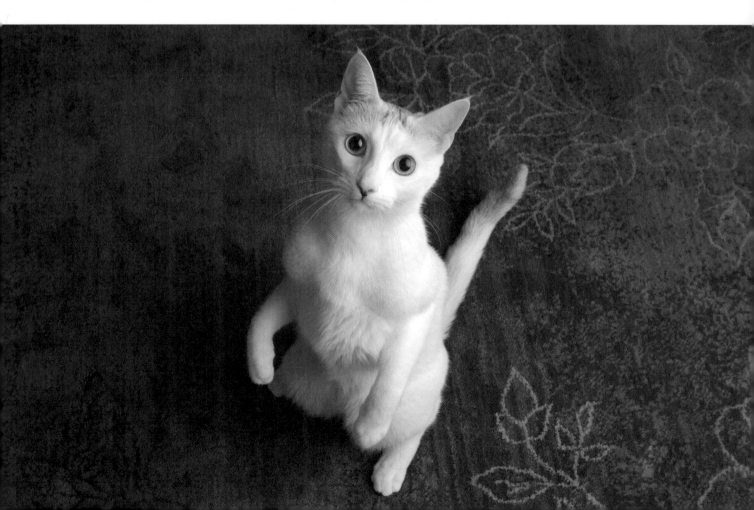

Photographing indoors can often mean lower-light conditions. I might find a gorgeous location but discover that it is too dark to photograph with the desired shutter speed and aperture combination. This will require me to make decisions about the lighting or to choose another spot.

Indoor locations in clients' homes can sometimes be visually cluttered, which can be challenging. Because you want to prioritize the pet in your images, busy areas in a home can become a distraction. I have found myself in incredibly beautiful indoor spaces that were difficult to photograph for this reason.

Prioritizing locations indoors is another issue to consider. Juggling all the options of where to photograph first and when and where to set up equipment can get a bit overwhelming.

PHOTOGRAPHING YOUR OWN PETS

Chances are that if you are interested or involved in pet photography, you have your own pets. Photographing your own pets is a great way to learn and build your creativity around pet photography.

GETTING CREATIVE AT HOME

The best aspect of photographing your own pets is that you have total freedom. You get to take all the time you need to turn your vision into a reality. You can photograph during the time of day that has the most beautiful light and stop when it disappears. If needed, you have the option of taking the time you need to set up lights and play around with different effects, leaving the lights where they are and picking things up the next day. Photographing your own pets can allow you to be more spontaneous with creating images, as there is less pressure to produce a final product in a specific time frame. This freedom can leave room for creative exploration.

Consider setting up an "official" shoot with your pets that allows you to experiment with lighting techniques, backgrounds, lenses, and perspective. This is different from grabbing a photo here or there and really requires your proactive energy. Remember that your own pets are the most available models, and of course, having images of them for you to cherish is a huge reward for your efforts.

LOCATIONS GREAT AND SMALL

It is possible to create beautiful portraits in any location, whether that is a mansion or apartment, an incredible garden or a patch of grass. Make an effort to stay open to possibilities that exist in any location. Know that there are inherent challenges in all locations, and positive results are within your grasp.

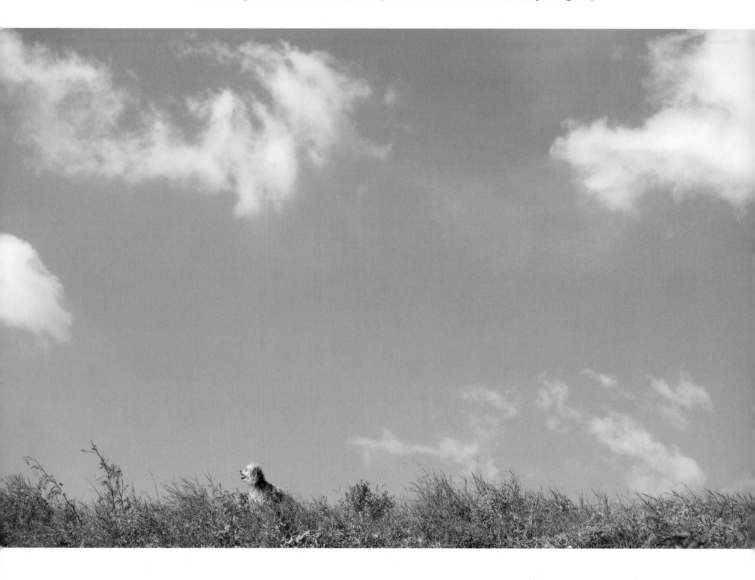

The Director's Dance: Photographing People with Their Pets

When I first started photographing pets, my interest was mainly in photographing pets individually. While I still love photographing individual pets, I have acquired a passion for capturing the relationship that exists between people and their pets. This relationship is so special, and I've seen firsthand the value of these images to the people who hold these animals so close to their hearts.

Photographing people with their pets requires a certain level of direction and guidance. I'm referring to it as a "dance," because it is a choreography of sorts, requiring a balance between controlling the outcome and allowing for surprises and spontaneity. While the moments in my images of people and their pets are authentic, I have contributed as a photographer to setting the stage for those moments to occur in a way that is communicated in an aesthetically pleasing way.

This is the dance.

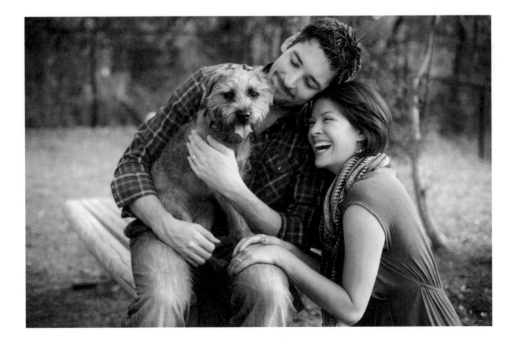

GETTING ON THE OTHER SIDE OF THE LENS

I strongly urge you to spend some time being photographed with or without a pet and allowing another photographer to give you direction. This experience will help you empathize with anyone who finds themselves on the other side of your lens.

When you are in front of someone's camera being photographed, you count on them for guidance, encouragement, and feedback. This is such a good reminder of the emotional experience of being photographed. You might have specific expectations of yourself or your pet looking or acting a certain way, you might feel shy or intimidated, or you might feel pressured or confused about what the photographer wants you to do. Every time I experience what it is like to be photographed, I learn something new or am reminded of something valuable I may have forgotten.

BUILDING RAPPORT

It is vastly important that you build a rapport with whomever is in front of your camera. The more comfortable and at ease your subjects are with you, the better the experience and results will be. Ask questions about the pet and their relationship, as this will help you generate ideas and also allow the pet parent to relax and distract them from feeling overly self-conscious. When you ask people about their pets, they tend to feel really positive, and this feeling will be evident in the photos.

WARDROBE

In general, I will ask the person I am photographing to choose a wardrobe that is comfortable for them and that they can move in without difficulty. I recommend that they do not wear clothing that they need to fuss with often or that wrinkles easily.

I love color and encourage people to wear colorful clothing that isn't overly distracting or that contains large logos or writing. Otherwise, the item can become the first thing the viewer notices in an image and take away from the pet and person interaction. I find that pastel colors, denim, and neutral colors photograph nicely and don't detract much from the subjects. Patterns can sometimes work, but I usually ask that people put aside a second option just in case it feels too busy in the photographs.

Wardrobe for pets, while I have tried it in the past, is not quite my style. If you feel inclined to go this route (or the pet parent insists), have fun with it, ensuring that the pet is comfortable and the experience is positive.

LOCATION SPECIFICS

It's important to find an alignment between where the pet and person are most comfortable and what works visually. Photographing someone with their dog in the middle of a busy city area may be beautiful but may not be the ideal place for the subjects to feel confident and relaxed. I find that the person's home environment or a place where they spend a lot of time are the best places to capture the relationship between pet and pet parent.

Within the location, there may be personal elements and areas that are meaningful to the person—maybe a couch where they love to lounge with their pup or a corner of the kitchen where they always brush their cat. I am always sure to ask about these locations. Sometimes these spots are conducive to photographs, and other times they are not great because of issues with lighting or visual clutter.

My goal is to find a location that interests me and allows for strong composition and lighting. When I find or create this scenario, I then think about how I will place the subjects into the scene. You can have a beautifully authentic interaction in a dark corner of a room, but it will not necessarily translate well in a photograph. It is our job as photographers to allow all the necessary elements to align. This is part of the director's dance.

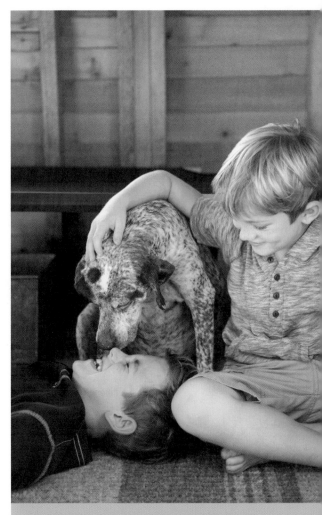

I photographed these boys in their tree house with their dog. This location was very special to the boys and the parents, and I know the images I created there have special meaning.

A NOTE ABOUT NERVES

I HAVE BEEN PHOTOGRAPHING FOR MANY YEARS, AND I STILL GET NERVOUS BEFORE EVERY SHOOT.

I WANT YOU TO KNOW THAT THIS IS TOTALLY NORMAL AND, IN MANY WAYS, VALUABLE.

I CARE DEEPLY ABOUT CREATING MEANINGFUL PORTRAITS AND A POSITIVE

EXPERIENCE FOR MY PETS AND PEOPLE. I AM SURE YOU DO, TOO. KNOW THAT

NERVES ARE NOT A BAD THING AND THAT THEY MAY ACTUALLY CONTRIBUTE

TO YOUR SUCCESS!

POSING AND CAPTURING CONNECTION

I frequently hear from clients or potential clients that my portraits, specifically of people with pets, do not feel posed. This makes me feel really good because it means that the images portray a certain truth in them that is often missing from completely posed portraits.

WAYS TO SHOW CONNECTION

In order to show connection, there usually has to actually *be* a relationship. I have photographed models with animals they do not know, and while not impossible, this makes it much more difficult to convey the bond between animal and person.

PHYSICALLY CONNECTING the animal and person in some way has a huge impact. Sometimes people are a bit nervous in front of the camera, and having a pet with them takes the focus off them and, as a result, eases anxiety.

EYE CONTACT between the pet and the person is a great way to show a bond. Even if the person and the animal don't lock eyes in the portrait, the act of having them look at one another can trigger authentic reactions and interactions.

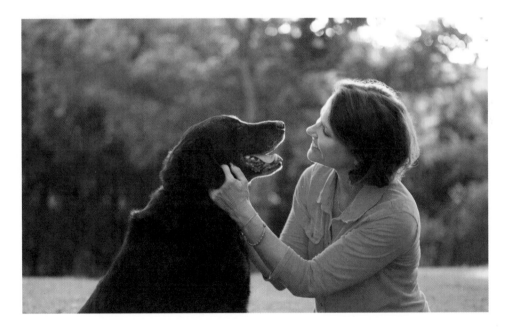

SOFT EMBRACES are often a beautiful way to show connection between a pet and their person. Be sure that hands and fingers are relaxed and that the body language of both the pet and the person looks comfortable and easy. If either the pet or the person looks tense, it will be communicated in the images. While animals don't hug to show affection, people certainly do, and many animals are used to being hugged by their human. I love photographing embraces, and if the animal responds well, the bond between the animal and person shines through beautifully.

> WHEN PEOPLE AND ANIMALS PHYSICALLY CONNECT, THERE IS AN AUTHENTIC EXCHANGE OF ENERGY THAT CANNOT BE MANUFACTURED.

SHARED ACTIVITY AND PLAY are great ways to generate authentic moments between a pet and their person. Throwing a ball or playing tug with a dog, brushing or playing with a cat, and grooming a horse are all common activities that can lead to sweet memories captured by your camera. Although these may not be typical portraits, they are moments that will likely have significance to the pet parent and truly tell a story. In addition, by participating in an activity, the person you are photographing can easily forget that they are being photographed and can be fully present in their interactions with their pet. Even if these activities take place between more static portraits, they will contribute to the comfort level of everyone involved and lead to stronger, more authentic portraits.

PEOPLE AS PROPS

Sometimes it is helpful and effective to incorporate posing that involves just a part or limited view of the pet parent in the image. For example, if the dog cannot be let off-leash or is having trouble holding still long enough for you to create a static portrait, you can ask the pet parent to gently hold the dog so you can crop in on the scene to include only a part of the pet parent or perhaps not show his or her face. In these cases, the person is being used in a more supportive role to help with the pet or simply add a little variation to your session. While connection can certainly be conveyed in these types of images, it isn't always necessarily the main goal.

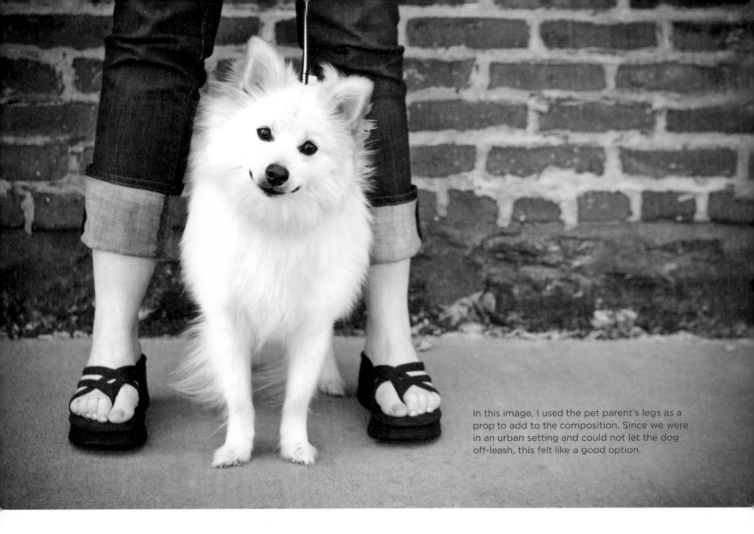

In this image, I used the pet parent's legs as a prop to add to the composition. Since we were in an urban setting and could not let the dog off-leash, this felt like a good option.

BODY POSITIONING

The most important thing about positioning your people and pet subjects is that everyone looks comfortable. I'll admit that some of the positions I have asked my subjects to take are not natural, but the successful ones will ultimately *look* natural. If I am having trouble describing what I am asking, I will often physically show the person the position I'd like them to take. (Sometimes when I try this I realize it doesn't work, which is also helpful.)

Photographing animals and people together is like fitting two puzzle pieces together. Some pieces are large and some are small, but they can perfectly align if you get creative. My general go-to approach is to ensure that the people and animals are on the same eye level or close to it. Also, consider the size of the person and the animal you are photographing, and go over your options either in your head during the shoot or before in your preparation notes.

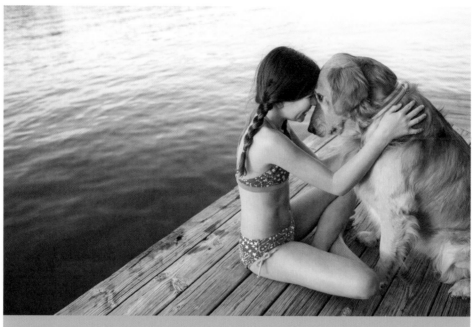

I wanted to get Kiki and her dog, George, on the same level. Since George was a big dog, I knew I could get them eye to eye if they both sat. I love their connection as they gaze into each other's eyes.

If you are photographing a child with an animal, you may have very different options than if you are photographing an adult. Children are closer to the floor and so are smaller pets, which can make photographing them together a bit easier. If you are photographing a horse, you will need to think about ways to show the connection between the horse and rider that do not involve lying on the ground (as horses don't usually do this).

LARGE PETS

I'm always trying to think about how I can position the pet closer to the person so they can physically connect. For large pets or pets that are large in relation to the person, I'll want to position the person at a higher level so this physical connection can occur more easily. If I am photographing a Great Dane and a young girl, I will have the girl and the dog stand so that they are practically at eye level. If I am photographing a horse and a standing person together, I will think about raising the person to the eye level of the horse. If my goal is to capture authentic connection, I wouldn't generally think to pose a large dog standing and a person standing next to him or her. If I am looking to show scale, however, I will likely want to show the difference in size and will take an entirely different approach.

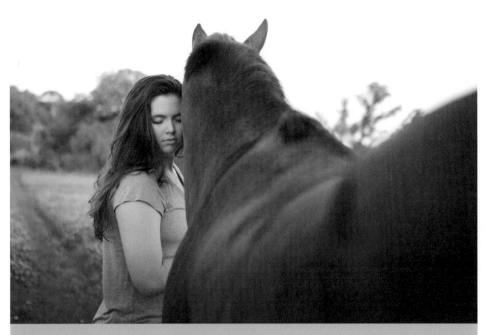

It's important for me to find multiple ways for people and their pets to connect physically. This often involves getting them on the same level.

SMALLER PETS

Small pets can be placed in locations that a horse or larger dog cannot. In many ways, small pets are easier to pose, because their small size offers many options. They can be picked up, placed in laps, and easily brought to the eye level of the human. Small pets can fit into the nook of a person's arm or the nape of their neck, placed on their shoulder, or cupped in their hands. Small dogs can be nuzzled in a person's jacket or relax on a tiny pillow.

Small pets offer more posing options, because they can fit into small places and are easily held by children and adults. Little Daisy loved getting out of the cold and into her dad's jacket for this portrait.

COMMUNICATION AS DIRECTOR

It is essential that you, as the photographer, give some sort of direction during your photo shoots. Be sure that you communicate your needs, whether you are choosing to capture posed imagery or candid action photographs. Throughout the shoot, remind yourself what it feels like to be on the other side of the camera, and communicate in a way that would be comfortable to you.

DURING THE SHOOT

For the most part, I photograph real people and pets, and they don't have training in posing for the camera. Sometimes poses and positioning just happens—but I can't count on it. So, I ask for interaction and physical connection, and I guide my subjects throughout the process. If I love what I am getting, I will communicate this and ask them to continue doing the same or repeat an action or gesture. I will pay attention to what I like and what seems to read well photographically, as well as get ideas from what occurs naturally.

I find it valuable to approach my posing and positioning, especially when photographing people and pets together, with a level of inquiry. I'll often ask questions out loud as part of my direction-giving. I do so because I find that this approach allows for a degree of fun during the process. As opposed to "Do this"/"Do that" direction, this more playful approach also allows me to shift ideas quickly and easily if they aren't working well. Communicating as I go lets the person in on the process. Lastly, approaching the direction in this way takes some of the pressure off the humans I am photographing.

Here are the kinds of questions and ideas I might put forth:

- What if we try this?

- What if your hand is here? Nope, that doesn't work. OK…let's try this.

- What would it look like if you both sat here?

- Would it work if we put you here?

- Let's try…

- Let's see what happens if…

- What if you two stood up? I'd like to see what it looks like from this perspective…

ENCOURAGEMENT

It is very beneficial to encourage the people and animals involved in your photo shoot. People and animals love positive feedback, and when you are encouraging as a photographer, the energy on the shoot will remain higher for longer and the humans and animals will be more relaxed—and this will all show up in the final product. Humans respond well to being assured that they look great, the photographs look great, and the pet is looking amazing as well. Pets also need a break during the shoot and some love and attention, either in the form of physical affection, treats, or play rewards.

ACTIVE VERSUS PASSIVE SHOOTING

Not everyone loves to give direction or even wants to create posed portraits. That's fine! You can photograph pets and people together in a more passive or documentary manner. Keep in mind that a passive fly-on-the-wall approach will generate very different images than one that involves more active direction.

I try to find a balance between active direction and passive moments. I set up the scenario in a way that suits my aesthetic needs and then allow for natural action and moments to occur. Some moments are more controlled than others, and some situations lend themselves to a more passive, candid approach.

I find that if I align the elements I want to create a strong image and direct just enough to initiate the opportunity for authentic connection between humans and their pets, I am happy with the results. This requires decision-making and direction on my part, even if all I'm really saying is, "Just love on Buddy," or "Hold him closely." I love capturing images that I have in my head, but I always prefer to be surprised by a gesture or reaction that is completely unplanned. These are the moments that make me really love pet photography.

CHILDREN AND PETS

If you are photographing children with animals, you'll want to find ways to engage them with their pets. You can ask for hugs and kisses, or ask them (sometimes silly) questions about the pet:

- Do you think Buster likes to eat spaghetti?

- Do you think Buster would like to wear your shoes?

- Can you tell Buster a secret?

- Are Buster's ears bigger than yours?

These kinds of questions help encourage interaction and reactions from children and pets.

Keep in mind that you'll need a lot of patience to photograph children and pets, because both have short attention spans. After photo shoots with children and animals, I am always exhausted! It is not an easy scenario—but it is so rewarding when I am able to photograph them successfully.

DEPTH OF FIELD AND FOCUSING FOR MULTIPLE SUBJECTS

For portraits with a single pet, I typically choose to focus on the pet's eyes (unless I have a creative reason for not doing so). But what if there is more than one pet? Like with any other technical aspect of creating portraits, my philosophy is to make whatever I do look intentional. There are no hard-and-fast rules about this, but here is an example with some ideas on how to approach the issue:

Pet and person, with exposure of 1/250 second, f/2.8, ISO 800

- If the pet or person is looking at the camera, I generally like to have them both in sharp focus and on the same plane.

- If the person is looking at the pet and the pet is looking at the camera, I focus on the pet.

- If both the pet and person are looking at the camera and are in the same general plane of focus, I focus on the person.

- If the person is in the background and the dog is in the foreground, I focus primarily on the pet but might also focus on the person as a creative option.

- If multiple people and pets are looking at the camera, I focus on one of the humans initially, and then shift my focus based on composition.

This image was taken at 1/125 second, f/3.5, with studio strobes indoors. I wanted to focus on the cat and have everyone in the background soft. Based on my own general "rules," I would typically have the pet parent look at the cat, but I think this approach works; because of the extreme difference in depth of field, there is no confusion about where I intended to place my focus and where I want the viewer to look first.

How do you make your focus choices and differences in depth of field look intentional? Make the difference extreme. If you have a pet in the foreground and a person out of focus in the background, have the person soft enough so it is clear that you weren't trying to have them in sharp focus and missed it. These choices are easier to do with shallow depth of field. I would still apply the same rules for myself for focus with a greater depth of field, but the differences would not be as obvious.

EDITING DECISIONS

So, what am I looking for when I choose the best images from the session? What exactly are *authentic* portraits anyway? Authentic portraits between people and pets are believable. The relationship between the pet and the human in the images elicits a level of connection that feels *real*. As I am shooting and editing, I am looking for an honest moment or exchange between the pet and the human. An authentic moment can present itself in many ways, and my favorites involve soft eyes, relaxed body language, and a shared moment or playful interaction between them. Of course, as photographers, we are the ones who get to choose which images to keep, and when I am editing, I want to keep the images that feel representative of the relationship I witnessed. I choose the joyful moments, expressions, and connections.

Pet photography shoots can be incredibly demanding, both on a physical and emotional level. I've developed strategies for approaching my shoots so that I can be as prepared as possible for anything I encounter; navigate my way through difficult situations that may arise; and produce meaningful, beautiful images (hopefully) in the end. As you continue to photograph pets, whether with people or without, you will start to develop your own strategies. Perhaps you will want to keep notes about what works and what doesn't resonate as much. I like to have a starting point for each shoot and then allow myself to adjust as needed to each unique situation. That's the fun and challenge of pet photography!

CHAPTER 7: PHOTOGRAPHING DOGS

I photograph dogs more than any other type of pet for clients and other projects. Dog portraits have existed in art and photography for many years, and more than ever before, people consider dogs and other pets to be part of the family. I'm grateful for this!

I attribute a huge part of my success as a pet photographer to my understanding of dog behavior and the awareness I've cultivated for how to create images and experiences that are personal to my clients. Knowing how to successfully gain a dog's attention, get creative during the shoot, and troubleshoot challenging situations will significantly improve your ability to create strong dog portraits.

Understanding Dog Behavior

Consider that, as photographers, we approach dogs with a giant "eyeball" and loads of equipment, and an agenda for them to "perform" according to our artistic vision. It's important to understand their needs and learn to read their communication for this to work well.

Like humans, every dog has his or her own unique character, tendencies, likes, and dislikes. Unlike humans, however, dogs *usually* share with us how they feel. This communication can be large and loud or small and subtle. If you pay close attention and start to learn about the way dogs communicate, it will help you tremendously with your portraits and editing. You don't need to be a dog trainer in order to start building an awareness of their behavior, and I highly recommend that you start before you're in the middle of a photo shoot.

PAY ATTENTION TO BODY LANGUAGE

A dog's body language provides valuable information about his or her comfort level with you, the environment, and the overall situation. Our goal as pet photographers is to allow the dogs to feel as comfortable as possible, and as a result, we'll be better able to capture the images we want and stay safe in the process. Note that the purpose of sharing some signs of stress that dogs typically display is to cultivate awareness, not to scare you.

When I am interacting with and photographing dogs, I am looking first at some of the major body language signals, including their eyes, ears, tail, mouth (both physical gestures and verbal), and general body position.

A LARGE PORTION OF A DOG'S COMMUNICATION OCCURS THROUGH BODY LANGUAGE.

I want a dog's eyes to be soft and relaxed, as they are often an indicator that the dog is at ease. Squinty eyes are typically considered "hard" eyes and will usually tell me that a dog is experiencing stress of some sort or possibly displaying signs of aggression. I never want to stare or point my lens at a nervous or aggressive dog, because this can actually indicate to the dog that I am being aggressive or contentious.

In this image, the dog's body language is relaxed. Just what we want!

If a dog's eyes are wide open, even showing a lot of the whites of its eyes, this can indicate that the dog is concerned, stressed, or at the very least, has a heightened state of awareness. Sometimes this happens when treats are introduced—this isn't necessarily a reaction to bad stress, but it isn't usually a good look for portraits.

Expressions can change from moment to moment, and as I'm photographing, I can notice these changes from frame to frame. I may capture an image wherein a dog has soft, relaxed eyes; and then in the next frame, the eyes appear squinty and tense. These expressions as captured on my camera aren't always indicators that a dog is stressed during the entire shoot, but if these expressions persist, I pay close attention and make sure I respond appropriately by taking breaks, providing needed space, or changing some action that may be causing the discomfort.

While you are focused on your own photographic goals, it's important to remember that your camera, gear, and actions can make some dogs very uncomfortable. (See the "Troubleshooting" section of this chapter for ideas on how to navigate this situation.)

A dog's ears will also provide a lot of helpful information about his or her comfort level. Regardless of the type of ears on a dog, I typically want them both looking either alert or relaxed for the images. Some dogs, like German Shepherds or Chihuahuas, have ears that are permanently upright. In this case, physical shifts in their ears are subtler than, for example, a Labrador Retriever's. Dogs with ears that are permanently standing up can still move their ears, and this impacts the look of the portrait. For example, a Chihuahua's ears are a bit like antenna and can move around subtly in response to sounds or action. My ideal positioning for dogs with these types of ears is to have them both facing straight forward.

Phillip, the Chihuahua, has ears that always stand up, so I'll need to look at his eyes and other body language cues to get clear information about how he is responding to the situation.

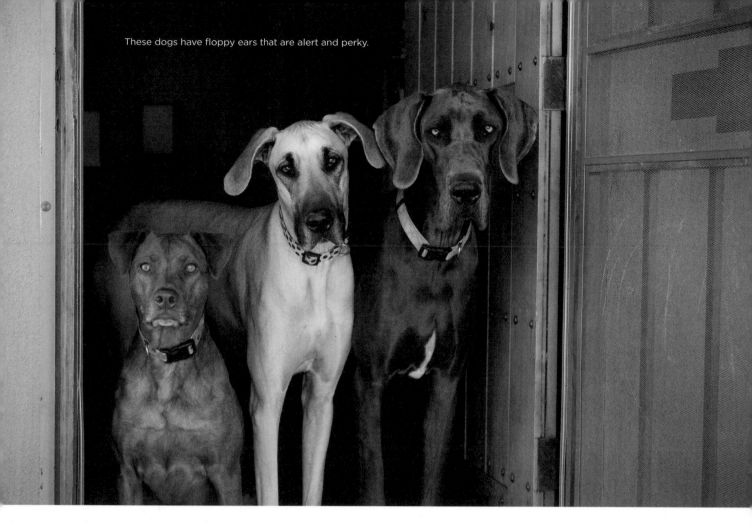

These dogs have floppy ears that are alert and perky.

Floppy-eared dogs have a lot to say with their ears. When a dog's ears are pinned back close to their head, it usually tells me that the dog is stressed. What I'm usually aiming for with these types of dogs is that their ears are either perked up or soft, loose, and floppy. When their ears are perked up, it seems to help their character show through, and at the very least, they appear comfortable, curious, approachable, and (honestly) cuter.

Tail wags can tell us a lot about a dog's reaction to a given situation. Tail wags are often a misunderstood dog behavior; not all wags indicate a content dog. My preference is the swooshing, swaying, fluidly moving wag, as it's usually telling me the dog is relaxed and enjoying herself or himself. While a rapid tail wag may tell me that a dog is excited, it can sometimes mean that the dog is unsure or nervous. Dogs that don't have permanently curly tails will sometimes point their tails in a very stiff manner. This can indicate that the dog is alert and focused, or potentially stressed and/or aggressive. Dogs with straight tails can also show signs of intensity and stress when they curl their tails. So much information is shared with just this one body part! I wonder what we'd be able to share about our emotional state as humans if we had tails.

Dogs also provide a lot of information about how they are reacting to their environment with their mouths. As I'm photographing, I'm keeping my eyes open for a soft jaw and mouth, maybe a little tongue sticking out or easy panting. Tense, clenched jaw muscles tell me that a dog isn't comfortable.

Barking and other verbal sounds are a major way for dogs to communicate. When it comes to barking, I always try to take into consideration the intensity and the context; it could be a friendly greeting, an alert to the owner that someone new is present, a warning, an excited whine, or anything in between. My dog, Otis, has several different versions of his bark: the type that seems to shout and grumble at me when I return from being away; the piercing bark he gives his sister, Mika, when he wants her to play with him; and the deep, guttural bark he makes when he sees something scary or threatening. I'm sure if you have a dog in your life, you know just how much variety there can be in their sounds.

This dog is displaying a relaxed, open mouth with just a little bit of tongue showing.

When you photograph dogs, you can gather lots of information from the sounds he or she makes, and paying close attention to these signals will help you determine how to respond during the photo shoot. In addition, having strong communication with the pet parent about the dog's temperament can be very beneficial. For example, if someone comes over to my house and Otis is using his "grumbling" bark, I will be able to tell my visitor that he is talking to them and wants to play. Ultimately, though, it is up to you as the photographer to read the signals and respond appropriately.

Lastly, looking at general body language and posture is hugely helpful in judging the comfort level of a dog, especially when you've taken into consideration the other major body signals. When a dog is leaning toward you with hard, intense-looking eyes, it's a good idea to back away and give them some space, because that dog is potentially showing signs of aggression. Some

larger-breed dogs tend to be "leaners," and will lean into your legs as a friendly way to connect.

Hair standing on end, typically on the back and tail area, and tight, tense muscles are sure signs of intensity and extra excitement of some kind; this is often a result of fear or potential aggression. During my photo shoots, I want the dog to display loose, relaxed body language, because I know I'll get better photographs and the whole experience will be more enjoyable for everyone. None of my clients has ever wanted portraits of their dogs when they looked stressed out.

EXCESSIVE LICKING OF LIPS AND LOTS OF YAWNING ARE INDICATORS THAT A DOG IS ATTEMPTING TO CALM HIMSELF OR HERSELF, BECAUSE THEY'RE UNDER SOME KIND OF STRESS. IF THIS OCCURS, ADJUST YOUR ACTIONS AND ENERGY AS MUCH AS POSSIBLE TO ALLOW THE DOG TO RELAX AND BECOME PHOTO-READY.

Of course, there are always exceptions, but being aware of these major signals and expressions is a good start. Also, be sure to consider these signals and communication in context to the situation. For example, are there other dogs or animals in the location? Are they sick or old? Are you asking them to do something they're not normally allowed to do (like get on the couch if they're typically not allowed)? Did you introduce something new like a toy, sound, or movement that they might be reacting to? Does your camera seem to scare them? Are the treats you are offering getting the dog too excited? Context is very important.

SPEND TIME WITH BEHAVIOR PROFESSIONALS

You definitely don't need to get certified in dog training and dog behavior to photograph dogs, but the more information you have, the better equipped you'll be when photographing. I often find myself feeling a bit like a dog trainer when I'm working as a photographer, so the information and support I've gained from spending time around dog trainers has been priceless. I love positive reinforcement techniques and have seen this method work wonders with my pups. I choose to continue to learn from people whose methods I respect and whose vision aligns with mine. If you get a chance to develop a relationship with a dog trainer in your area, do it! Perhaps ask the trainer if you can interview them or watch them work for a consulting fee or maybe even trade for photographs for their business. This experience will help prepare you to navigate through a variety of dog behaviors you're likely to encounter during your photo sessions and allow you to witness the behaviors I am addressing in this chapter.

Regardless of the knowledge you have going into a photo shoot, you will need to navigate each situation individually (with some patience) and adapt to the dog's energy, training level, and response to you during the photo shoot.

SPEND TIME AT A LOCAL ANIMAL SHELTER

One of the most valuable ways I gained an understanding of dog behavior was to volunteer at my local animal shelter by photographing dogs and cats available for adoption. This experience was tremendous, not only because I got to learn and grow as a photographer, but also because I got to help dogs and cats find homes. As an animal lover, it can be very tempting to want to bring every animal home, but this is an excellent way to help them when you can't adopt them all. No promises that if you get involved with animal shelters you won't end up with at least one newly adopted family member!

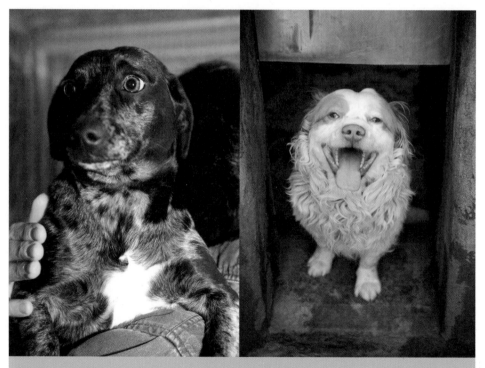

Photographing in animal shelters will give you a lot of exposure to a variety of temperaments and lots of practice for a good cause. The dog on the left was very shy (you can see the pinned-back ears and averted eyes), whereas the dog on the right was easygoing and displayed lots of excitement (with relaxed eyes and soft mouth).

Shelter animals in general are not trained, and each will respond differently to people and stimulation. In one kennel, you may interact with a very shy, timid dog; and then in the next kennel, a dog enthusiastically jumping all over you. I encourage you to consider developing a solid relationship with a shelter you'd like to support and find ways to use your creative skills in photography to help dogs (and cats) find forever homes.

Later in the book, I'll be diving deeper into the value of photographing for non-profits and animal welfare organizations and will offer ideas for how you might explore this in your own photography practice.

Going Into the Dog's Home

All dogs display different characteristics and are unique. If you're going to a friend's or client's home to photograph, remember that you'll want to gather some helpful information ahead of time (for more details, see chapter 6). Before photographing a dog in someone's home environment, I'll get a sense of the dog's typical behavior. I try to remember to ask the pet parent if the dog is typically comfortable with strangers coming into the home. Even if the answer is yes, I still proceed with awareness. If the answer is no, I may suggest meeting at a more neutral location. Dogs can sometimes act protective of their home, car, yard, pet parent, or favorite toy. Paying attention to the body language and behavior signals I mentioned earlier can help when you engage with a dog for the first time. I've only encountered a couple dogs in my years of photographing who were extremely protective of their home or space; one of these occurred when I didn't inquire about a dog's behavior. I will not soon forget this lesson!

When entering a home for a photo shoot, I leave my equipment either in my car or outside the front door. I usually ignore the dog initially and keep my voice calm and relaxed as I chat with the owner. Sometimes I can tell immediately through body language that a dog is really comfortable and approachable, and of course, I'll say hello and love on them. After I've paid close attention to their communication signals, I like to get down on their level and let them approach me. I adjust the volume and level of my voice based on the dog's reaction to me. I don't need to stick my hand in their face to let them smell me as they've already smelled me when I walked into the house. Once I bring my equipment inside, I'll let them give that a sniff, too. If I am encountering shy dogs, I may offer them a treat to connect positivity with my presence if it feels appropriate and if I have asked the pet parent for permission.

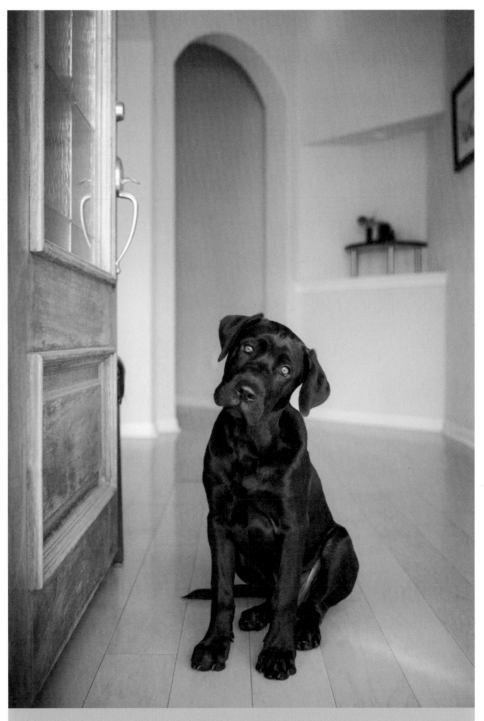

I love photographing in and around dogs' homes, and I make it a point to be fully prepared for a variety of behaviors.

The Value of Self-awareness

I can't emphasize enough the value of self-awareness when photographing animals. Paying attention to your energy and maintaining awareness throughout the session will help ensure that the experience remains positive and that you get stronger photographs—and more of them. Making notes about dog behavior in general and building your toolbox of experiences when photographing pets will prove to be helpful when you're on location. When I enter someone's home to photograph, I am focused on getting the final images, but I've learned that I will be most successful if I stay aware of the energy I'm bringing into the situation and adapt accordingly rather than just barreling through.

If I am working with a shy dog and I am super hyper in my physical body language—using high-pitched sounds, making unusual noises, and popping flashes around—I'm not going to provide a fun experience for the dog, and I definitely won't be happy with the results. I recommend that you keep gestures slow initially and pay attention to the way the dog responds when you introduce equipment, make funny noises, and create big movements.

Staying connected to the pet parent and checking in every once in a while to make sure they're comfortable with poses, locations, and interactions is another important element of maintaining self-awareness. Sometimes I might get an idea for a photograph, but the location isn't quite stable or large enough for the pose I want and I'll need to let the idea go. While I may push for my ideas to come to life, I don't choose to put dogs or people in unsafe positions or scenarios where they look uncomfortable.

I try to practice good listening and observation skills when I'm photographing other people's pets, because I often get ideas by doing so. For example, when photographing Simon, he ventured down the hall; and when I asked where he had gone, I was told that he loves to

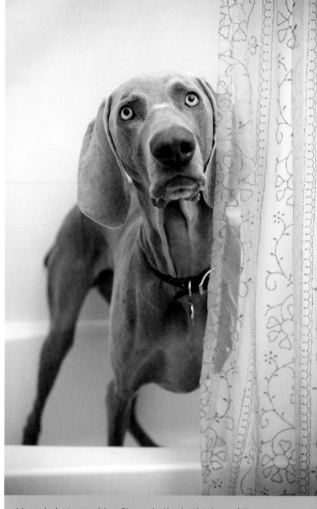

I loved photographing Simon in the bathtub, and I'm so glad I was able to discover this activity of his.

hang out in the bathtub—a fun and unique spot for a photograph! I had already been exploring my own ideas, but because I was listening and paying attention, I became aware of another interesting opportunity that resulted in a meaningful photograph for Simon's owners. Many of my photographs are a result of being observant and noticing opportunities. Sometimes I'll see a sweet gesture or action from a dog, and I'll either be ready with my camera or I may try to get the dog to repeat the action or activity.

Static Posed Portraits

I often receive positive responses to my portraits, because I am told they don't feel posed. I really appreciate getting this feedback. I wouldn't say, however, that my photographs are entirely un-posed, because I typically have a lot of input in their creation.

My approach with more posed or stationary portraits is to control as much as I can about the environment—the lighting, location, composition, and other details—and then within that space, allow for authentic reactions and moments to occur. This applies to all of my portrait work, including dog portraits.

While I don't love the term "static" or even "posed," those words do provide a clear delineation between portraits and candid or action-based imagery. I gravitate aesthetically to more posed-type images for a few reasons. I find I have a little more control in the design of my frame, and I generally produce a higher ratio of successful images when I'm photographing in this way. I also love the level of engagement expressed by a dog looking directly into the camera—and in effect, to whomever is looking at the photograph. This is fun and certainly meaningful to me when I'm looking at photographs of my beloved pets.

THE UNPOSED POSE

TRY TO CREATE IMAGES THAT DON'T LOOK POSED, EVEN THOUGH YOU ARE IN CONTROL OF WHEN AND HOW THE PORTRAIT IS TAKEN. TRY THIS NEXT TIME YOU'RE ON A SHOOT: CHOOSE A LOCATION THAT HAS A CONSISTENT LIGHTING SOURCE AND ENOUGH PHYSICAL WIGGLE ROOM FOR YOU AND THE DOG. THEN PLAY WITH DIFFERENT PERSPECTIVES AND ATTENTION-GETTING TECHNIQUES, AND ALLOW FOR A LITTLE TIME TO JUST OBSERVE WITH YOUR CAMERA AND SEE WHAT UNPOSED MOMENTS PRESENT THEMSELVES.

This dog has a relaxed, natural pose as she lies on the floor in her home.

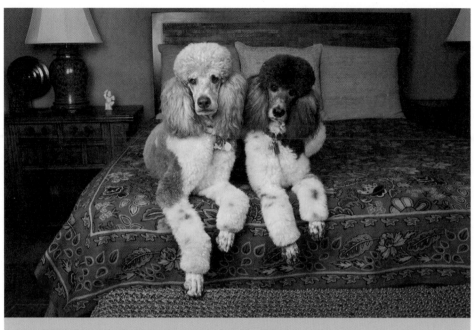

Dogs love being on beds where they're comfortable. This also helps contain them for their portraits.

I find that working with dogs in a contained area for posed portraits helps tremendously. This can be a bed, sofa, chair, table, flowerpot, rock, porch, patio, or boat, rather than an open space where there may be a lot of distractions and opportunity to move around.

STAYING CONNECTED

One thing I've noticed in working with other photographers is that urge to look at every image after the shutter is pressed. When you do this, you risk wasting the dog's energy or a special moment between dog and owner—which is no good! I try to get my exposure settings where I want them, check to see if I am happy, and then wait until after I photograph several images to see if I'm pleased with the initial results. Some amount of review does help me decide whether I want to tweak a pose or my framing or move on to a new idea. If you catch yourself over-checking your LCD, try to remember to stay as connected as possible.

FINDING VARIETY

It's a good idea to switch physical locations frequently to keep the dog interested and engaged. Having said that, there's a lot that can be done in one small area by switching from a sitting to a lying-down position for the dog or moving in closer to get some fun detail shots.

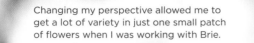

Changing my perspective allowed me to get a lot of variety in just one small patch of flowers when I was working with Brie.

Your choices for variety are not limited to changing physical locations—consider highlighting special features of the dog, getting creative with abstraction and focus, or capturing interaction with the pet parent or family member. Remember to pay attention to the details and what happens while you're photographing, because it may give you additional ideas.

PRIVATE "BITS"

A QUICK NOTE ABOUT PRIVATE "BITS" AND HOW TO HIDE THEM IF YOU FEEL THEY'RE DISTRACTING: WHERE POSSIBLE, POSITION THE CAMERA'S VIEW OF THE "BITS" BEHIND ONE OF THE LEGS, OR SOME OTHER WAY VISUALLY SO THEY DON'T DRAW ATTENTION. THIS ISSUE IS NOT ALWAYS TOP-PRIORITY BUT A DETAIL THAT I THINK HELPS GUIDE THE VIEWER TO THE AREAS WHERE YOU WANT THEM TO FOCUS.

TAKING BREAKS

Breaks are important for the dog, the pet parent, and you! If you get frustrated or tired, take a break for yourself. I'd be a liar if I said I never got frustrated during a shoot. My most frustrated moments are fleeting and are usually brought on by fear of not being able to get something I'm happy with. But in the end, I've found that my persistence pays off if I'm willing to try lots of different approaches and regroup when needed. There's something about this process and the results that keeps me coming back for more.

GETTING THE DOG'S ATTENTION

My objective with getting a dog's attention is either to have them look in a specific direction or straight into the camera lens with engagement, curiosity, or just good ol' sweetness. I want their body language, specifically their ears and eyes, to be inquisitively alert or relaxed. My favorite response (and often my clients' favorite) when I get a dog's attention is when they tilt their head to the side, because they can't quite figure out where the sound I'm making is coming from.

BAG OF TRICKS

I always bring my bag of tricks to every photo shoot with a dog. This is both a physical bag filled with attention-getters, treats, and accessories, as well as a mental bag of tricks I've acquired from years of practice. I started with a few items and just keep adding to my bag. I try to keep the bag close to me as long as the dog doesn't become too focused on exploring its contents or stealing my toys. If I have food in this bag, I am sure to keep it out of reach.

The key element to the bag of tricks, whether I'm dealing with verbal or physical tools, is novelty. Dogs will get desensitized to sounds, smells, tastes, and actions, and simply repeating the same action or activity will not give you good results. Novelty is key!

Remember to maintain awareness of how the dog is doing when you're implementing attention-getters. If the dog seems scared (as seen in his or her body language and other behaviors), do not repeat the action, noise, or use of an attention-getting tool. Try shifting gears with your approach and see what happens.

Here's what's in my physical bag of tricks:

SQUEAKERS. These come in really handy when I am trying to grab a dog's attention. I recommend purchasing a pack of small, plastic squeaker replacements that typically go inside dog toys. (Kong brand are usually available.) The

squeaker without the toy is easier to handle, and I don't have to worry about it not making noise when I need it to.

SQUEAKERS IN MOUTH. Anything that I can put in my mouth to make a noise is fantastic. This will leave my hands free for my camera controls. (I might drool a little when doing this, but that's OK.) One of my pups "dissected" a rubber chicken once, and I discovered that it was much easier for me to put the squeaker in my mouth than wave a rubber chicken in the air while trying to photograph with the other. In addition, dogs often want to get toys away from you and don't seem as interested in stealing a squeaker—I think because it's usually harder for them to see.

MOUTH- OR SELF-GENERATED SOUNDS. This is my favorite and most-used trick in my bag, because I don't have to hold anything in my hand, and as long as I have my voice, it's always with me. Whispering, asking questions, using words that the pet parent has told you pique interest, clicking and animal sounds, rude-sounding noises, airy sounds, and panting sounds are all noises you can make with your mouth if you practice. You can generate tremendous variety if you're willing to make a little bit of a fool of yourself and just have fun with it. Keep in mind that these noises don't always have to be loud or intense, just varied and interesting to the dog.

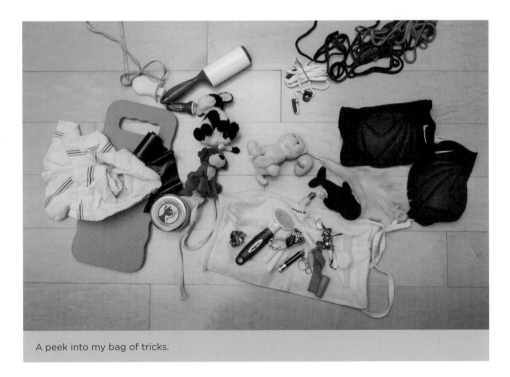

A peek into my bag of tricks.

PAPERS AND PLASTIC. Noisy materials that make rustling sounds often spark interest, usually because dogs think it might be connected to treats. Plastic bags, aluminum foil, and bubble wrap are all potential attention-getters.

TREATS AND FOOD. While I often come prepared with treats (I like soft tube-style food cut up in cubes), I prefer that the pet parent provides treats to prevent upset bellies. I use treats as a last resort, because I've found that once I've introduced food, many dogs can become obsessed and intense (remember the wide eyes I referred to when discussing dog behavior earlier in this chapter?). Or they'll excessively drool or just generally get overexcited when food is introduced—which doesn't translate well in photographs.

If I do give treats during a shoot, I try to be sure to follow through when the dog offers the behavior I'm looking for, but will pause long enough to get a few frames. I often joke that I don't want the word getting out amongst the other dogs in the neighborhood that I don't follow through! If you're really having trouble getting a dog to pay attention to your treats, consider using high-value treats. These are treats they may not typically get, like cheese or some kind of stinky food like hot dogs or liverwurst.

Choose your timing wisely with regard to attention-getting. Curiosity, which can be generated through your timing, is your friend when you're making an effort to get a dog's attention. I'll often put a treat or toy behind my back and then bring it out quickly so the dog can see it. I choose to position the toy or treat right next to the lens or wherever I want the dog to gaze. This buildup of anticipation, combined with the element of surprise, can often create a brief moment when the dog will swallow and maybe tilt his head in reaction to the activity. That's when I press the shutter. This is a great trick for creating novelty and can work well if you don't want the dog's tongue hanging out.

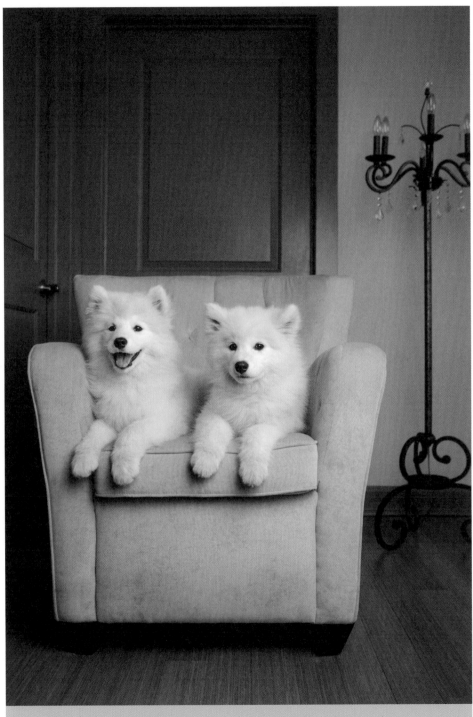

These puppies were very interested in treats and also responded well to squeaky toys.

WORDS AND OTHER SOUNDS

Words and special phrases that can evoke interest and excitement can be a really effective way to get a dog's attention. Here are some examples:

- "Wanna go for a walk?"
- "Who's here?"
- "Where's Dad?"
- "Squirrel?"
- "Ball?"
- "Where's the treat?"
- "Look!"

Because you will have asked all about the dog in your preparation time, you'll know which words he or she responds to. Just like when we use other types of attention-getters, remember not to overuse any one particular word or phrase. If a dog is getting desensitized to the words you're using, you'll want to switch to something different quickly. If you notice the dog getting stressed or overly excited (to the point where it is impacting your images or the experience in a bad way), you may want to switch gears and move on to another tactic or take a break if the dog seems tired.

Some words, actions, and noises can cause the dog to run toward the camera with excitement, making it difficult to photograph. If this happens to you, notice what causes the response and either try to avoid repeating it or take advantage of the split second before he moves and then try to regroup. My preference is to make an effort to find an attention-getting technique that evokes *just enough* response without causing the dog to rush the camera. Also, try to avoid calling the dog's name repeatedly, as this can get very confusing—most of us teach our dogs to come to us when we say their name. If the pet parent is helping you, be sure to communicate this politely to them.

All of these attention-getting techniques can be performed by you, an official assistant, or the pet parent, depending on how the shoot is going and what you feel is most effective given the situation. There are times when you may find more success directing the attention on your own and other times when you may really benefit from having someone else involved in the process. Pet parents have the best intentions and yet sometimes can be a distraction for the dog. If you've got a willing helper, it's up to you to politely ask them to hold a toy by your camera lens or to camera right, say a special word, or just sit to the side if that seems to be most effective. Whatever you choose, be sure to communicate your needs (as mentioned in chapter 6) and give clear direction on what you want your helper to do (or not do).

There is certainly an appropriate time and place for attention-getting. If your goal is to capture portraits wherein the dog is looking straight into the camera, the likelihood that you'll need to use some method of getting the dog's attention is pretty high. But if the dog is scared or intimidated, you'll want to be subdued, perhaps giving the dog some space and capturing images through a more documentary approach.

I invest significant time and energy in creating my pet portraits—I'm usually exhausted after my sessions! My goal for each photo shoot is to get as much variety as possible within a single location and to gather a small portfolio of images. For that I need persistence, which can be a good thing but can sometimes work against me. If I am really excited about a specific visual possibility, I will try my best to make it work, but if I spend an hour trying to get a dog to sit exactly how and where I want with no success, I risk missing many other images and wasting everyone's energy. There's a balance to achieve, and I learn something from each and every shoot.

MAKING IT PERSONAL AND SHOWING THE DOG'S UNIQUE CHARACTER

Pet portraits, in the commissioned portrait sense, are for the personal enjoyment of the pet parent. Do your best to find ways to make these portraits as personal as possible while showing the dog's special character.

CAPTURING DETAILS

The details I'm referring to can be a physical feature on the dog, elements found in the location and environment, or something related to the pet parent's interests. As I'm photographing in and around my client's home, I may ask myself some questions to help generate ideas:

- Is there a way to include details of the dog that the pet parent especially loves about him? Perhaps it's the fur on his head, a spot on his eyes, or some other physical attribute that stands out.

Eddie had the best fauxhawk, so I had to get a nice profile image for his parents.

- Is there an aesthetically pleasing way of using backgrounds and locations so that when the pet parent looks at these photographs years later, they are suddenly brought back to this moment via the sense of place portrayed in the images? These references can be as small as using a favorite chair or as large as an entire living room space or backyard.

- Are there elements that are personal to the pet parent that I could include to make the photographs more meaningful or fun? Maybe the pet parent has a quilt that belonged to their grandmother, or has a job as a firefighter and I can include an element of their vocation in the images—pretty fun!

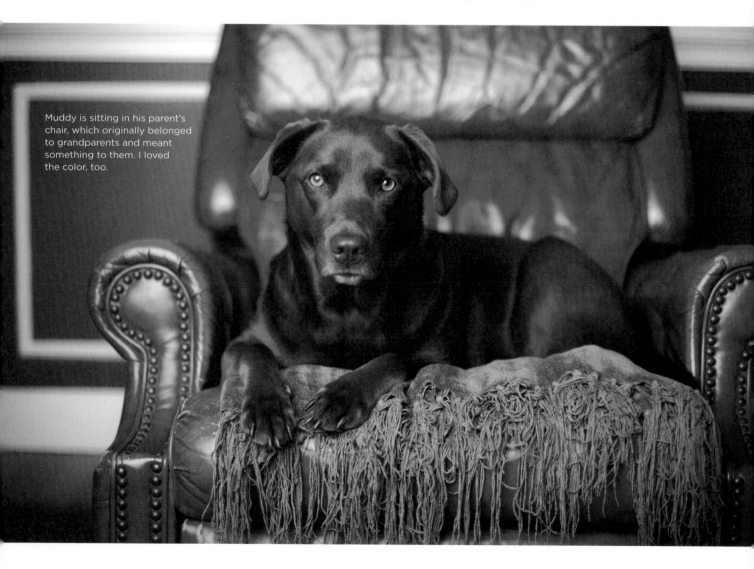

Muddy is sitting in his parent's chair, which originally belonged to grandparents and meant something to them. I loved the color, too.

DEPTH OF FIELD

As I am working on location, I often find that playing with depth of field helps to creatively portray the personal spaces and character of a dog and their pet parent. For example, I might choose a shallow depth of field to simplify a cluttered yard or busy interior space, or to create framing devices with out-of-focus colors or shapes from elements in and around the home.

While a great depth of field can be perfect for showing lots of details, I like to use the lack of depth of field to help direct the viewer's eye. I might direct the focus to the dog's eyes, face, tail, or anywhere else I want the viewer to look, choosing to include just a small reference to the background or other details.

CAPTURING ACTION

While photographing action isn't my preference for portraits, it can be refreshing to capture movement, and it's a great way to show a dog's unique character and energy.

BURST MODE. When I'm photographing lots of action like dogs playing, chasing balls, going after bubbles, or swimming, and my goals are to stop action, I'll set my camera to Burst mode or rapid-fire mode. This will help ensure that I capture the point in the action I'm looking for, because it is taking multiple frames per second. I want to press the shutter button only when I think the peak of the action is occurring or about to occur. If I just hold down the shutter for hundreds and hundreds of shots, my memory card is going to fill up really quickly and I'll have to spend a huge amount of time editing. (No, thanks!) Burst mode is a

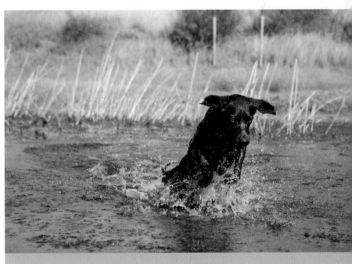

I used burst mode to take this action photograph of Friday.

big help in action-filled circumstances, but just because I'm shooting in this way doesn't guarantee a perfect frame—the lighting, background, composition, and gestures all have to be considered.

TRACKING FOCUS MODE. Another big help in photographing dogs in action is to use some kind of tracking focus mode. Depending on your camera model, it may be called something different, like continuous focus. Using this mode will allow you to pick a focusing point on your camera (I usually select the center

spots), and the camera will continue to very quickly refocus on the dog as long as you have the focus points aligned with the dog's face (or wherever else you decide you want the focus point to be). Of course, you may have to physically move to keep the dog's action within the frame, but the tracking focus tends to work much better than single focusing.

HIGH SHUTTER SPEED. If I'm interested in freezing action, I'll want my shutter speed to be fast—set to about 1/1000 of a second or faster—for example, if I am looking to freeze droplets of water when a dog is swimming or shaking off. Even with a fast shutter speed and tracking mode, I know I may not get exactly what I want right away. If possible, I may have the dog repeat the activity so I have plenty of opportunities to get what I'm looking for. In this situation, shutter speed takes priority in terms of my settings, and I'll select whichever aperture and ISO combination I need to ensure that my shutter speed is high enough to get the results I want.

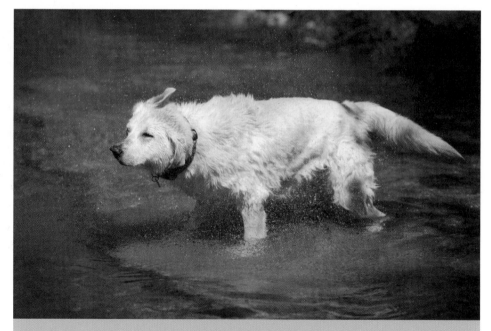

I used a very high shutter speed in this image (1/8000 of a second); you can actually see the droplets of water spraying off Hannah as she shakes.

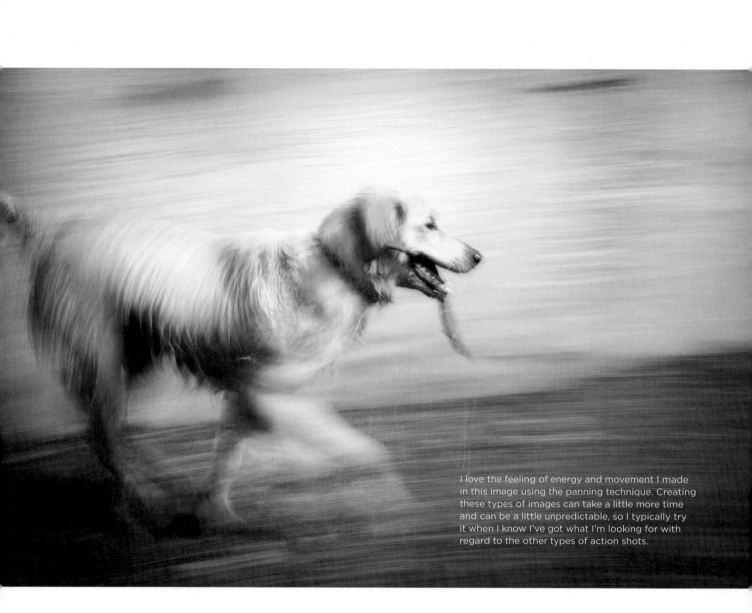

I love the feeling of energy and movement I made in this image using the panning technique. Creating these types of images can take a little more time and can be a little unpredictable, so I typically try it when I know I've got what I'm looking for with regard to the other types of action shots.

SLOW SHUTTER SPEED. Freezing action isn't the only creative choice when photographing moving dogs. Sometimes panning action can be a fun solution that can offer interesting variety. In these scenarios, I'll use the tracking focus mode and slow my shutter speed down to maybe 1/30 or 1/15 of a second. I encourage you to experiment with all of these options for your dog portraits.

Troubleshooting

Spoiler alert: you may run into some challenges while photographing dogs. Not to worry! Here are a couple scenarios and how you might navigate your way through them.

THE DOG IS TOO FOCUSED ON THE OWNER

Dogs are bonded with their pet parent and sometimes become so focused on them that it's difficult to capture their portrait alone. Communication is super important in these types of situations. I try to have a casual conversation with the pet parent *before* the shoot to let them know that if this happens, as it often does, I may ask them to step out of the room for a few moments to see if it enables me to get more direct connection from the dog. If the pet parent isn't comfortable with leaving the dog, I'll have him or her stand right next to me if I want the dog looking at the camera.

HIGH-ENERGY DOGS

While I love energetic dogs, a very hyper dog can be challenging to photograph. During the pre-shoot planning process, I try to find out the general energy level and age of the dog. I may suggest that the owner take the dog for a walk before the shoot if I find out that their dog is very high-energy. If that doesn't happen and we're in the middle of photographing and the dog is zooming around, I'll see if the dog can "run it out" a little and settle down. If they still

Daisy was a high-energy puppy who didn't want to slow down for her portraits. I decided to use her energy in my favor for this image.

won't calm down enough for stationary portraits, I'll try to find an activity that will allow the dog to display high energy and also translates aesthetically, like swimming, running in the snow, chasing bubbles or a brightly colored ball, or engaging in a fun wrestling game with their pet parent or a toy.

Having the pet parent included in the portraits can be very helpful when dealing with high-energy dogs. If the person is not excited about being photographed, you can suggest including them as a "prop" to help calm the dog, or ask that they gently cuddle the dog while only photographing a small section of them. It's really nice to have this option.

Especially in these scenarios, be sure to give yourself plenty of time, take deep breaths, and roll with it as best you can.

LOW-ENERGY DOGS

If I encounter a low-energy dog, maybe a big, slow teddy bear or a sweet elderly dog, I'll make sure I photograph them in a way that still honors who they are. Having said that, I still want the dog's photograph to portray some sort of energy and vitality. I will try my best to perk them up just a little with high-value treats, words, noises, and toys. Another option to refresh a low-energy pup is to take a break with a quick walk or some other activity that he or she enjoys. Mix it up a little!

These senior ladies easily overheated and tended to move slowly. I chose to photograph them in one of their favorite spots on the cool kitchen tile and to use their peacefulness to document their typical energy.

REACTIVE OR SHY DOGS

It is possible to photograph shy dogs, but special care and extra self-awareness are required. I've encountered this issue frequently over the years, most often at animal shelters. (The reactive ones are typically off-limits for photographing until they can be taken through some kind of behavior training, if it's available.)

While not always the case, I've found that most people who call upon photographers for portraits don't *typically* have reactive dogs. If I run into situations where I am concerned for my safety, I will either not photograph or will photograph from a distance if it feels doable. Photographs are important, but so is safety.

Certain dogs may not be considered shy to their owners but will act nervous or shy around strangers. In these situations, I will be very patient and calm, keep my voice subdued, and maintain a strong sense of awareness around the dog. I'll introduce equipment extra slowly and may even put a treat on my lens hood to associate my camera with rewards. If this approach doesn't work and I still don't have any photographs, I'll use a long lens (70–200mm) and mute my camera noises so that there are no sounds coming from my camera other than the shutter. (My camera has a focus "beep" option for auto focus.) Creating a greater distance between you and the dog with a long lens is often the best solution. If you need to, you can have the pet parent and the dog engage in some kind of activity to distract the dog while you photograph.

If I encounter a dog that is afraid of the flash or large strobe, I will stop using it immediately and figure out another way to make the photo session work without the added light. I don't think it's worth wasting the dog's energy or stressing a dog because of an idea I had initially.

At the end of the day (or photo shoot), we can only do our best as pet photographers—we are not magicians. Each dog and circumstance is going to be unique, and having a bunch of tools in your toolbox will set you up for success to not only troubleshoot when challenges arise, but also come out on the other side with strong imagery and pride in how you navigated the situation.

Otto was very nervous about my camera, despite my slow introduction and easy movements. I ended up photographing him with a 70–200 mm lens from across the patio.

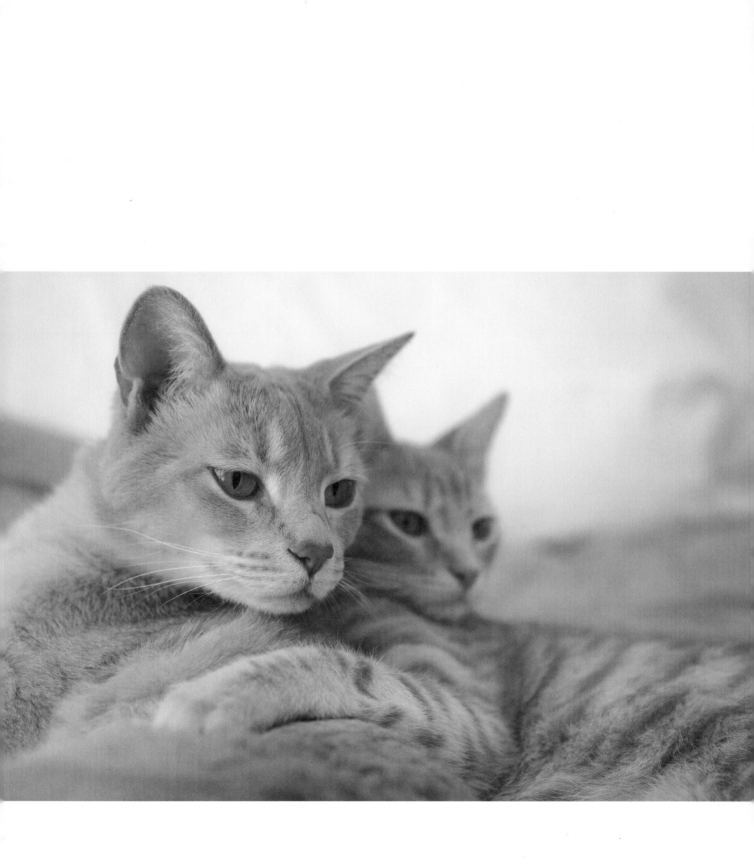

CHAPTER 8: PHOTOGRAPHING CATS

It's no secret that I adore cats. I think they are beautiful, intriguing, loving little beings that offer companionship to many, including myself. Photographing cats comes with different challenges than photographing other pets—that's no surprise. However, they possess just the right amount of mystery and sass to keep things interesting during the photo shoot, and these traits can really shine through in your portraits in a stunning way.

While cats aren't typically as popular as dogs in terms of commissioned portraits, they deserve to be photographed with just as much consideration. You may find yourself photographing your own cats at home, at an animal shelter, or as part of a commissioned portrait on location or in-studio. Getting tuned in to their unique behavior and creating awareness around what's possible will help you navigate your cat photography pursuits.

Understanding Cat Behavior

I'd be a liar if I said that photographing cats is easy. This adventure is certainly challenging for reasons unique to their species. But I think the images that you can create for yourself and others are worth the extra effort and commitment it takes to capture them.

Ideally, we want cats in our photographs to be relaxed or playful and not scared or angry. Happy cats are much better in photographs than the alternative—both visually and experientially. It's important to look at both the positive, happy signals, as well as the stress signals, to set up your photo shoot experience for success.

Developing a general understanding of feline communication that occurs via body language and through verbal means is going to help you as a pet photographer. As you begin to recognize cats' methods of communication, you will be empowered to adapt your behavior and approach as needed for the success of your photo session and for everyone's well-being.

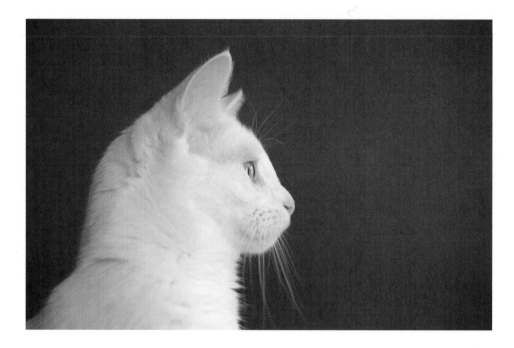

RELAXED, HAPPY CATS

Cats really share their opinions about their surroundings and circumstances with you. Like dogs and other animals, cats will respond to their environment both verbally and with their body language. Of course, cats all have different personalities, and not all will act or respond the same way. Some cats are verbal and action-oriented, while others are more sedentary and low-key.

Contented cats can exhibit many different signs of communication. Some show signs of curiosity as they check out you and your equipment by rifling through your bags. They might be playful or respond to playful cues. Mr. Kitty may instantly rub up against your leg or "headbutt" you (which is actually a way for him to get his scent on you but is nonetheless a positive sign that he is comfortable with you).

If a cat is *really* comfortable with you, he may lie on the floor, wiggle around a bit, and show you his belly as if to beg you for love and attention. He may even knead a blanket, the bed, or the air. This behavior is so cute to me—and impossible to resist. Although it might seem strange, a super relaxed cat may even drool!

If you have permission to pick up the cat and notice a soft space between their shoulder blades, they are relaxed.

A cat with soft, partially closed eyes is likely comfortable. Perked ears that are directed forward tell us that Mr. Kitty is ready for his closeup and not overly stressed. Also, a cat's tail can give you a lot of helpful feedback. No movement or a slow "swooshing" movement of the tail is typically a sign of a calm feline.

While cats are generally pretty quiet, some can be very vocal and will share lots of "opinions" with you. Meowing or little cat "barks" can certainly tell you that a cat is happy but wants attention of some sort. Purring is typically indicative of a happy cat, although this sound can also be used as a calming mechanism and can mean that the cat is under a bit of stress and trying to calm itself.

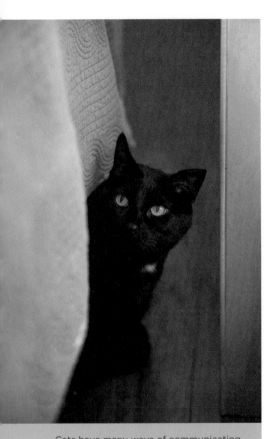

Cats have many ways of communicating their reaction to their environment and to you. This cat was nervous and wanted to hide as a response.

STRESSED CATS

When cats are stressed, they will let you know in a variety of ways. Their most common physical reaction when being photographed on location is to disappear by hiding in rooms or underneath furniture. This can be very challenging and is certainly an indicator that they need some time to get used to you.

Cats display other types of body language beyond the disappearing act. A stressed cat may try to make themselves look larger by raising the fur on their back and tail or standing sideways to increase the dramatic effect. They might twitch or swoosh their tail very quickly and in short bursts, indicating that they are either stressed or irritated in some way or that they are feeling extra spunky and want to play. (This "play" could result in pouncing on you or your camera, so be prepared.) If a cat's ears are pinned back to their head, they are either not happy or feeling super feisty. In either case, I advise that you adjust

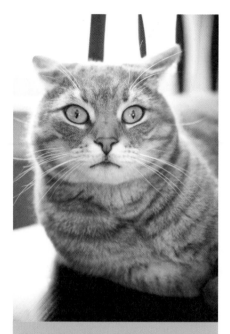

Mr. Stinky's ears pulled back along his head indicate that he isn't in the mood for photographs at this particular moment. His look can be one of stress but also an indicator of possible feisty behavior to come.

something you're doing so they can calm down a bit. Also, as opposed to calm cats, the space between the shoulder blades will be very tight, indicating tension.

A very upset cat could try to scratch or bite, but this type of behavior will usually be preceded by other body language signals. Scratching can sometimes occur through play, so it's always best to have the pet parent trim their nails prior to the session, if possible.

Angry or scared cats will generally hiss if they are afraid or angry and even growl at you with a deep sound that you can quickly recognize as an indicator of unhappiness. Like dogs, a stressed cat will shed an excess of fur and will lick his or her lips.

Just like with other pets, it's a good idea to gather information ahead of time about the typical behavior and demeanor of the cat, as well as find out how they usually react to strangers in the house.

SLEEPY CATS

If you're not familiar with cats, you should know that they sleep a LOT! While they may not be sleeping the entire time you are photographing, it's important to know that this is the norm for them. I love sleepy cat portraits, and you'll want to get some of those if you have the opportunity. However, you will likely want more than portraits of them taking a snooze.

Self-awareness

You'll want to pay close attention as you're interacting with cats to signs of contentment and stress, and adjust your behavior accordingly. Regardless of your goals for the portraits, it's important to remain very self-aware so that the cats are happy and the photographs make you and the pet parent happy.

Pay close attention to how your presence and your movements impact how the cat responds. Are you seeing the cat display signs of stress, or does he or she display signals that tell you that they are content with you and the situation?

I can't honestly say that it's always possible to create pet portraits without some level of stress to the animal. As a pet photographer with a job to do, I can't stop a portrait session if a cat starts shedding or licks her lips a few times. I can, however, adjust my actions and try my best to remain sensitive to the situation and do what I can to create a calm environment. Throughout the session, I check in with the owner to make sure they're feeling good about continuing. All I can do is commit myself to doing the best I can with each individual situation and use the many tools I've gathered to do so.

PHOTOGRAPHING YOUR OWN CATS

If you're lucky enough to have cats in your family, photographing them is a perfect way to build your experience and generate a bank of ideas for cat portraits. Photographing your cats at home allows you to choose the best time of day for their mood, as well as work when the natural light looks appealing. When you're at home and have your camera ready, you can capture sweet moments of them lying around the house, playing, or sunning themselves in a

window. You may find yourself creating photographs for 10 minutes, and then the moment passes. This is not a problem when you're photographing your own cats, as you can go about your business and wait for another moment to present itself.

You can also take time to set up specific lighting with a little studio setup in your own home. You can give the cats plenty of time to get used to the equipment and any backgrounds, which is really helpful. Having the freedom to leave these items set up for a while may offer you creative opportunities that would not be possible if you were photographing in someone else's home.

Photographing cats in your own home gives you the chance to experiment, make tons of mistakes, and gather ideas for other shoots that you might try with cats outside of your home environment. Maybe there are fun angles and perspectives or a new lighting technique you can try out and really take your time to see what works well. The more time you spend observing and photographing your own cats, the more opportunity you have to practice. Take advantage of it!

PHOTOGRAPHING SOMEONE ELSE'S CATS

Photographing other people's cats is not the easiest activity, partially because cats tend to get a little more nervous around strangers than dogs do. I've even experienced this with my own cats when I have had photographers come into the house. This reality may be a challenge, but photographing other people's cats is certainly not impossible.

I will always give my best effort to capture beautiful photographs for my clients. I find out as much as I can about the behaviors and character of the cat before I meet him or her. However, if a client calls me and tells me that their cat is very skittish, I cannot promise that I will be able to capture many portraits. That's just the reality.

Give yourself plenty of time when photographing cats. I find that photographing them in their own environment is the best way to capture and interact with them. Bringing them into a studio can be quite stressful for them, and as a result, much more challenging for you.

When you enter a cat's home (let's call our subject "Moo"), be sure to spend time introducing yourself and allowing Moo to settle in with you and your equipment. Moo may want to smell your camera, bags, and you in order to get comfortable. Make your movements slow and subtle, and keep your energy

subdued so that Moo doesn't get too star-
tled. If it's OK with Moo's owner, this may be
a good time to offer a treat or two (if she'll
take it) to establish your new friendship.
Pay close attention to how Moo responds to
you, and be as patient as possible.

Communicate with Moo's parents, and let
them know that you came prepared to take
your time. Letting them know that you're
expecting to take some time will often
help them stay positive and calm. If Moo's
owners are assisting you, maintain clear
communication with them throughout the
shoot. Kindly indicate that you will be try-
ing to get the cat's attention unless you
say otherwise. You don't want them trying
to force anything too quickly or adding to
chaos, as you might lose Moo's willingness
to participate.

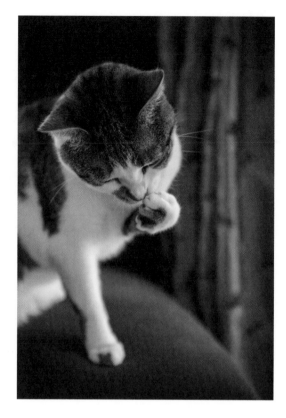

Posing Cats

OK, "posing cats" is a bit of an oxymoron. Cats don't typically know how to sit,
stand, or lie down like dogs (or maybe they all do and they're just messing with
us). Having acknowledged this, it is still possible to have a game plan that can
produce results when it comes to photographing these glorious beings. To do
this, we need to recognize their qualities as cats and as individual characters.
We must think like cats.

While I love closeup images of cats and quite often create these types of
images, it's going to be important for you to move beyond the headshot and
photograph cats in other positions, as well as have the creative option to
include elements of their environment.

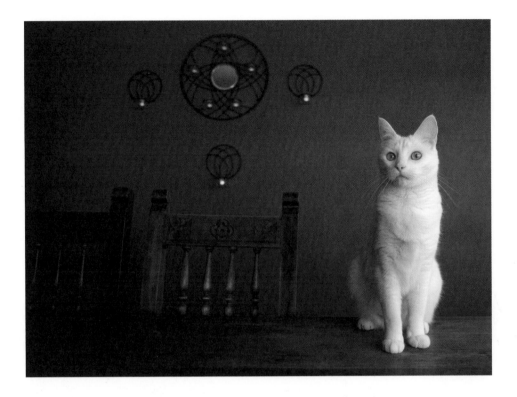

WHERE TO START

Much more so than with dogs, the location for photographing cats is often heavily weighted on where they like to spend time and are comfortable. While their favorite spots might change from day to day, these spots are at least good places to begin. Some of the typical locations cats tend to be comfortable might include:

- Couch
- Chair
- Cat hammock
- Cat tree

- Bed
- Table or chair
- A bag, box, or bowl

Cats that are permitted to go outdoors will have additional options for locations, including:

- Flowerpots
- Outdoor furniture
- Patios

- Trees
- Flowerbeds

By all means, don't limit yourself to these locations, but keep them in mind. Cats generally seem to feel comfortable off the ground, but you may encounter a cat that is perfectly content to sprawl out on the carpet or wood floor.

If you have allocated the time for it, you can choose to wait until the cat gets used to you and just settles in comfortably somewhere before you start photographing. This may take a little more time and gives you less control over your backgrounds but is a totally viable option.

If you discover a spot within a location that might lend itself to a stunning composition, you can make an effort to lure the cat to that location with a treat or toy or simply physically bring them there and see if you can get them to stay with a treat or good ol' fashioned love fest. As a note of caution, I don't generally recommend picking up other people's cats or any other pet without checking in with the pet parent beforehand.

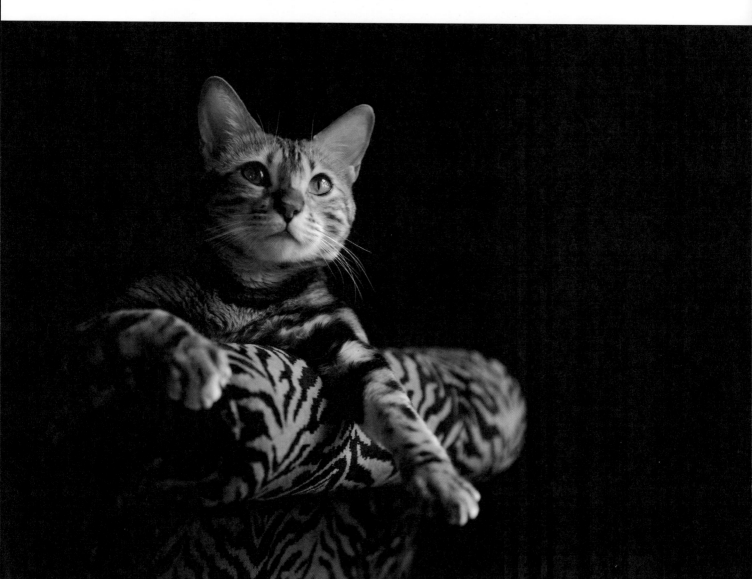

PHYSICAL HANDLING

I often physically handle the animals I photograph, as long as I've checked in with the pet parent and I'm paying attention to the important communication signals. Physically connecting with the animals I photograph can be very helpful and often necessary for animals that aren't very trained. I might adjust their position slightly, have them to sit or lie down by applying a gentle amount of guidance, or pick them up to place them where I want them for a composition or specific body position. In the case of cats that are pretty calm, I will pet them with one hand as I photograph them with the other. In between petting, they may change their body positioning or expression, and sometimes they will roll over onto their back, exposing their belly. I will continue to intermittingly pet them and remove my hand as I press the shutter.

Sometimes I find that if I keep petting a cat or even just keep my hand on them after I have positioned them, they kind of give in to being in that new spot or body position.

LIMITED ACCESS

Once you decide where you want to photograph, I highly recommend closing all doors that aren't part of the portrait and limiting the access to rooms and spaces that you aren't using in the creation of the photographs. You don't want to find yourself chasing a cat around a house unnecessarily, not only because it takes a lot of extra energy and effort on your part, but mostly because cats can get extra nervous or excited with this kind of activity going on around them.

BACKGROUNDS

One of the logistical advantages of photographing smaller animals like cats is that you can often photograph in smaller areas and can incorporate smaller background elements. For example, you can add a splash of color as a background element with a section of a couch or chair or small area of a wall. I've even used the side of a refrigerator as a white background that worked quite nicely.

THE DETAILS

I love the details of cats—whiskers, paws, special markings, tails, or beautiful eyes. It helps to work with a lens that allows you to photograph close up in some way rather than having to overly crop an image later. I tend to prefer images that are captured in-camera as tight frames rather than extreme crops.

USING YOUR RESEARCH

Use the information you've gathered about the cat to help you generate ideas about where and how you want to photograph them. As we know, most cats enjoy sleeping, but beyond that, what are the activities they enjoy? Some possibilities may include:

- Being brushed by their pet parent

- Drinking water from the faucet

- Chasing a laser light

- Playing or hiding under the bed covers

- Getting their belly rubbed

GETTING THEIR ATTENTION

Like with dogs, getting a cat's attention may vary drastically from animal to animal. This is why you'll want to come prepared with your bag of tricks (both mental and physical). Cats are generally more responsive to visual stimulation than dogs are, so you'll want to start using toys and tricks that might capture their eye first. Here are some items you can use to attempt to gain a cat's attention:

- Toys they already have and enjoy

- New toys that might spark their curiosity (for variety)

- Catnip—placed in an area where you'd love to photograph the cat if they are being lethargic

- Thin, curly sticks (from the floral section in craft stores). They're lightweight enough for you to use as a way to direct their gaze

- Feathers and cat teasers

- Pipe cleaners, curled up or straight

- Ribbons and string—with a knot tied at the end to provide a little weight and give the cat more to try to grab

- Sounds—created with your mouth or even through noise-making toys. You'll know right away if they are effective

- Tapping on the window or scratching the wall or fabric of a piece of furniture

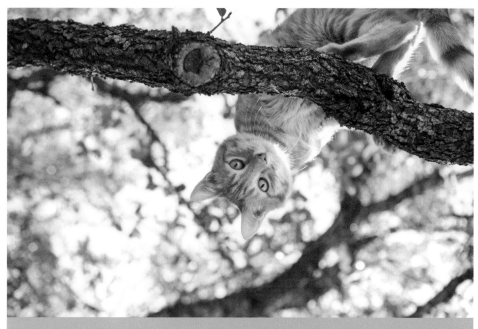

Fuego was having fun climbing this tree, and I used a piece of long grass to get his attention for this image.

Just having these objects won't ensure that you get a cat's attention. I will often see new pet photographers holding a toy next to their lens without moving it, expecting the cat to become interested. While this photographer might get lucky and the cat will gaze up into the lens, a stationary toy isn't going to do much for you or them.

IF YOU'RE USING TOYS OR ATTENTION-GETTERS, everything you do to get the cat's attention needs to either evoke some sense of response based on their sense of curiosity or become part of play. Use these tools sporadically and alternate your movements. I find that quick movements with toys tend to evoke more of response than slow ones.

Scratching sounds tend to be quite effective, for example, scratching your lens hood or a reflector or nearby surface. Crinkling aluminum foil or plastic bags is another way to generate some interest. If whatever you're doing doesn't elicit the desired response, stop and move on to something else quickly. Like dogs, cats can get desensitized and you'll want to retain as much of their energy as possible. Treats and stinky food can also work well for cats who don't seem to respond to anything else. I once photographed a blind and deaf cat and was able to use the scent of food to position them for a portrait. While treats aren't typically my "go-to," I have had very good results with them.

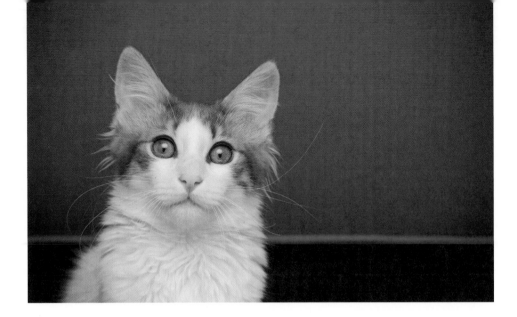

If the cat you are photographing shows signs of fear or aggression as you introduce any of your attention-getting toys or tactics, take a break for a few minutes. Perhaps move to a different room within the location, or try using a longer lens if he or she continues to act nervous or overly stressed.

If the cat you are photographing completely disappears, try to have the pet parent find them, rather than chase them around the house. If, after you try treats, play, and other luring techniques, you are unable to get the cat where you want him or her, you may need to settle for photographs by the bed, under a couch, or hiding by a curtain.

WORKING WITH KITTENS

I love photographing kittens. Kitten behavior is very different from adult cats, and most of the considerations regarding the demeanor of adult cats flies out the window when photographing kittens. While there are always exceptions, kittens tend to be quite playful and curious and are not generally as nervous about changes to their environment as adult cats. The challenge when photographing these little guys and gals is typically that their energy is quite high, and they don't like to stay in one place for long.

Attention-getting rules and techniques all apply to kittens, with the exception of catnip, which for some reason, they don't respond to until they get older. The best option for photographing kittens is to lure them wherever you'd like them to go with some kind of toy, laser light, or cat teaser; or physically pick them up and move them.

Kittens tend to pounce a lot so be ready for that. Once I was photographing a kitten that jumped on top of my lens!

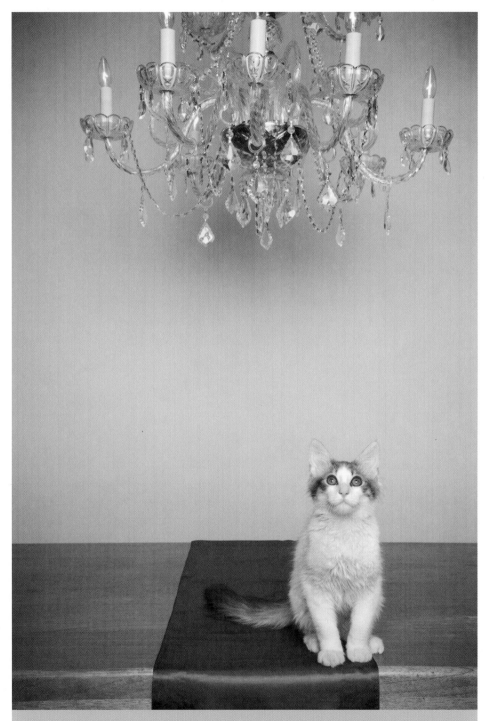

I loved photographing this kitten with the chandelier and the simple, soft-toned background. Kittens are typically so curious and playful. For this image, I set up studio lights and lured the kitten to the table with a cat teaser.

Light

The best light for photographing cats depends on the mood I'm trying to convey, the demeanor of the cat I'm photographing, and the general time I have to accomplish what I need to in a given session. If I have a very specific idea in mind that requires the look of studio lights or I really need the extra light for exposure and depth of field, I may choose to set up lights and see if the cat will be accommodating. If I have an assistant, I may be able to accomplish more by having them set up the lights for me while I photograph in another room.

Most of the time, however, I prefer harnessing the natural beauty of window light when photographing cats indoors and find that working with natural light helps me focus on capturing expressions and interactions and gives me more time to photograph.

I highly recommend trying all options so you can experience the values of each approach. You may determine, like me, that a combination of lighting approaches is most helpful. You get to choose what works best for you!

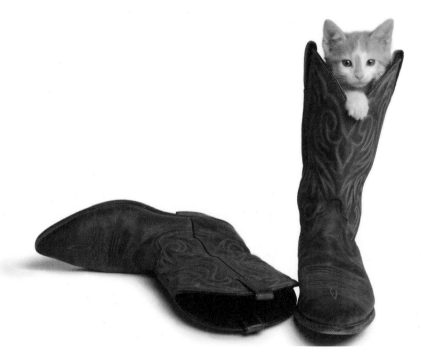

Window light is such a great resource for cat portraits. You don't always have to show the window, but in this image, I chose to reference the curtains as a compositional element.

WINDOW LIGHT

Window light is my favorite kind of light for photographing cats. It helps that cats tend to be drawn to the warmth of sunlight spilling through a window. While this is, of course, not the only light option for cat photography, it's certainly one that you'll want to be open to as you work on location.

I typically set my ISO to 400 as a starting point for window light situations and try to get the room as bright as possible by opening as many curtains and shutters as I can. Any extra light in the room will help fill in some of the contrast if it's too extreme.

If the contrast is way too high, I'll tape diffusion material to the window to soften the light a bit. If there are strong beams of light coming directly through the window causing bright highlights and dark shadows, exposure can be difficult and the diffusion material is an inexpensive and quick solution.

Since the window light often creates a backlit situation, I like using a foam core reflector or other type of white or silver reflector to bounce light back onto the cat. If I do this, I need to watch my reflection in the glass so that my reflection

isn't a huge distraction in the images. If this happens, I'll adjust my perspective. If I don't have an extra hand to hold a reflector, I will prop it up against a chair, a wall, or anywhere else where I notice it making a difference. Cats don't typically seem to get bothered by stationary reflectors, once they're in place. If they fall over or move a lot, however, it can be startling to them.

When I am photographing a cat in a window-lit area, I will change my perspective as much as I can to see how many different images I can create while the cat is in one place, comfortably sleeping or just hanging out.

You can also use the contrast of window light to create more dramatically lit portraits. If you angle yourself in such a way that incorporates a darker background (either dark in color or not lit by the window light), the resulting images can look almost like studio-lit images and feel more dramatic. If you have a helper or the pet parent is willing and you want the cat to look outside, you can have your helper go outside and make movements with a toy to keep the cat's gaze toward the window light.

STUDIO LIGHTS

I have used studio lights to photograph cats and know it can be a really beautiful option. It is not my go-to approach, mostly because this added element can cause undue stress and may mean that I don't get the shot at all. Small strobes can sometimes act as a good in-between solution, because they're a little less bulky.

If you are going to use studio light, either with a seamless background or environmental scene, you'll likely need to lure the cat or cats to where you want them. Unless the cats you're photographing are trained or super comfortable with strangers and strange situations, you may need the help of an extra hand, as well as a dash of extra patience.

If you're having trouble getting the cat to be comfortable, my suggestion is to choose a location where the cat already spends some time, so at least one element is familiar to them. I realize this isn't always possible and that sometimes the best place for the cat isn't the best place for the photograph. The most beautifully lit scene won't do you a lot of good if the cat isn't comfortable in it.

Don't let the challenge of photographing cats stop you from following your vision of using studio lights in your favorite spot or with your favorite modifiers on location. I encourage you to think big and make all efforts to turn your vision into reality. Just be ready to adjust and be flexible, if needed!

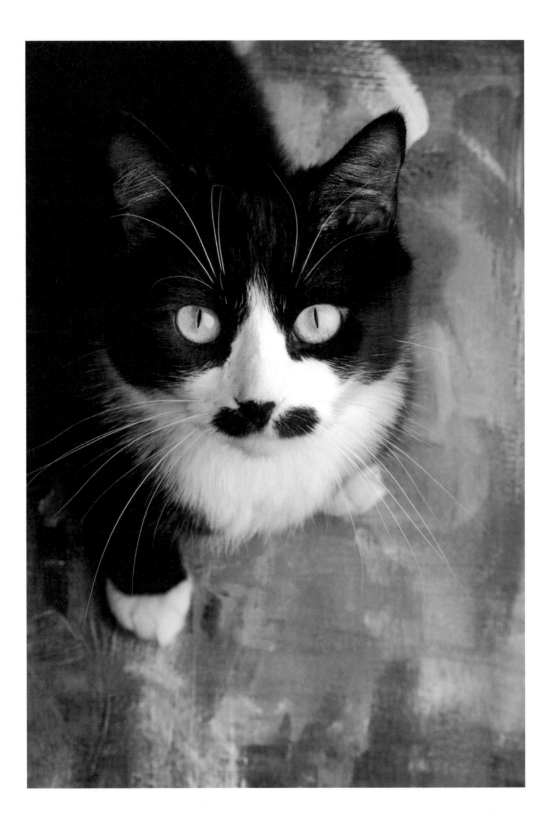

Getting Creative

If you find yourself photographing a cat that is comfortable with whatever situation he or she is in, try to get as creative as possible by moving yourself before moving the animal. This approach will help give you a lot more options in a given time frame.

I changed my perspective and used a shallow depth of field (f/2.8) to create this image.

DEPTH OF FIELD

If a cat is napping or comfortable lying on a sofa by the window or you are limited within the location to make a big change, you can play around with depth of field to get some variety in your images. I know I can sometimes get a particular idea stuck in my head of what an image should look like based on the scene or location, and it's important for me to remember that I can create lots of variety by changing the depth of field.

KEEP YOUR EYES OPEN

If the area in which you are photographing could use a little aesthetic help, see if you can move a piece of furniture or adjust your perspective to simplify it and make it more pleasing. Look for small areas with interesting color, texture, or shape to use as backgrounds. See if there are elements you can shoot through, like windows or doors, or perhaps incorporate framing devices like curtains or material to add something a little different to your images.

I tucked myself in between these curtains when I noticed the opportunity to use them as an interesting framing device. I waved the material around to get the kitten's attention.

Photographing Cats with People

Cats offer unique companionship to their pet parents, and I love capturing their relationship with my camera. When it comes to photographing cats with people, the best thing we can do is bring a willingness to be flexible and patient and make it easy for everyone to be as relaxed as possible.

It would be so easy if all cats loved to be held when you want to hold them, wherever you want to hold them…and in front of strangers. The fact is, this isn't always the case.

BEFORE YOU START

I always try to remember to have a short chat about the game plan before I start photographing people and cats together. I remind the pet parent that I will guide them and that if I want something different, I will let them know. I ask that if they are looking at their cat, they try to refrain from a lot of talking and keep their interactions to a physical connection. If they want to pet their cat, I will want to avoid the "claw" hand, so I ask that their hands stay open and soft. This little pep talk seems helpful, because it guides them from the beginning toward what I want visually and gives them a few directions.

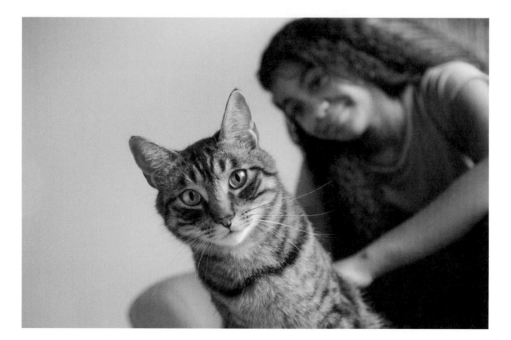

DIRECTED INTERACTIONS

If you run into a situation where the cat and pet parent you are photographing happen to be very easygoing and comfortable, you may find success in giving the pet parent a lot of direction regarding posing and body positioning.

Some cats love to be snuggled and held, and if that's the case you are definitely going to want to take advantage! You can photograph the person on the same level as the cat or have the cat in his or her lap, maybe even positioned cheek to cheek. In these situations, you can provide specific directions for where you want their hands positioned, for example, and really fine-tune the image as much as possible. You don't always have to have the person or cat looking into the lens and might direct the person to look at the cat or elsewhere.

You might work this way for a little while and then switch gears to a more passive role as photographer if you notice the cat needs a break or the energy has stagnated.

BEING AN OBSERVER

If I find the owner or cat to be a little nervous or I simply feel like trying a different approach, I may choose to start the session by taking on a more passive or reactive role. I may ask the person and the cat to interact within an environment that works for me visually and is comfortable for the animal and give minimal instruction. With this approach, I am reacting to what happens rather than actively directing my subjects. While the observer or reactive approach has similarities to my directed, proactive portrait approach, it's different in the sense that it can be more activity-based. Creating at least a portion of the portraits this way can take a little pressure off everyone feeling that they have to look a certain way or even look at the camera!

By being an observer, I am waiting for a moment that captures that connection between the two subjects, where the person is fully in the moment, enjoying their time with their cat.

If the cat likes to be brushed, it might create a great opportunity for a portrait or sweet moment to be documented. A pet owner gently petting and nuzzling his or her cat can help to convey an authentic moment of connection between the two. If a cat is feeling playful, photographing play between a cat and owner can also be a fun documentation of their bond.

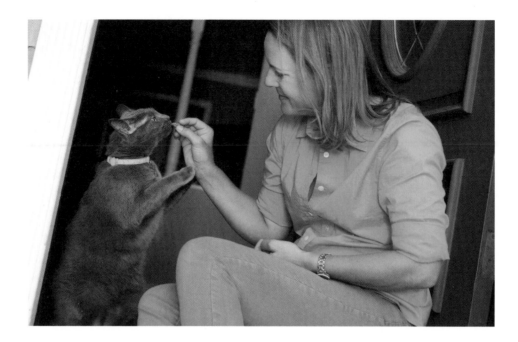

Photographing this bond between people and animals is one of my favorite things to do. I like to encourage interaction on a physical level and remind them to smile as it comes naturally but not to talk too much, because it's hard to photograph a talking person without it looking awkward. I need to make these moments translate well into photographs, and these are all ways that help me do that.

In order to make sure I don't miss too many sweet moments, I will have the pet parent wait to interact and play until I am initially set up with my exposure and lighting. If a major change occurs that requires me to regroup with my settings or equipment as interaction is happening, I might ask for a pause in activity in order to save everyone's energy.

You don't necessarily have to commit to photographing a session that is fully directed or fully created with more of an observer role. It's a good idea to have an awareness, however, of your position as you move along during the session so you can clearly communicate with your subjects. Most of the time when I am photographing I find myself transitioning from a more passive approach to a proactive one. If I see a body position or interaction that I really love, I might pause a passive approach and direct for a few minutes. I communicate with the person I am photographing along the way as much as I can.

During cat portrait sessions, the cats are the ones that usually dictate the role you will need to take! And no matter which approach you choose, it's important

to continue to provide positive feedback and encouragement to whomever is in front of your lens.

PEOPLE AS PROPS WITH CATS

Because cats don't typically follow directions as well as dogs (although I am convinced they know exactly what we are saying and choose to ignore us half the time), it can be helpful to use their human as a "prop" for the portraits. For this approach, the human will be there to hold the cat gently in place with a hand or in their lap. I can choose to crop out the human's head and focus in closely on the animal and include the pet parents' hands as a nice reference. I also might choose to use a shallow depth of field, focus on the cat, and let the pet parent fall out of focus. This is a good option when Mr. Kitty isn't cooperating or just as another creative possibility to try.

PRACTICE MAKES PURRFECT

Go for it! You now have a ton of knowledge to get you started with your next cat portrait session. If you have your own cats, start practicing with them or with a friend's cat. Pay special attention to their reaction to you, maintain an awareness of your energy, and start to build your toolbox of techniques for getting creative on location with these loving companions.

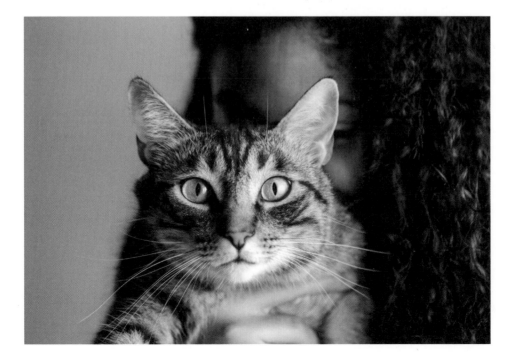

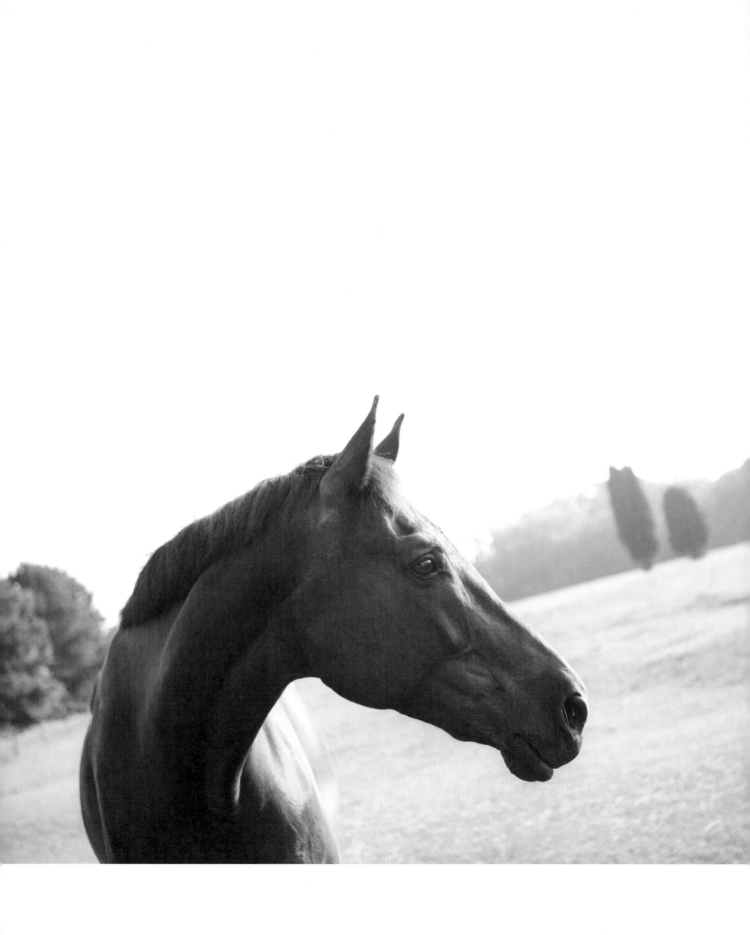

CHAPTER 9: PHOTOGRAPHING HORSES AND OTHER ANIMALS

I welcome the opportunity to photograph animals of all shapes and sizes. While dogs are the primary type of pet I tend to photograph, horses and other types of animals have also become part of my life as an animal photographer.

This chapter primarily focuses on horses, but it will also cover some helpful tips on photographing other animals. I am here to support you in feeling prepared and confident, so you can creatively and logistically handle any pet you find in front of your lens.

Horses

Horses are elegant, beautiful creatures that, in my experience, have a very unique bond with those who adore them. I love photographing these magnificent beings, and I really enjoy capturing the powerful partnership between horses and their people.

To clarify, I am not so interested in capturing images of the owner riding the horse, nor am I keen on photographing horse events or competitions. While these types of photographs have their place and value in the equine world, it is simply not where my interests lie. I find it rewarding to capture the organic connection that emerges through emotion and sweet moments of interaction.

UNDERSTANDING HORSE BEHAVIOR

Horses are very large animals that might be intimidating if you are not used to being around them. They undoubtedly command respect, and I recommend developing a sense of their behavior before you start photographing them—for your own safety, as well as for others. Like other types of pets, gaining some basic knowledge of their mannerisms and general reactions will help you have a smooth experience and make more impactful images.

One of the things that held me back from photographing horses for some time was the misconception that I had to know *everything* about them. Not a rider or horse owner myself, I felt as if I wouldn't be able to do the photographs justice, and I was definitely intimidated by the size and power of the animals.

In order to overcome my intimidation, I decided to enlist the support of my friend, Joy, who had multiple horses of her own and years of experience working with them. She shared loads of knowledge about how to interact with these beautiful beings. I gained valuable experience spending time around Joy and her horses, watching her interact with them. As my understanding of their behavior grew, my intimidation of horses transformed into respect.

If you have the opportunity, seek out someone in your community or network who may be willing to allow you to spend time watching them interact with their horse(s) and share their knowledge with you.

BEFORE THE SHOOT

When you are planning the session, start by simply asking the horse owner to tell you about the horse you'll be photographing. If you want to prepare even further, consider doing a little research on the type of horse you'll be working with. You don't need to know everything about the horse ahead of time, but more knowledge is often helpful.

One high-value way to prepare is to find out about the horse's temperament. Some terms that might be useful include: gentle, quiet, hot, spooky, nervous, easily excitable, or stubborn. Be aware that just because the owner may describe their horse as quiet, for example, it doesn't mean that the horse is incapable of being frightened or of reacting to something that makes them uncomfortable. Knowing the horse's general demeanor, however, will give you a good indication of how you'll be able to work with them.

It's a good idea to have a discussion with the horse owner about regular feeding times, so you can adjust if you'll be photographing during that time. It can take a while for horses to eat, and if they need to eat in the middle of the photo shoot, you'll be missing out on some valuable time. I find that having the horse fed prior to the session is helpful so that they have a full belly and aren't agitated because they are hungry.

Ask the owner to either bring or have snacks accessible (like carrots or whatever their horse likes), or bring some yourself. Treats for horses can be perfect rewards and provide extra incentive during the shoot.

Unless you'll be photographing the grooming process, kindly remind the owner that their horse should be presentable for photographs—brushed and groomed as needed, ready to go when you arrive. Bridles, halters, and leads should ideally be clean if they're going to be included in the shoot. If the horse tends to have an issue with flies and typically requires fly spray, it's a good idea to ask the owner to apply it before you begin.

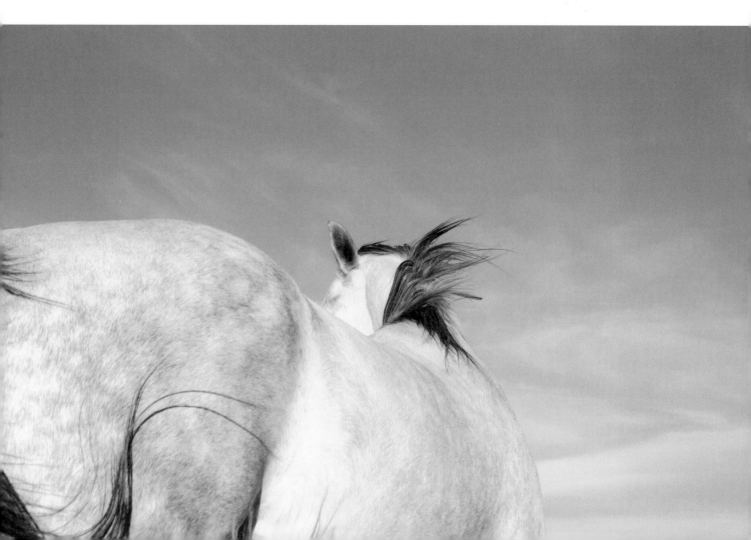

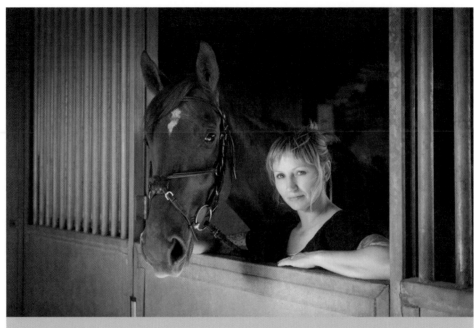

The light in this barn stall was beautiful and made for an interesting background.

Ask about the location where you'll be photographing, and if possible, scout ahead of time to gather ideas and set priorities for your session. Before the shoot, find out what the owner is looking for in the session. Here are some questions you may want to ask:

- Do they want a natural setting, a structure like a barn, or both to be featured?

- What important features of the horse or horses are they looking to capture? What do they love most about their horse?

- Do they want photographs of grooming and prepping the horse?

- Is there anything you need to know about the horse in terms of do's and don'ts?

- Will the owner be included in the portraits?

- Is there any special activity or physical exchange that the horse and owner share that you might capture?

If the owner/rider will be photographed, I want them to feel confident about how they look. I suggest that they dress comfortably, but a little more dressed-up than they would be if they were just riding the horse on their own time. They may or may not choose to wear riding-specific clothing, and a helmet is really only necessary if they're going to do a lot of riding.

BODY LANGUAGE AND SAFETY

There is a vast amount of information available regarding the behavior of horses, and as you dive deeper into the equine world, I invite you to research away. For the purposes of getting you ready to create photographs of horses, I will stick to some of the main factors I've found to be most helpful. When I photograph horses and interact with horse owners, I do not pretend to know more than I do about horses, but rather, ask plenty of questions and check in with the owner as we navigate our way through the session.

The most important element of safely photographing horses is to maintain awareness of your body language and energy and to notice how the horse responds as you interact with them.

A HORSE'S PERSPECTIVE

Horses' eyes are on the side of their head, unlike dogs' and cats' eyes, which are on the front. Thus, horses have some blind spots that are important to be aware of as you're moving around them while photographing. They can't see directly behind them, directly below their nose, or directly in front of their forehead. As you approach and move around a horse, make sure they are aware of your presence before moving around any areas they can't see. You can do this by talking to them, or you can introduce yourself to them from where they can see you, and maintain a connection to them with your hand. This way they can make a connection between the person they've met and the presence to the side of them or behind them.

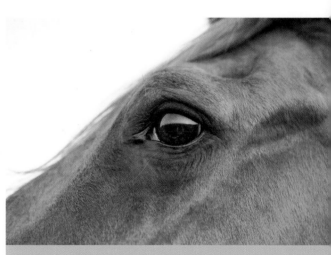

Horses' eyes are on the side of their head, not the front, like dogs' or cats' eyes.

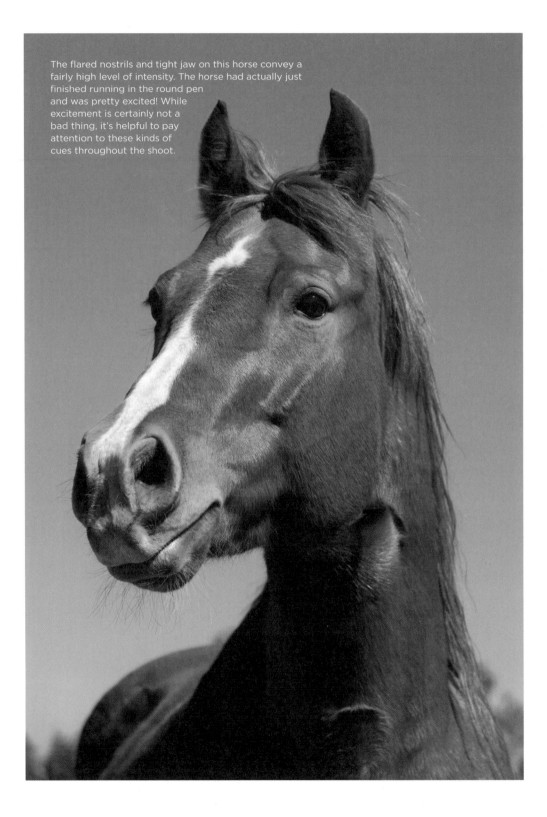

The flared nostrils and tight jaw on this horse convey a fairly high level of intensity. The horse had actually just finished running in the round pen and was pretty excited! While excitement is certainly not a bad thing, it's helpful to pay attention to these kinds of cues throughout the shoot.

It's wise to stay out of the horse's "kick zone," which is anywhere in their blind spots where their legs can reach. Horses can kick out to the side and back behind them, so stay out of this area as much as possible. Remember, just because an owner has told you their horse has never kicked before doesn't mean they're not capable of it, especially if they're startled.

EARS

Horses' ears can provide very helpful information. Pinned-back ears (when they're tightly folded against their head) generally indicate that a horse is upset or afraid. When their ears are turned to the side—just one or both—it can indicate that they are listening to something on the side or behind them. Forward-facing (perked up) ears can mean that they are listening to something in front of them and are alert. Perked up, forward-facing ears are generally the most desired for portraits.

I love creating images in which the horse's ears are perked up and facing forward. This is not always possible, especially if I am working alone or if the horse just isn't in the mood to perk up!

EYES

Relaxed horses have soft eyes that aren't open so wide that you can see a lot of the white areas. If they're really relaxed, they may even close their eyes. When I am photographing, I want to capture images in which the horse has relaxed eyes, and I will always pull images that show the whites of the horses' eyes because they look too intense.

BODY

Like dogs, horses often exhibit their response to the environment and others through their musculature. For example, a horse with a clenched, tight jaw is showing nervous tension or stress. Ideally, we want to photograph and interact with horses that have soft mouths and relaxed musculature. This can be a subtle indicator of their reaction to what's going on around them, but valuable nonetheless.

WEATHER AND BEHAVIOR

Weather can absolutely impact the behavior of horses. Windy and stormy days can result in overstimulation and make it difficult for them to remain calm for portraits. Even storms in the distance can affect the temperament of a horse. If your goal is to create serene portraits, it might be a good idea to reschedule for calm weather days.

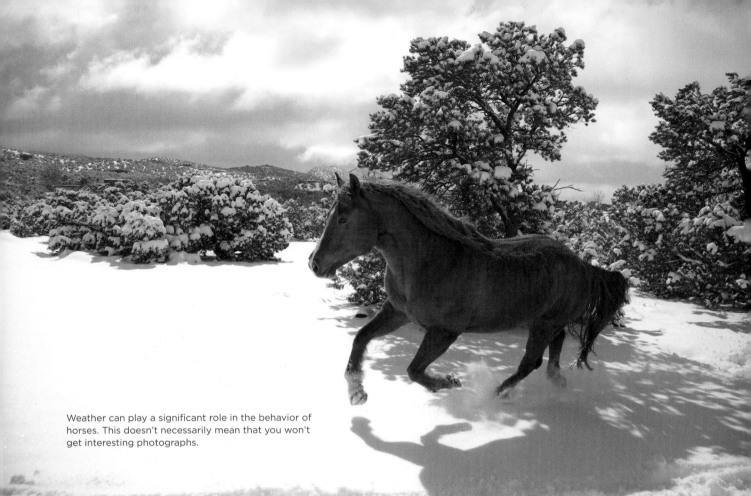

Weather can play a significant role in the behavior of horses. This doesn't necessarily mean that you won't get interesting photographs.

The Shoot

Portrait sessions with horses, as with other types of animals, require decision-making about location, timing, communication, attention-getting, and aesthetics.

LOCATIONS FOR HORSE PORTRAITS

Most of the time I photograph horses in and around where they spend their time. This location generally includes a structure like a barn, a round pen, a fenced-in arena, or a nearby open space.

SHELTER STRUCTURES

The types of structures where horses are boarded or live vary as much as houses for humans. You may find traditional wooden barns or beautiful corrugated metal barns that are dedicated to keeping horses sheltered from the elements. They can all photograph quite well and may lend themselves to your portrait creation. I love having the option of photographing in and around a

structure of some sort, because it often allows for open shade lighting and fun compositional elements like color and texture. Also, in a barn or other structure, the horse is contained in some way, making it easier to capture details. Most of my favorite images of horses, however, are created away from structures.

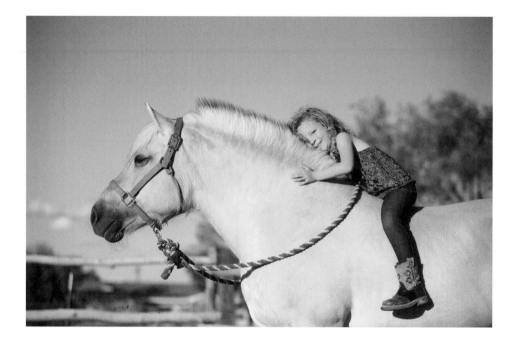

ROUND PENS AND ARENAS

These types of spaces, which are fenced in and used mostly for training purposes, can be a great place to capture action. The fencing isn't usually an element I'm interested in including in my composition, at least from the inside. But on the outside, fences can come in handy for photographing people with their horses. For example, a person can sit on or lean against the fencing as a great option for posing. If I have to create portraits in an area like this, I will try to diminish the background using a shallow depth of field or see if there is a way to change my point of view, either by photographing from up high or down low. If the horse is going to be running, I will usually want to stay along the fence line and shoot with a long lens or stand in the center of the pen as the horse moves around the perimeter.

OPEN SPACES

My favorite location for photographing horses is in an open space, clear of fences and other structures. I love creating images in big fields with tall grasses, flowers, or beautiful trees. The challenge of photographing in open spaces is that photographing the horse solo may not be safe, as the horse could get

loose or harmed. So, if I am shooting in an open space, I usually enlist the help of the owner and will use my friend, Photoshop, to remove the person from the image later.

OTHER LOCATIONS

I tend to stick with locations where the horse is comfortable and spends time, but don't limit yourself if an idea for another location strikes you. If you find the horse is really adaptable and the owner is excited and up for transporting the horse, by all means, go for it!

TIMING

Once I've made a decision about my favorite location(s) to photograph, I will determine where the sun is going and how the light will shift so that I can decide where to start. Sometimes my location choice at the time is based more on the light than the location.

The amount of time a horse will cooperate for a portrait session will vary greatly and depend on the particular horse's temperament, the weather, the owner's energy and involvement (or lack of involvement), and the types of images you're trying to get. My sessions with horses typically last no more than two hours, and I usually don't use a lot of equipment (unlike other types of animal sessions, which is why those can take more time). I find it helpful to do most of the static images toward the beginning, and as I notice the horse losing interest or getting a little restless, I'll capture more candid-type images. I will also give the horse breaks from having to do anything or holding still; I will use that time to regroup, adjust my equipment, determine my next steps, further connect with the owner, or capture detail images.

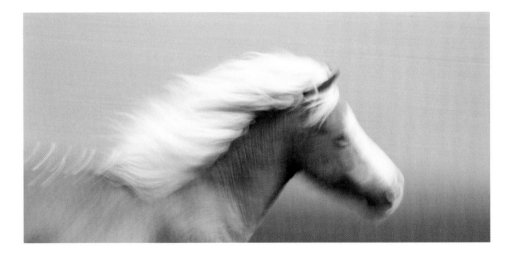

I tend to push just beyond the point when the horse is finished with the photographic experience, because I really want to make sure I've given 100 percent to the creation process. I do so, however, with sensitivity to the fact that when the people and horses are really "over it," I won't get anything positive by continuing.

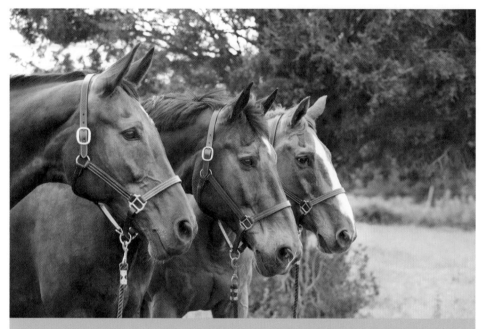

I often feel that less is more when it comes to accessories for horses, but sometimes the circumstances call for including them. It would have been much more difficult to photograph these three horses together if they weren't wearing bridles.

TACK

Tack for horses includes bridles, stirrups, saddles, halters, reins, and bits—or any other equipment that is used on a horse. Some basic knowledge of these items is helpful for when you're photographing and directing. If the owner of the horse really loves a particularly fancy bridle, you may want to photograph it on the horse and get some nice detailed, closeup images.

In general, I gravitate toward including minimal tack in order to keep things simple, but I am certainly willing to work with what feels best for the client.

HORSES AND YOUR ENERGY

When I first meet a horse, I will typically leave my camera at my side or even in my car. If the horse seems curious or even tentative, I may let them smell my equipment and me and settle into my presence.

When you're around horses, do your best to keep your energy soft and slow. Keep your actions small and notice how your presence and actions are affecting them. Each horse has unique characteristics and will react differently to you, your actions, and your equipment. If you are stressed and frazzled, moving too quickly and dropping a reflector, for example, may spook a particular horse.

HORSES SOLO

When I photograph a horse, I usually enlist the help of the owner and photograph in an enclosed area, so the horse doesn't get harmed or lost. An owner can help guide the horse or hold his or her attention (the level of cooperation depends on the horse's demeanor and training level).

Horses generally like to graze if they have the freedom to do so, and this can be a challenge for photographing them without their owner. In general, I will either have the owner hold onto the reins or help guide the horse's head upward (and later digitally remove the reins), or see if I can get the horse's attention enough for them to lift their head on their own. The other option is to photograph a little tighter and crop out the owner or helper.

DETAILS

I love photographing details during a photo shoot with horses, and these shots can be quite meaningful to owners. For example, horses' large, striking eyes can work really well as detail images. Sometimes I will photograph their mane, markings on their coat, or even nametags and special tack that is worthy of documenting. While detail images are typically not the images that clients choose as main wall portraits, they can be great for albums or wall galleries.

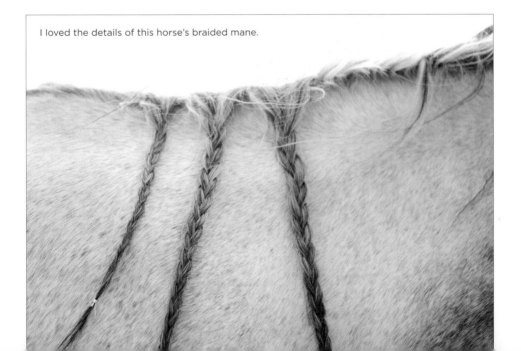

I loved the details of this horse's braided mane.

GETTING A HORSE'S ATTENTION

Horses primarily respond to sights and sounds that are coming from a distance. They don't typically respond to squeaky noises, although some will perk up at the sound of their owner's voice or clicking sounds.

Your ability to gain the attention of the horse will shift dramatically depending on his or her demeanor and mood at the time. Some horses are desensitized to most sights and sounds and will likely require novelty or big movements to get their attention, whereas a very nervous horse could get perked up easily with something quite subtle. For attention-getters that go beyond noises you make with your mouth, it's important to ask the owner's permission and ensure that you test out your attention-getters when everyone is prepared and not mounted on a horse. Some ideas for attention-getting, which may require the help of an assistant or the horse owner, include the following:

- Reflective surfaces at a distance

- Umbrellas opening and closing at a distance

- Treats in a bucket making noise

- Someone waving a piece of grass at a distance

- Tasty treats (carrots or apples) as incentive

- Dancing and general movement of a person at a distance

- Throwing something (such as rocks or dirt) up in the air at a distance

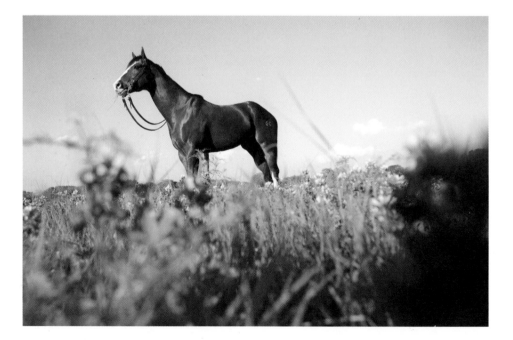

If you test out one of these ideas and the horse seems stressed, you'll want to shift your approach. If you're not sure how to tell the difference between the horse being curious and stressed, check in with the owner, and they'll easily let you know whether or not it's OK to continue. Whatever you choose to do, make sure you do it in short bursts, because horses can get desensitized pretty quickly and you don't want to miss that perfect moment by using your attention-getter when you're not ready to press the shutter.

If you don't have an assistant and you are photographing a horse and person together, just do your best and see what you can do on your own to get the horse's attention. You might be pleasantly surprised.

LIGHTING AND GEAR

Generally when I photograph horses, I bring a ladder, some large reflectors, my camera body and lenses, attention-getters, and a small flash unit with a small softbox on a pole (to be used if I have an assistant). While it is totally possible to photograph horses with studio lighting (and even in the studio), it is not usually my approach. I like to focus on my connection with the horse and the client or person I'm photographing and not make the experience too gear-heavy. Also, having a large amount of equipment slows me down and, as discussed, can be startling to a horse. Unless I'm going for one amazing "hero shot" for my portrait clients, less equipment gives me more freedom.

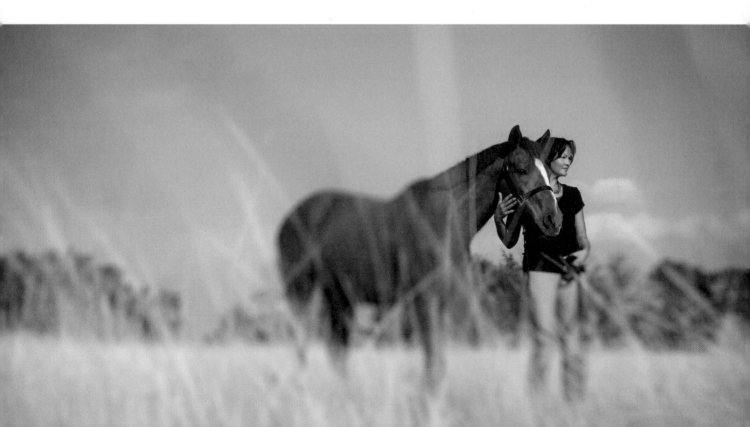

Because horses can get a little nervous around equipment, I am always sure to communicate clearly with the owner to ask if they have a sense of whether a flash or a reflector might startle the horse. If they don't know, I will ask permission to test it out while the person is at a safe distance from the horse. If the horse backs away dramatically after the pop of a flash or the raising of the softbox, they are showing me that they're uncomfortable, which is a signal for me to either stop or continue very slowly (with the permission of the owner) to see if the horse will get used to it. If the horse is unfazed by what I am doing or introducing, I'll continue as long as I like the results.

If I decide to put my reflector down for a while, I will put something heavy on it so it doesn't blow away in the wind, which could really frighten a horse. Use care when opening and closing the pop-up reflectors, as those guys can get away from you easily. Likewise, if you choose to set up a light, I highly recommend that you have a helper stand with that equipment to ensure that it doesn't blow over and startle the horse. I also suggest setting your equipment bags off to the side so that if the horse runs, he or she will not run over your bags and hurt themselves and your gear.

This may seem like lots of do's and don'ts, but once you start interacting with horses, photographing them will become second nature and will not seem overly prohibitive. Feel free to develop a way of working with your equipment that works well for you, but maintain communication and awareness in order to keep you, the horse, the owner, and your equipment safe.

People and Horses Together

Horses possess a unique grace and strength, and I love capturing the bond between horses and their people. Horse owners typically spend a lot of time with their horses, and as a result they are very in tune with one another.

COMMUNICATION DURING THE SHOOT

Good communication from the beginning of your interaction with the person and horse you are photographing will help create a smooth, more successful experience. I already addressed the benefits of finding out as much as you can about your subject before you photograph them, and I encourage you to continue this communication as you photograph.

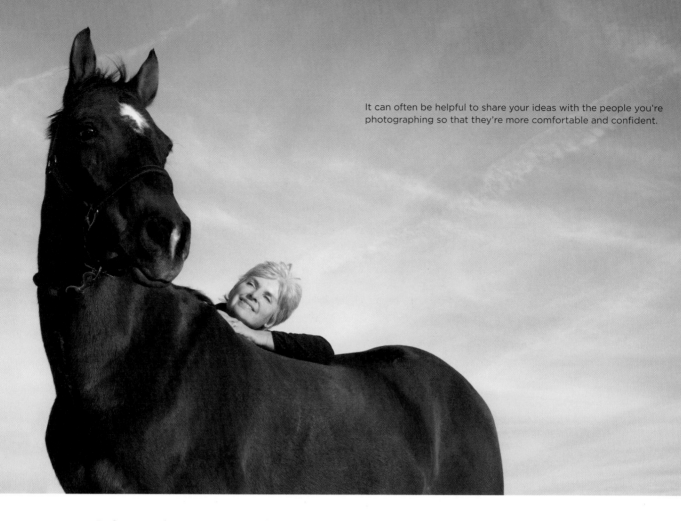

It can often be helpful to share your ideas with the people you're photographing so that they're more comfortable and confident.

Before you begin, communicate your ideas with the person who will be in front of your camera. You might address wardrobe choices, locations you have selected, or specific ideas you have in mind. Sharing your game plan sets them at ease and makes them a collaborator in the process. You can use phrases like, "I was thinking we'd start over here by the barn" or "I love the way what you're wearing contrasts with this background, so are you comfortable beginning over by those trees?" You may also want to ask if they have their own ideas. The more involved they feel as a collaborator, the more they'll enjoy themselves and the more comfortable they'll appear in front of the camera. If I ask for my client's opinion and I get a response like, "I don't have a clue. You're the expert," I'll back off from asking their opinion and recognize that they'd really just like to be told what to do and where to go.

If I find that I need to adjust my settings, add some kind of lighting element, or move my position, I will communicate these things as they come up. I want to make sure that everyone knows what's going on, including my assistant if I have one. If there is going to be a longer pause, it might be good to have the owner walk the horse around a bit to refresh them.

Even if I get frustrated with myself or I am struggling to get something right, I am always sure to stay positive with the people and animals in front of my lens. If I look down at my camera and make a face or a noise, the person I am photographing will likely feel insecure and think that they did something wrong or don't look good. If I overexpose a few frames without realizing it, I practice keeping my mouth shut and my attitude positive.

Once the photo shoot gets started, I often allow the interactions between the horse and owner to develop on their own. I want to make sure I allow for some surprise moments, gestures, and actions and respond to them.

The easiest way to remember to communicate as you're photographing is to remind yourself of what it feels like to be in front of the camera and how much you value being supported in that position.

POSING AND GESTURES

The posing and gestures that occur between horse and owner are quite different on a physical level from those between pet owners and their dogs and cats. I will certainly photograph a person on a horse as part of capturing their special partnership, but this physical setup can be somewhat limiting in terms of poses and gestures. I love having the rider lean forward to embrace the horse and get their faces closer together. This physical connectedness effectively turns the exchange from a more formal horse-and-rider relationship to an embrace of friendship and love. In general, I like to try to have the human's face close to the horse's face. This may be possible if the person is standing on the ground, sitting on a fence, or even standing on a ladder behind the horse. Positioning their faces closer allows for a tighter image, which offers nice variety and more intimate portraits.

When I am trying to capture more fluid, interactive images, I will ask the human to love on the horse by caressing it softly or embracing it. If I am going to try to get the horse's attention, I will communicate this with the human and tell them to stay focused on the horse while I gain the horse's attention. I will always need the owner's help getting the horse into physical position, but it can be difficult to have them help with attention-getting if they are standing next to the horse.

If the horse is wearing a halter and reins, I will have the person hold them loosely and with as soft a grip as possible. I find it difficult to photograph horses with bits (the metal pieces that are attached) in their mouths, because they often bite at them, which looks awkward in photographs.

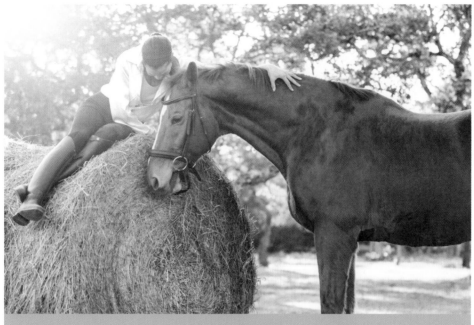

I used this hay bale to get the woman's and horse's faces closer together.

I will certainly ask for specific gestures, be very intentional about which side of the horse I want them to stand on, and so on. If I am committed to getting the best images, I make sure to ask the owner to move around and reposition the horse as needed.

FLATTERING A HORSE

I photograph horses with a variety of lenses and find there to be solid uses for all of them. I am mindful, however, to stay away from distorting horses' bodies by using a really wide-angle lens up close. This distortion elongates their noses, which isn't flattering for them. If I am going to use a wide-angle lens or wide zoom, I like to keep some distance to avoid this distortion (unless I'm going for an intentionally funny look). By contrast, longer lenses are quite flattering for horses; I love the 70–200mm in particular.

HORSE "WARDROBE" TIP

IF YOU PLAN ON PHOTOGRAPH-ING A HORSE WITHOUT A SADDLE, I RECOMMEND CREATING THOSE IMAGES FIRST. ONCE YOU PUT A SADDLE ON A HORSE, IT OFTEN GETS SWEATY AND CAN LEAVE LARGE DARK MARKS ON THEIR BODY. IF POSSIBLE, SAVE YOUR-SELF THE RETOUCHING TIME AND SADDLE UP LATER.

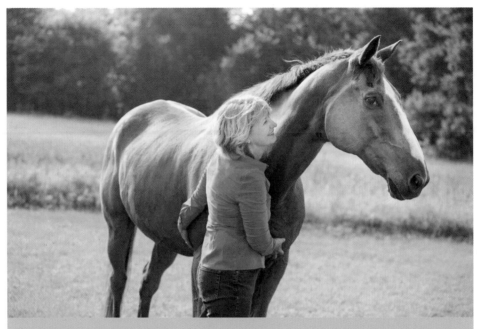
This image was created with a 70-200mm lens which helped soften the background without distorting the subjects.

My favorite view of a horse is a profile or partial profile, because this angle really shows off the sleek lines on their faces. I find it challenging to get a flattering photograph of a horse from a straight-on view, because the long body becomes truncated, turning it into a big blob (that's a technical term).

UTILIZING THE ENVIRONMENT

While I love moving in close and photographing details, making images that include a horse's environment—with people—is a powerful way to showcase compelling compositions and scenery, illustrate scale, and tell a story with your photographs. Each location will offer something unique for you to share with the viewer about that horse and owner's story. When the owner views these images in the years to come, they will be able to emotionally tap into that time and place, making the images that much more meaningful to them.

The bluebonnet flowers made for a beautiful environment for these portraits of Lauren and Tuf.

Other Types of Animals

I am intrigued by all kinds of animals. While I've photographed dogs most frequently, I have had some really magical moments working with a variety of species over the years. I've photographed a pig, goats, a rat, a bird, baby tigers (not pets but wow, was that amazing!), a monkey, a turtle, a chicken, a hedgehog, a duckling, peacocks, bunnies, longhorns, and a ram. The level of "petness" varies for each of these animals, but the opportunity to photograph these beautiful creatures has been a dream come true. With each type of animal, I have the opportunity to learn something new.

PREPARATION

The most important thing to remember is that these pets are likely going to be more unpredictable than dogs, cats, or horses; and as a result you will want to give yourself plenty of time, patience, flexibility, and a double dose of humor. Here are some things to keep in mind with other types of animals:

- Can the animal be held?

- Is the animal treat-motivated?

- Can the animal be put on a bed or couch or elevated in some way, if desired?

- What kind of environment is the animal in (indoors, in a cage, fenced in, free roaming, etc.)?

- Is there anything especially unique about this animal, for example, something special they can do?

- Can the animal be photographed with lights?

- Can I physically handle the animal as a photographer?

- Is there anything that you know of that seems to get his or her attention?

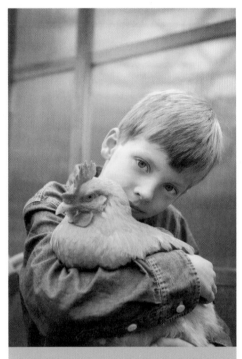

I loved this sweet moment between this little boy and one of his pet chickens.

ANIMAL ENCOUNTERS

Here are a few notes about my experiences with some of the different animal characters I've photographed.

THE PIG I photographed was super sweet and hung around with the dogs. He was very food-motivated (surprised?) and despised being picked up. He didn't seem to care much about the noises I made, which I thought was interesting. Pigs don't sit like dogs do, but they lie down, which made for a cute photo when he decided to nap in the bed. Pigs don't like slippery, shiny surfaces and generally don't let you know when they have to go to the bathroom, so yeah...that's something.

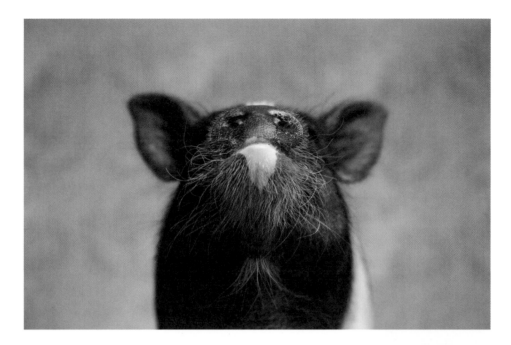

GOATS pretty much have their own thing going on, and the level of direction I've been able to give them is limited to treat bribery. Baby goats are easier to photograph while they're being held, but they are still challenging because they get distracted very quickly. Be prepared to move quickly when you photograph goats!

SMALL PETS that can be held, such as chickens, ducklings, tortoises, hedgehogs, rats, and mice will likely be easier to photograph with people holding them. I recently created some stock images with an educational petting zoo in Austin, TX. The company specializes in working with children, and I took the opportunity to capture children spending time with small animals.

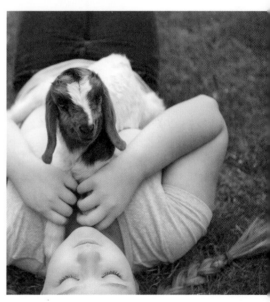

Photographing chickens can be quite entertaining, as they move and blink so quickly! If they're used to being held, I enjoy photographing them in the arms of either a child or adult who knows them. Even a sweet chicken that is used to being held won't let someone hold them for very long, so acting quickly is a must. I highly suggest making sure that you have your lighting and settings ready before having the person you're photographing pick up the chicken.

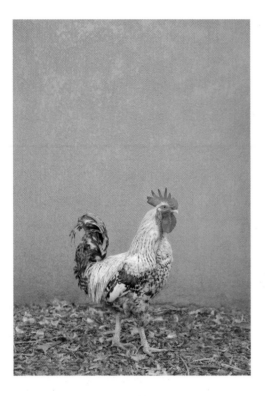

The biggest issue in terms of photographing these small pets—unless they're specially trained animals—is that they typically move around a lot and do what they want, when they want. This requires you to be more flexible as a photographer and go with the flow. The good thing is you may end up really surprised with the unplanned!

FARM AND RANCH ANIMALS aren't necessarily considered pets but can be beautiful animal subjects nonetheless, and I love to use imagery of these types of animals in my fine art. When I've photographed longhorns, peacocks, a ram, geese, donkeys, chickens, and roosters on farms and ranches, I've spent a significant amount of time at the locations, letting the animals get used to my camera and me, observe me, and respond to me. I am always sure to maintain self-awareness in these situations; it's important to stay safe and make sure the animals I am photographing feel safe, too.

You'll likely learn something new from each type of animal you photograph, even if you do your research and prepare ahead of time. Try to have fun and think of it as exploration!

FINDING SUBJECTS

If you're looking to create a portfolio of images with a variety of animals other than dogs, cats, and horses, you'll want to look in the right places. Do some research and reach out to businesses and organizations in your area that work with different types of animals. You may want to make connections at a local feed store where ranch and farm owners purchase food and supplies for their animals. See if there are businesses in your area like the educational petting zoo I mentioned, and look into the possibility of offering them imagery in exchange for some time with their animals or even paying a modeling fee.

As you talk to people and create your animal portfolio, you may find that people start to find you versus you finding them. As you create images, be sure to include them in your portfolio so that people can see examples of your work. "Renting" trained animals with handlers—as is done in the movie industry and

commercials—is an option, but you'll need to be prepared to invest some significant money if you go this route.

As time passes, I have found myself more and more interested in photographing a variety of animals, and I think this is a result of my curiosity and general admiration for animals and their beauty. Whether I'm photographing a beautiful horse with their person, or a little boy with his pet chicken or pig, I feel a sense of creative fulfillment. If you have the curiosity, I encourage you to explore photographing all types of animals to discover what resonates with you.

There are so many ways to get involved in animal welfare with your camera. Photographing animals ready for adoption is just one!

CHAPTER 10: PHOTOGRAPHING FOR NONPROFITS: GIVING BACK AND COLLABORATING

Chances are that if you're interested in pet photography, you have an affinity for animals. Regardless of whether you're involved with pet photography as a business or hobby, I highly encourage you to get involved with animal organizations and start contributing with your camera. Collaborating with nonprofits has been one of the most rewarding elements of my career as a pet photographer.

Photographing for Adoption

As I mentioned earlier in this book, photographing for my local animal shelter helped me gain valuable experience in working with animals. Unfortunately, many animal shelters are full of animals, and as a result there is a tremendous need for strong imagery to help them find homes.

LEARNING OPPORTUNITIES

Getting started photographing animals in shelters was especially difficult for me, because I felt emotional about the animals and their situation. Knowing that I couldn't adopt them all broke my heart—and I know this is a struggle for many photographers. In order to be able to continue contributing with my camera, I had to recognize the value in creating appealing imagery of these animals to highlight their beauty, to make finding a home more likely. Because many people search the Internet for adoptable pets, the photographs play a significant role in the animals' adoption chances—which makes this work very rewarding.

Because there are so many animals with unique personalities in one place, animal shelters are great places to help AND learn as a pet photographer.

Photographing in animal shelters taught me so much about the communication signals of dogs and cats, and it helped me build my awareness of their behavior in general. While I had pets of my own, photographing in a shelter gave me the opportunity to interact with a variety of characters, whose personalities ranged from extremely shy to super energetic and intense. Learning to understand so many different temperaments required a lot of patience and helped me build self-awareness in terms of how I engaged with animals.

During some visits to the Española Valley Humane Society (just north of Santa Fe, New Mexico), I would photograph 20 dogs and 15 cats, each personality different from the next. Because each animal had a unique temperament, I had to use a variety of approaches to get their attention—which was really good training for me! With some I made loud, exciting noises with my mouth so that I could keep my hands free; whereas others required more subtlety, such as hanging out in their kennel for a bit or offering a treat. As I photographed each animal, I paid special attention to their body signals, looking for signs of stress. My goal was to engage with each one and show their best-possible character, in spite of the stress they may be experiencing in a shelter environment.

For some dogs and cats, being photographed wasn't their favorite thing, but as long as I did my best to make them comfortable, I felt that a little bit of stress for the purpose of finding them a home was legitimate. Of course, in those types of situations, I didn't go beyond what was necessary in terms of capturing images; I'd get what I needed and move on.

TECHNICAL AND LOGISTICAL ISSUES

When you photograph in a shelter, you need to think and respond fairly quickly and navigate some less-than-ideal lighting conditions. This is a great way to prepare for photographing in someone's home, where the lighting conditions can be challenging. Most of the time I used a flash and practiced bouncing the flash and diffusing it so that it was soft and appealing. Where possible, I would photograph with ambient light.

When I photographed in shelters as a volunteer, I would sometimes have an assistant or helper, while other times I found it was easier to capture the images on my own, especially with cats. If you choose to volunteer for this purpose, the shelter you connect with may pair you up with another volunteer to streamline the process.

Because there are often quite a few animals that need photographs, spending a long period of time with each animal might not be feasible, especially if you have another volunteer with you. These situations are good practice in thinking and responding quickly.

Also it's important to recognize that the shelter situation can be stressful for animals, so they may not be able to respond in the same way they would if they were in a comfortable home environment. Photographing shelter animals isn't the easiest way to explore pet photography, but it certainly offers many benefits for both you and the animals.

AESTHETIC CONSIDERATIONS

While there are certainly exceptions and a lot of variation, animal shelters are not known for being aesthetically pleasing, and this often meant that I needed to figure out ways to simplify backgrounds and make sure that the animal was featured in the most flattering way possible. I often did this by using a shallow depth of field and tried to avoid photographing any fences or gates whenever possible. I loved using a colorful blanket (approved by the shelter for use) as an out-of-focus background to add some vitality and contrast to the images. Just a little splash of color can go a long way.

If you have the opportunity, try photograph-
ing the dog or cat away from the confined
space of the shelter kennels and cages and
in a "warmer" environment like a garden
area, or in the case of cats, an interior or
exterior play area. Shifting the environment
helps the potential adopter envision that
animal as part of their family and induces
positive, rather than negative, emotions—
which can be a challenge with images
created in shelters. I have even seen some
very sweet images that implement props or
involve adoptable pets wearing necklaces
or costumes. I love seeing the creative ways
that photographers and volunteers help ani-
mals look their best and find homes.

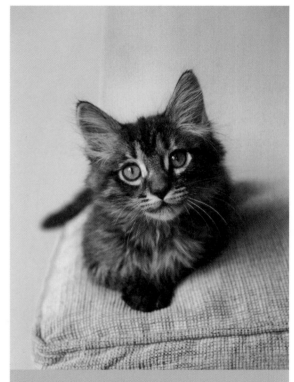

I enjoyed the opportunity to photograph this little kitty
in a home environment while she was in foster care.

FOSTER CARE

For a variety of reasons, shelters may not
be able to take in some animals; for exam-
ple, they may require special care before
they can be around other animals. In these
cases, foster care is required. Some organizations are actually structured
entirely on a foster care system and do not have a physical location at all.
Photographing animals in a foster care home can be a great chance to create
beautiful portraits for their potential adopters. You may be able to get involved
by contacting your local animal shelter to find out if they have a foster care
program or do some online research about other established foster care pro-
grams near you.

HOW TO BEGIN VOLUNTEERING IN SHELTERS

The physical facility and operational procedures of animal shelters can vary
dramatically from organization to organization. Some shelters have teams of
volunteers and a waiting list to help, whereas others are thirsty for assistance.
Because of the variety in these organizations, your experience aligning with an
animal shelter or humane society will also differ from one to the next. If you find
a group that feels like a good fit, I encourage you to share your photographic
skills to help homeless animals and the organizations that support them.

Start by looking on the shelter or humane society's website for listed volunteer opportunities and information. If this is not available, you may be able to find a phone number so you can call and ask about volunteering. Some humane societies even have volunteer coordinators, and if so, you can reach out to them.

Once you establish a connection, you will need to adhere to that specific shelter's volunteer training, if any, to be able to interact with the animals safely and according to the shelter's guidelines. Make sure that you are clear on which animals you are allowed to interact with (or not), based on health or behavior issues. No matter what, you want to make sure that you feel comfortable with the animals you're photographing.

As you begin to volunteer your time, my hope is that you start to develop a solid relationship with the organization, hone your photographic and awareness skills around all kinds of temperaments, and help some amazing animals find homes.

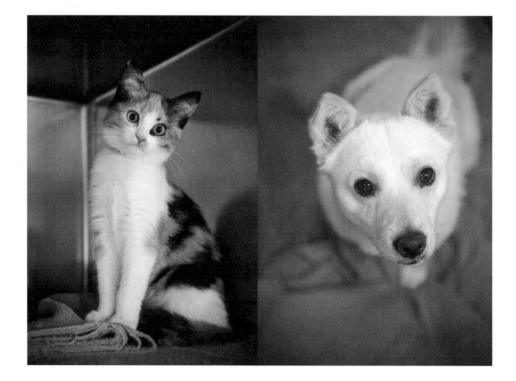

Collaborating with Nonprofits

In addition to photographing animals in need of adoption, there are lots of creative ways to collaborate on marketing efforts and special projects for non-profits. In addition to promotional imagery, special projects and fundraisers are also great ways to get involved and connect with your favorite animal welfare group.

MARKETING AND FUNDRAISING CAMPAIGNS

It's no secret that impactful images help sell products and convey messages to consumers. Even though animal welfare organizations are very different from a brand of jeans or sports drink, for example, imagery used for nonprofit animal welfare organizations is effective in very similar ways. Photography helps animal welfare groups keep the community and their donor base in tune with their message and presence. Compelling images seen on websites and social media, in print, and in e-newsletters have the potential to catch a viewer's eye and perhaps lead them to pause for a moment and consider donating, adopting, or getting involved in the organization in some other way.

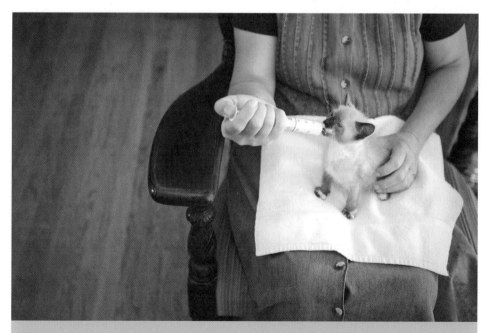

This image was part of a small marketing book of images intended to illustrate the many positive aspects of the Española Valley Humane Society in northern New Mexico. This particular image was representative of their foster care volunteers.

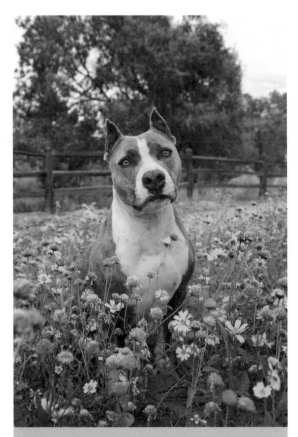

I photographed Lill as part of the marketing project for Española Valley Humane Society. She beautifully represented the shelter and all the possibilities that come from adopting a dog and perked up quite nicely after hearing the crinkle of a potato chip bag. Lill was adopted from the shelter in 2008. She went on to become a registered therapy dog with Pet Partners and primarily visited schools and worked with children, but in later years visited hospice patients as well.

I am very inspired by the possibility of supporting a meaningful cause by generating imagery that has the potential to reach a wider audience. I have really enjoyed working on animal welfare marketing campaigns and appreciate participating on longer-term projects that contain a succinct body of work.

If you are interested in these kinds of opportunities, you may want to start building a relationship with an organization you care about and sharing your ideas, as well as listening to theirs. Keep in mind that it may take some time to cultivate these relationships.

SPECIAL EVENTS AND PROJECTS

Animal welfare groups often host creative events to help their cause, and photography can certainly play a valuable role in these kinds of activities. You may even come up with your own ideas and pitch them for consideration. Mobile adoption events, calendars, photo booths, auctions, fashion shows, dog walks and races, and fundraising galas are just some of the activities that call for a photographer. As a new pet photographer, especially, this can be a great way to meet new people and get involved in the animal welfare community. Donating a pet photography session can help you meet new clients and also generate needed funds for the group.

While in New Mexico, I created a group of dog and cat portraits that were later printed and wrapped on the organization's mobile adoption van. This was a really fun project that helped raise money for the shelter and gave the donors an opportunity to have their pet featured on the outside of the van. These kinds of special projects are great ways to get involved as a photographer and animal lover.

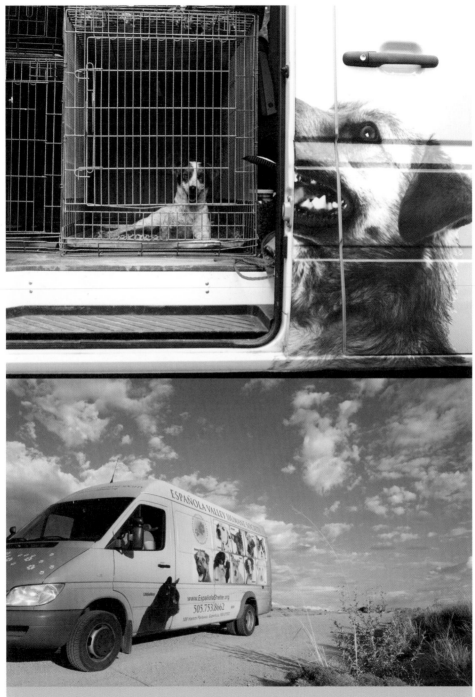

This van wrapped in pet portraits transported puppies from New Mexico to Colorado for adoption.

·GIVING BACK ... SUSTAINABLY

Should you donate all of your time and skills? When should you or can you get compensated for your time, talent, and images? What's the right thing to do? These are important questions to consider when it comes to collaborating and doing work for animal-related nonprofits. Unfortunately, there is not one "right" answer to these questions. My hope is that I can guide you in the process so that you can determine what's best and possible for you. Keep in mind that what is right for you may not be right for someone else, is based on many factors, and can change dramatically depending on these factors. Where you are in your career, your creative goals, your financial situation, and your other commitments can all impact your decisions.

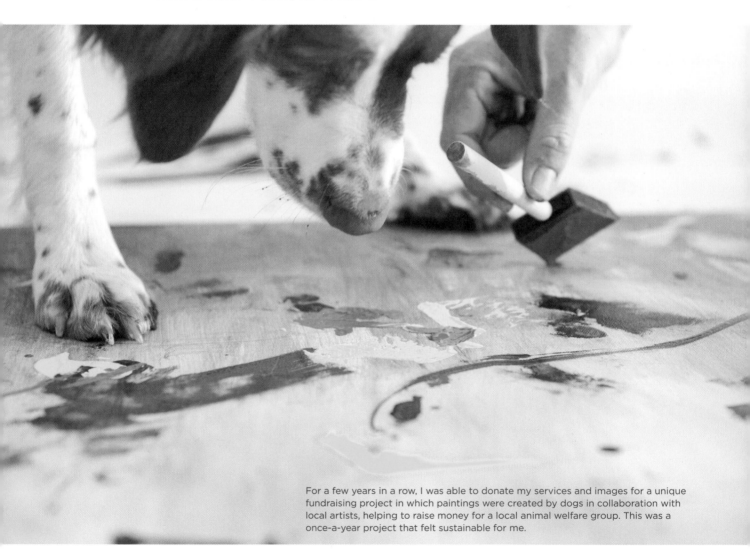

For a few years in a row, I was able to donate my services and images for a unique fundraising project in which paintings were created by dogs in collaboration with local artists, helping to raise money for a local animal welfare group. This was a once-a-year project that felt sustainable for me.

If you're like me, money can be a difficult topic to address, and talking about it with nonprofit organizations can be especially uncomfortable. They are, after all, nonprofits and often have limited access to funds. In addition, if you get paid for your services on any level, you may have the concern that you're taking away from the animals. These are valid considerations but aren't necessarily the case.

Whether pet photography is a hobby or your profession, it is an honor to help animals and organizations we believe in, and I 100-percent support donating some of your time and talent for these purposes. I've addressed some of the ways you can contribute by creating portraits of adoptable animals, photographing a fundraising event, or donating to an auction. But keep in mind that just because you enjoy taking photographs and love animals, you are not required to give beyond what you feel is right for you.

If you are a professional photographer, you will likely want to consider what is sustainable for your business and for you as an image-maker. Projects can range from a one-day event to longer-term commitments. There is a seemingly endless need for high-quality photography in the nonprofit world, and you are ultimately responsible for navigating how and if you contribute. If you choose to donate, I encourage you to do so with clarity and to feel **really** good about it.

Although photography has certainly become more accessible thanks to digital technology, being involved with photography doesn't come without financial investment, as you likely already know. Photography on a professional level involves expensive camera and lighting equipment that constantly requires upgrading, a computer and software, insurance, marketing costs, and so on. Consider that when you are donating your time, you are not making money with your other photography projects or spending time getting clients, so I encourage you to find situations that not only feed you creatively but also feel sustainable for your business in general.

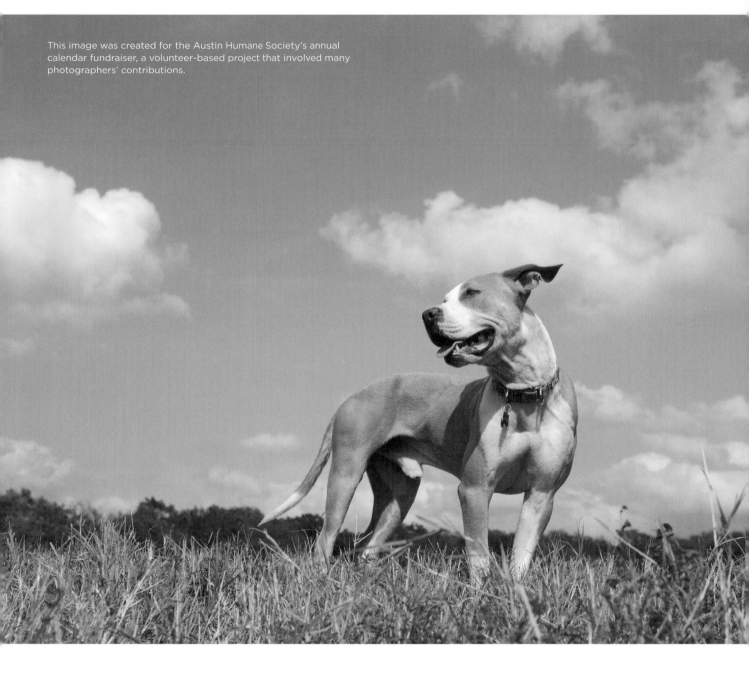

This image was created for the Austin Humane Society's annual calendar fundraiser, a volunteer-based project that involved many photographers' contributions.

To help me make decisions about whether I can or should pursue new projects, I've started to practice asking myself some questions: Is the subject matter within the scope of my interests?

- Will it challenge or fulfill me creatively?

- Would this offer me helpful experience that I could take with me to develop another project?

- Does the time commitment feel possible given my other projects and life priorities?

- Do I feel inspired to make a difference with the project or activity?

- Is this project financially sustainable given its parameters? Is it donation-only or is there an opportunity to receive financial support?

- Will it bring me joy?

Spending a little time answering these questions can help generate some clarity around nonprofit projects that may come up. Some of these questions might seem "selfish," but in the interest of sustaining my business, I often need to protect and nurture it. I love helping

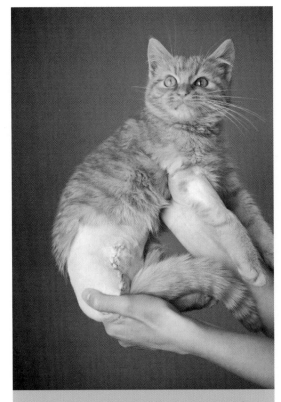

I created this image as part of a special project for the Española Valley Humane Society, to help raise funding for special medical cases. These stories touched my heart, and I was glad to be able to donate my services for the cause. I appreciated the challenge of creating beautiful photographs of emotionally painful situations.

animals and people, and at the same time, I need to honor what feels right for me and continue to be able to do this work for many years.

Photographing animals available for adoption is most likely going to be voluntary work, and unless the shelter has a full-time photographer, I really think this activity should be volunteer-based. However, larger projects, marketing campaigns, and other events may be funded.

If you're interested in a project and determine that you would require some funding to make it sustainable, take the time to discuss possibilities with the organization. Ask if they have a budget for a project or if there is a possibility to obtain a grant to cover your costs or compensate you as photographer.

Because I have been clear about what is sustainable for me and my business, I have been involved in some projects for animal welfare groups that were funded. Although my fees were significantly lower than they would have been for a for-profit business, being compensated on some level made working on the project doable. In these circumstances, the organizations I dealt with were happy to make an investment, because they valued how the imagery could help their organization spread a message to their donor base and clientele.

This image was created as part of a marketing campaign for Animal Trustees of Austin (now Emancipet). Text and graphics were later placed over the image to promote their services for the community. In order to make this project sustainable for me, I collaborated with the organization at a discounted rate.

Personal Projects

Sometimes you may really want to get involved in a project because it just feels like something you can stand behind, and it will bring you joy and creative fulfillment.

Personal projects are long- or short-term visual explorations that can be adopted purely as a creative outlet, a new challenge, a way to get outside your "norm" or comfort zone, or a way to produce social change or awareness. These projects can be large or small in scale, simple or complex, serious or fun, shared with no one or many. If you're finding yourself in a creative funk, personal projects can be a great way to refresh yourself and expose yourself to something different.

My experience with a personal project taught me a great deal about myself as a photographer and person and was one of the most rewarding endeavors I've ever undertaken. In sharing my experience and process of pursuing this project, I hope to inspire you to pursue any curiosity you may have for a personal project.

THE LIFELINES PROJECT

The Lifelines project is a personal project involving environmental portraits of homeless people and their pets and is dedicated to honoring their incredible bond. Rather than focus on the inherent sadness of homelessness, the idea was to create authentically joyful images in a similar manner to how I would approach photographing for my clients living in homes.

Not only did the process of creating the images change my perspective, but it also showed me the value of committing to a long-term endeavor for which I had curiosity. Much to my surprise, the project transformed into something much bigger than myself.

THE BEGINNINGS

When I moved to Austin, Texas, from Santa Fe, New Mexico, I was eager to build community and get involved with the animal welfare world, as it was such an important part of my life in New Mexico. I connected with Animal Trustees of Austin (now merged into an incredible organization called Emancipet [www.emancipet.org]) to learn about their programs in the hopes of being able to contribute with my photography.

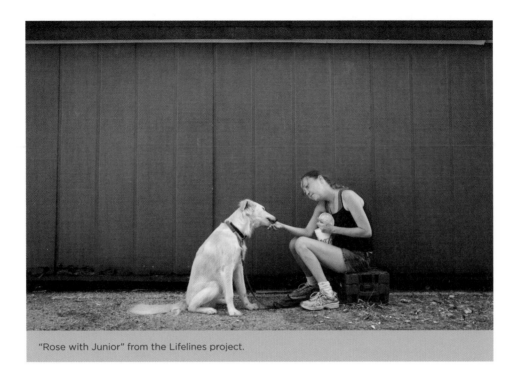

"Rose with Junior" from the Lifelines project.

When I learned about one of their programs, which provided free services to the pets of the homeless, I was immediately inspired to start a personal project. With the organization's blessing and the valuable help of one of their employees at the time, Gabrielle Amster (co-creator of the Lifelines project), I was eager to begin. I would have a head start in finding subjects by connecting with clients who had used the organization's services and who might be willing to participate in the project. My hope was to create portraits and capture short audio pieces that would help build awareness around the need for providing veterinary services to the pets of the homeless. I called it the Lifelines project, because I felt it perfectly referenced the close relationship between people and their pets. I wasn't initially clear what would happen with the images and audio after they were created, but I anticipated sharing them with the public somehow—perhaps in an exhibit.

Over the course of the photo shoots, we shared information about the Animal Trustees of Austin programs and brought some supplies for the animals, and Gabrielle even coordinated appointments for some of the participants.

THE INTENTION

I wanted to create images and capture audio that focused on the relationship between homeless people and their pets in a way that was beautiful and sincere

and that allowed the viewer/listener to shift possible judgments about who "should" and "shouldn't" own a pet. I wanted the love conveyed in the images and audio to invite a sense of empathy into the narrative. We may not think we have anything in common with a homeless person, but so many of us can identify with how it feels to love a pet. I wanted this commonality to open people's minds and, ultimately, help the pets of the homeless get the care and support they needed to stay together and stay healthy.

When I initially envisioned the project, I hoped that the pets were being treated with love and that I would be able to create authentic portraits of beneficial, loving partnerships. I promised myself that if in the process I did not find this to be the case, I would stop. While I can only speak from my experiences, I was grateful to find the majority of the relationships to be mutually beneficial and positive.

I wanted the audio pieces to allow the listener to further understand the value of the relationship between each person and their pet, specifically, as people living on the streets. Gabrielle did an incredible job producing the audio pieces for the project, and I really think these pieces added tremendous value to the project.

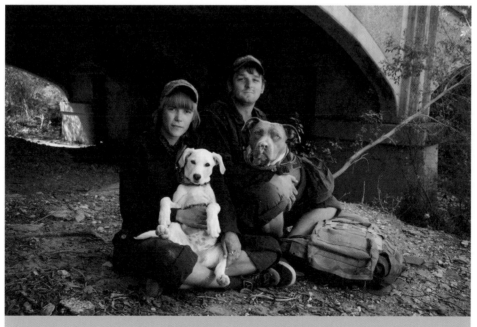

"Maggie and Eric with Dixie and Reptar" from the Lifelines project.

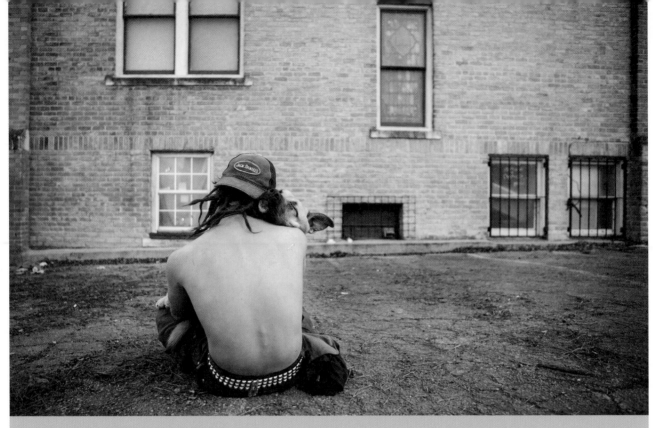
"Connor with Super Max" from the Lifelines project.

Part of what helps me capture authentic moments between people and animals is spending time interacting and engaging. For the Lifelines project, I wasn't interested in grabbing snapshots of people and pets as I walked by in the streets. It was a priority for me to take a little time to allow them to be comfortable in front of the camera and focus on their relationship with their pet.

THE PROCESS

Throughout the course of a year, we photographed and interviewed about 20 people-and-pet combinations. Most of the photo shoots were scheduled (surprisingly, this worked out about 85 percent of the time) and were created in places where the subjects spent time. Some of the people we met while spending time on the streets, and those photo shoots happened on the spot.

The locations for the photo shoots were chosen based solely on where the person I was photographing spent time in some way; I didn't scout or choose the general locations. The backgrounds varied and included camps in the woods, bridges, street sidewalks, parking lots, and even a culvert. Just as I would with my portrait clients, I made intentional aesthetic choices within the given location to highlight the subjects' connection. I didn't bring outfits for the dogs or people, nor did I style the locations.

Some of the people I photographed had been homeless for years, whereas others were new to the streets. Some were young travelers, only staying in the city for a short period of time before moving on to another location, and others were more settled. While I was certainly interested in each person's life story, my focus remained on their bond with their pet.

I wanted to keep my equipment and presence pretty low-key so as not to make the people and animals I photographed feel insecure about the added attention a lot of equipment can attract (and it would have been difficult to bring a lot of gear to some of the locations). I always brought my camera, a small flash unit with a softbox on a pole, a reflector, and a diffuser. Most of the images were shot with ambient light, but I did use the flash on occasion.

The photo shoots and interview process lasted about an hour, sometimes less, and the overall experience seemed fun for those we connected with. Just like you and I, the subjects had a great deal of pride in their pets and their relationship with them. When they talked about their pet, there was a sparkle in their eye and a smile on their face. Their animals were their family.

THE CHALLENGES

Logistically, finding and coordinating with subjects would sometimes prove to be a challenge, as they would move around the city a lot, and getting in touch with people was a little difficult. Many homeless people have pay-as-you-go cell phones, which would often run out of minutes. Locations weren't always easy in terms of lighting or were physically challenging to navigate, but we always figured out something that worked in the end. Capturing the audio was also challenging, as there was usually a lot of ambient sound.

Emotionally, being involved in this project required significant investment. Homelessness is not a beautiful or simple thing. I felt sympathetic to the difficult lifestyle of being homeless and the many complicated issues surrounding it. Sometimes I felt guilty that I wasn't doing enough. However, in order to complete the project and be able to share the beauty I witnessed in the relationships, I needed to stay focused on the positive aspects of what I was encountering. I knew that I couldn't solve the issue of homelessness, but what I could do was continue creating portraits in the hopes of making a difference with my images.

WHAT I DISCOVERED

In the years following this project, I've given a lot of thought to what I learned in the process. Homelessness can be heartbreaking, stressful, and dangerous—and,

I am quite sure, feel very lonely to those who face it. It is a complicated issue, and by no means does this project intend to ignore its nuances or make it seem dreamy, nor am I an expert on homelessness after spending a year on a project. But I do feel that the relationships I witnessed between these people and their pets are positive ones and that they need to be supported by our community. Of course, like with people who have homes and shouldn't care for a pet, there are exceptions; but in general, I believe that these animals truly are lifelines to these people, just as they are to those of us fortunate enough to have a roof over our heads. These animals deserve to be cared for, and just because their owner might not be able to pay for their care doesn't mean that relationship shouldn't exist. These pets get to spend all day and night with their pet owners, an opportunity that my pets—and most people's pets—do not have.

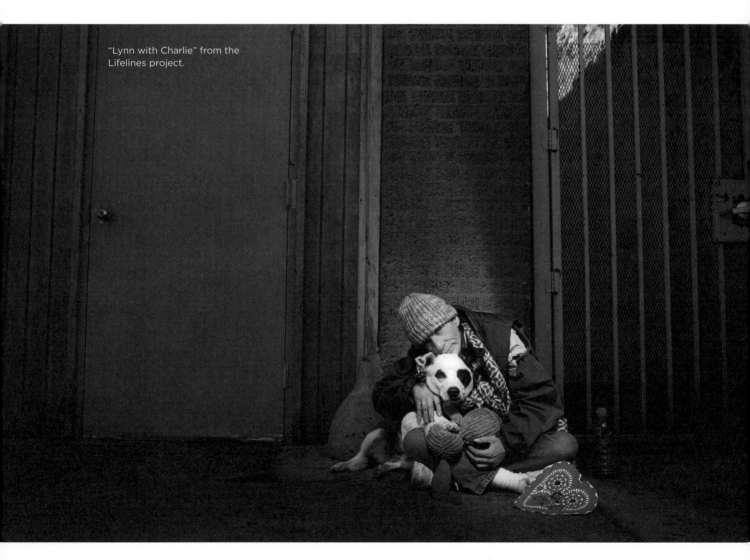

"Lynn with Charlie" from the Lifelines project.

There are so many benefits of having a pet, including how they can affect our mental and physical health. Imagine how much more impactful that relationship might be if you were living on the streets?

I am so grateful that my love of photography and animals gave me such a meaningful experience.

EXHIBITING AND SHARING THE WORK

I printed and delivered the portraits to as many of the subjects I photographed as I could reach. I am truly grateful for their participation in the project and for their willingness to share their relationship with others.

My immediate goal for sharing the images was to generate funds to print them on aluminum and have them exhibited locally in Austin. This vision came into reality and then some. After the money was raised through an online fundraising campaign (via Indiegogo), I had the images printed on large aluminum in vivid color. The images were exhibited in a gallery space and Austin City Hall and also in Los Angeles at The Animal Museum (formerly the National Museum of Animals & Society) and in their pop-up shows around the United States. The Lifelines prints are now part of the museum's permanent collection (www.theanimalmuseum.com).

The Lifelines images have been shared online via *The Huffington Post* and Yahoo.com and throughout the world via online publications including MSN in Africa, Italy, Brazil, Malaysia, Ireland, Japan, and elsewhere. The images have been shared on many blogs and websites, and they have been used in educational materials to support bringing social change and laws into effect.

I received many heartfelt, positive emails from people around the world telling me that the images touched them and gave them a new perspective. In their own words, people expressed their love of their own pets and donated funds to the animal welfare program that inspired the project. I have had the honor to speak about this project and have been truly amazed to have received such a tremendous response. The images and project have become much larger than myself—and that is truly powerful.

I share the reach of this project not to toot my own horn, but rather, hopefully to inspire you to take action to pursue your own curiosities—to see where your vision might take you. Your projects don't need to be shared around the world to be rewarding or impactful, but exploring your creative interests can be such a powerful experience. I had no idea I would have the opportunity to share my images to the extent that I have, but I learned that having the curiosity and commitment to pursue the creation of the images was the only way I could

start to open up the possibilities. I feel grateful that so many people were able to see the work and that the images and voices made some impact that I may not even be aware of.

WHAT YOU CAN DO

I want to encourage you to keep your eyes and ears open for ideas that pique your curiosity. Not all of your projects need to be socially impactful or serious or involve an animal welfare organization. You can create projects purely for fun and aesthetic exploration—and that's great, too.

You may have lots of ideas but still don't know how to find subjects and get started. I suggest generating a list of people and businesses that have the greatest reach to the people and animals you'd like to connect with. For example, if you have an idea for photographing spotted dogs, you might want to connect with a doggy daycare, dog trainer, or groomer so that you can connect with potential subjects. Do what you can to extend your reach as far as possible with the least movement so that you can spend more time and energy on the photographic aspect of the process.

You may feel a pull to explore a project that involves an animal welfare or rescue group, and if so, I encourage you to take some steps toward that goal.

If you don't have a specific idea in mind, you can start with a sense of inquiry. Connect with an animal welfare group in your area, and try to find out about programs and initiatives they're currently involved in and projects they have in the works. It may help to build a relationship with the group first, but it's not always necessary. You may be able to connect with a volunteer coordinator, a marketing specialist, or anyone in the organization who can speak with you and brainstorm ideas. Ask questions that will help you learn about possible ways you might get involved. Find out where there are gaps in the story that the organization is trying to tell.

If an idea surfaces for you and aligns with the organization, you can choose to take it on as a personal project or see if there is any budget to make it sustainable. You will also want to have the organization's blessing. You may find that you will be required to take a lot of initiative and left to do your own thing, or they may choose to get very involved. Try to find an arrangement that feels right for you and the organization.

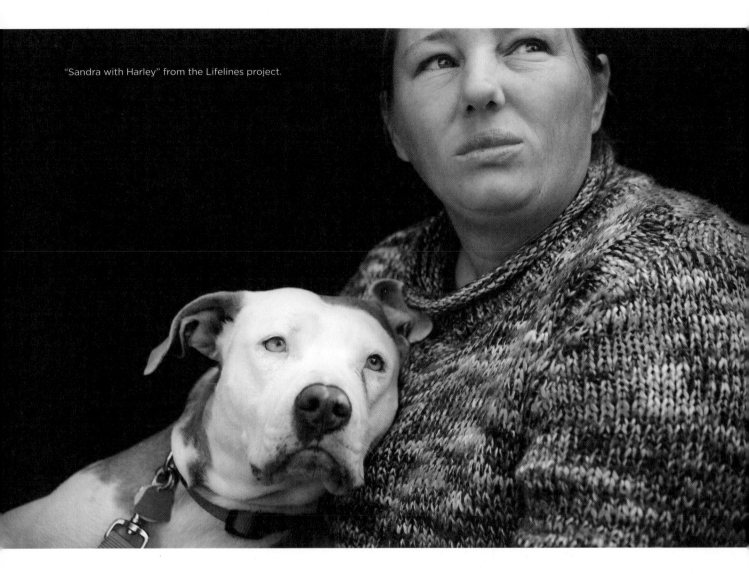

"Sandra with Harley" from the Lifelines project.

You don't have to know exactly where your project is going to go from the beginning, and it can be helpful to recognize that the trajectory may very well change. You may discover that you don't love the project as much as you thought you would, and it may generate an idea for an entirely new direction.

If you do choose to create a project, I'd love to hear about it. Getting involved with causes I believe in has been one of the most rewarding aspects of being a pet photographer. My hope is that I can encourage you to take a step toward something you are curious about and see where it takes you.

Moving Forward

The camera is a powerful tool, and it's pretty incredible that we have the ability to participate in something we enjoy, cultivate our own creativity, practice our skills with people and animals, generate awareness for a cause, help animals find homes, creatively preserve memories between loved ones, and spread joy with our imagery.

I hope this book has been valuable for you. Maybe it has encouraged you to pursue your interests in pet photography or given you the information and motivation to take your work to the next level, or the extra bit of confidence you need to dabble with pet photography on the weekends. Whatever your next steps are...enjoy!

It's been my honor to share my experiences and observations with you, and I invite you to stay connected with me. I'd absolutely love to see what you're up to and continue the journey together.

You've got this!

VISIT NORAH'S WEBSITE OR CONNECT WITH HER ON SOCIAL MEDIA:

- NORAHLEVINEPHOTOGRAPHY.COM
- FACEBOOK.COM/NORAH.LEVINE.PHOTOGRAPHY
- TWITTER.COM/NORAHLEVINE
- INSTAGRAM.COM/NORAHLEVINE

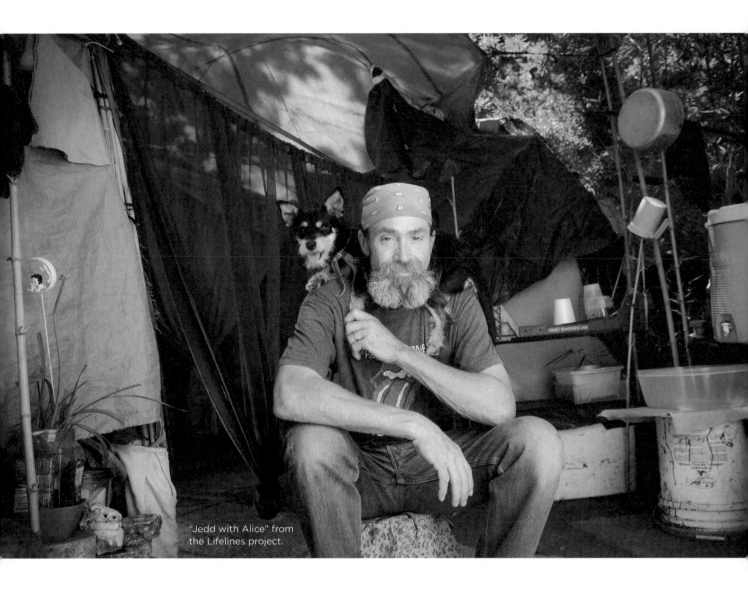

"Jedd with Alice" from the Lifelines project.

INDEX